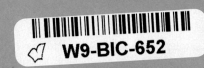

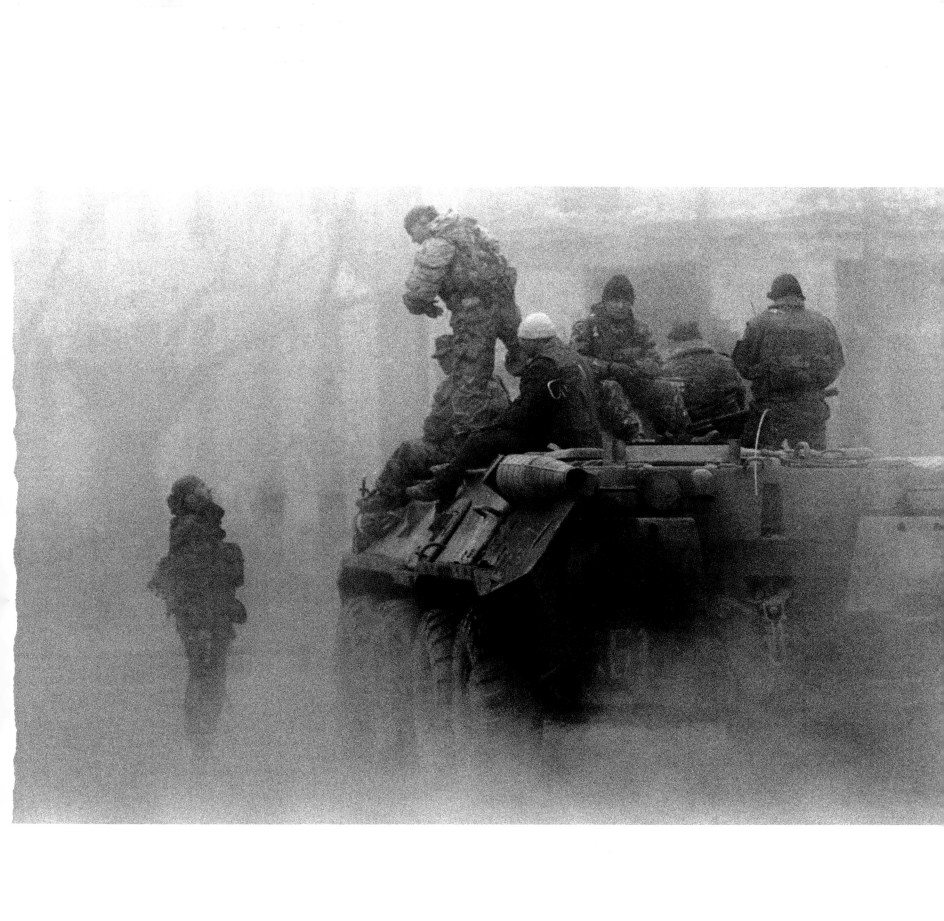

THIS BOOK IS DEDICATED TO THE MEMORY OF
MY FRIEND OLIVIER REBBOT AND
ALL THE OTHER BRAVE MEN AND WOMEN
WHO DIED PHOTOGRAPHING WAR.

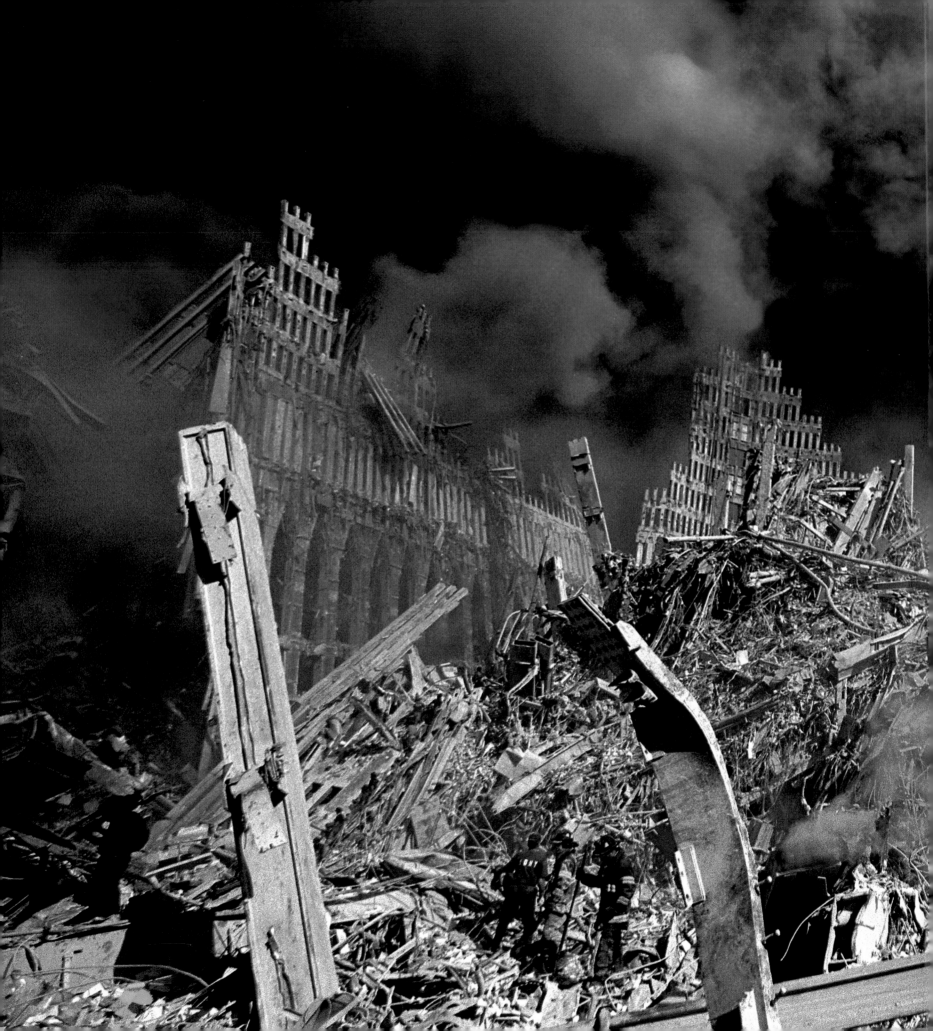

Shooting Under Fire

THE WORLD OF THE WAR PHOTOGRAPHER

PETER HOWE

ARTISAN | NEW YORK

Published by Artisan
A Division of Workman Publishing, Inc.
708 Broadway
New York, New York 10003-9555
www.artisanbooks.com

Library of Congress Cataloging-in-Publication Data

Howe, Peter (Peter R.)
 Shooting under fire : the world of the war photographer /
Peter Howe.
 p. cm.
 ISBN 1-57965-215-8
 1. War photography—United States—History. I. Title.
TR820.6 .H69 2002
070.4'9—dc21 2002074606

PRINTED IN JAPAN

10 9 8 7 6 5 4 3 2 1

BOOK DESIGN BY SUSI OBERHELMAN

Page 1: Christopher Morris: Russian troops in Grozny, 1995

Pages 2-3: Laurent Van der Stockt: Refugees from Kosovo, 1999

Pages 4-5: James Nachtwey: Ground Zero, September 11, 2001

Pages 6-7: Susan Meiselas: Sandanistas, Eseli, Nicaragua, 1979

Pages 8-9: Christopher Morris: Chechen fighter in Grozny, 1995

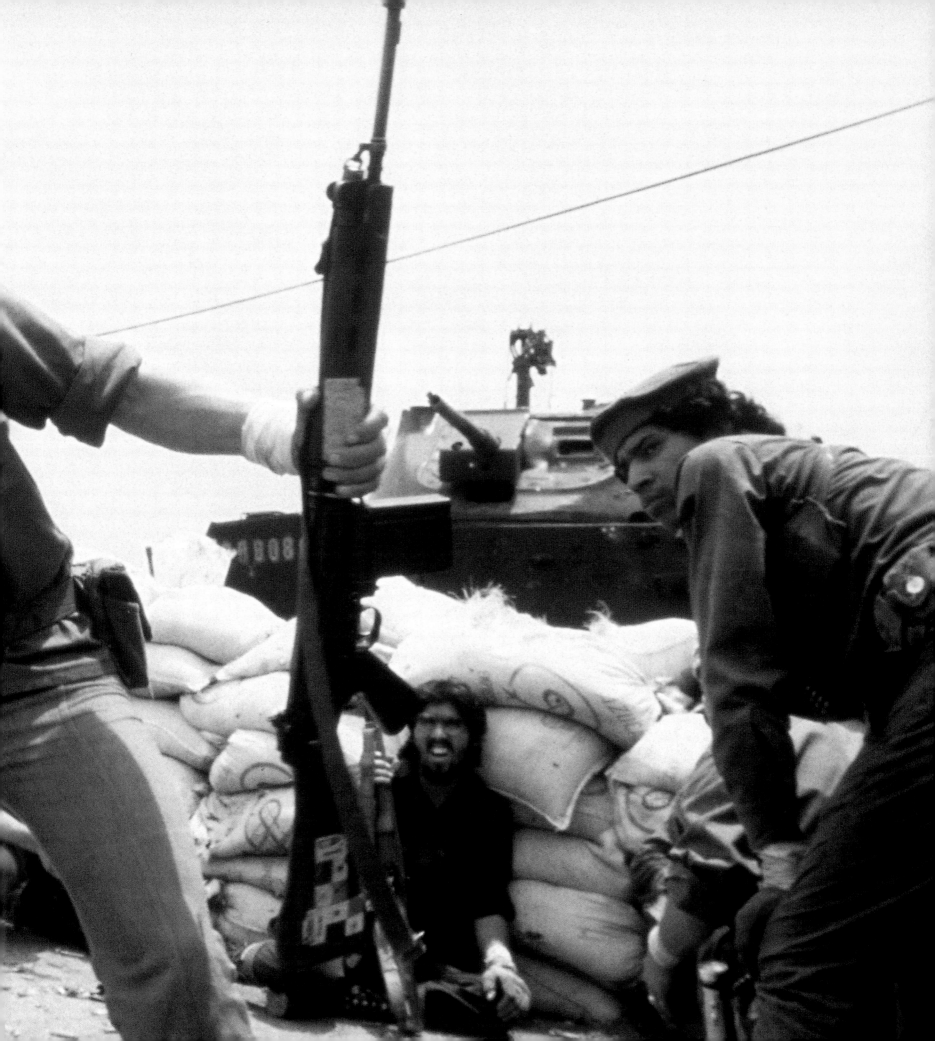

Contents

Introduction

THIS IS THE STORY OF COMBAT PHOTOGRAPHY, TOLD THROUGH THE EXPERIENCES of ten of the most famous living photographers who have gone into battle armed only with a camera. It's not a history book, although history fills its pages. It's not an encyclopedia of combat photography; it doesn't even give equal time to every war, as many of the photographers alive today come from the Vietnam era. What it does offer is a collection of extraordinary true stories—harrowing, heroic, tragic, even funny accounts from photographers on the front lines of conflicts ranging from Cyprus in the 1950s to Afghanistan in the twenty-first century.

Combat is arguably the most intense experience a human being can endure, whether as a soldier or as a photographer. It is also one of the most complex. Days, sometimes weeks, of unimaginable stress, where life on an hour-by-hour basis becomes a blinding reality, produce emotions ranging from terror to ecstasy in a maelstrom of confusion. How do I know this? In some ways I don't. My experience of war is limited to photographing two civil wars, those of Northern Ireland and El Salvador. Civil wars produce stress of a particular kind, with their own uncertainties and dangers. The firefight that erupts suddenly and out of nowhere is different from the pounding of artillery; a car bomb is not the same as aerial bombardment. The stress of a civil war lies in what might happen; the stress of combat is in what is happening.

My limited encounters with groups of (mostly) men trying to destroy each other led me to a fascination with war. I am not the kind of military buff who pores for hours over maps, studying strategy. My interest is in the sensation of combat, of what it feels like to survive on the edge with life's final experience as your constant companion. In its intensity, combat seems to be a distillation of life, a compression of time whereby a young man can age and die within the space of a few hours. But the trouble with a quest for this kind of knowledge is that it is largely unknowable to those who haven't experienced it.

On my return from Belfast or San Salvador, it always took me several weeks to get used to the pace of civilian life. Without the tensions of war, the daily routine is dull stuff, for survival is exhilarating only when it is unpredictable. There were many instances in the Second World War in which soldiers recovering from wounds in a safe and comfortable institution would go AWOL in order to rejoin their comrades in battle. War is also an experience that bonds its participants in ways that are stronger and longer lasting than any other. I was recently struck by footage of the Pearl Harbor veterans at services commemorating the sixtieth anniversary of the Japanese

WAR IS THE HELL OF YOUNG MEN

A member of the 173rd Airborne Division advertises his feelings about war while on duty at Phuoc Vinh airstrip in South Vietnam in June 1965. The photographer, Horst Faas, was seriously wounded in a rocket attack in 1967; his life was saved through the efforts of a young medic who had been in Vietnam only three months. Both survived the war and were recently reunited in Rochester, New York, after more than thirty years.

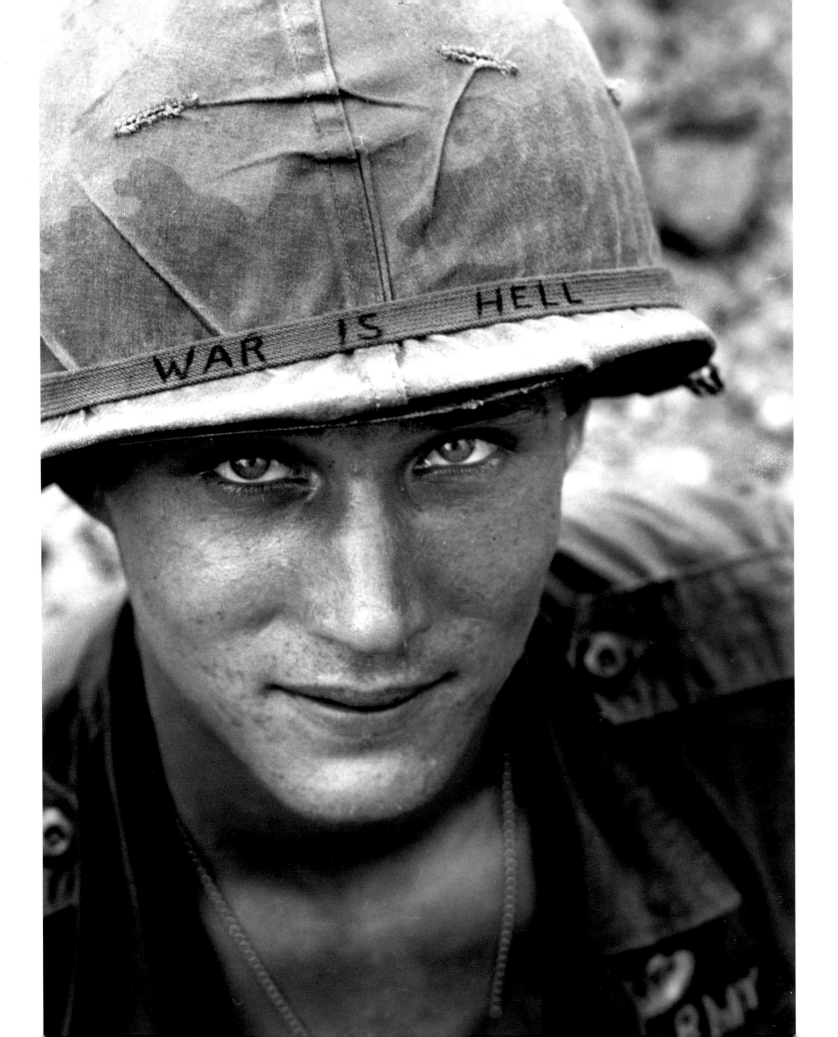

bombing. The intensity of emotion expressed in the faces of men who are now in their eighties was impressive. However hazy memories of other parts of their lives may be, recollections of December 7, 1941, pierce the fog of age with a forcefulness that even now disturbs those who recall that day.

The bonds formed between photographers under the duress of combat are equally strong. Theirs is a camaraderie that, as one leading photographer puts it, has been forged in fire. Photojournalism, like any other form of journalism, is an extremely competitive profession. It is a world dedicated to being there first and alone. For the most part, combat photographers are an exception to this rule. They typically work together, sometimes in partnerships of two battle-hardened friends, but often in teams that include representatives from competing magazines or newspapers. While this comes from a concern for security, it is also the result of the intense ties that come from working together in nightmarish places, from sharing fears and relief, from helping the wounded to live and the living to survive. These are relationships that are hard to destroy and impossible to replace.

Although the character of these bonds is constant, the nature of warfare continually changes. The First World War was substantially different from the Second; Nicaragua bore scant resemblance to Chechnya; the war in Afghanistan was nothing like the Gulf War. And as war changes, so do the techniques for covering it. The same technological society that developed the "smart bomb" also produced the digital cameras, laptop computers, and satellite phones that are the tools of today's photographic war correspondents. Their biggest concern is no longer taking enough film and keeping it dry. It is finding a source of electricity to recharge the batteries on which modern equipment relies.

The survival of the modern combat photographer still depends on the ability to exist in some of the most hostile working conditions imaginable. Staying alive means not only avoiding death from mines, mortar shells, and machine gun fire, it also means finding food to eat and a place to sleep and going without running water. It means working in a place where even the act of going to the bathroom can become a death-defying experience. Everyone knows how much baggage we can require for a two-week vacation. Imagine taking the equivalent to the deserts of Afghanistan, or the battered shell of Grozny, where the permanent inhabitants live in the cellars that are all that remain of the town's buildings. What would you need for two months under battle conditions? Well, the unisex list basically includes a change of trousers, two shirts, socks and underwear, a short wave radio, a flashlight, a medical kit, a wash kit, and a water pump with a filter if you're going to somewhere without potable water—all under twenty pounds.

Philip Jones Griffiths once described the perfect war photographer as being four feet tall and weighing sixty pounds. In reality they come in all shapes, sizes, colors, and motivations. And although most are male,

A PAINFUL RETURN HOME

Laurent Van der Stockt took this photo of a woman and child returning to the battered remains of Grozny in the Republic of Chechnya in August 1996. The Russian army invaded the country in 1994 to keep it part of the Russian Federation, but it could neither defeat nor contain the rebel forces. By August 1996 the Russians had to negotiate a peace agreement that was tantamount to a humiliating defeat. More than 100,000 people died in the conflict.

many women have achieved great distinction among their ranks. What they all share is courage, ingenuity, determination, and resourcefulness. What they lack is a desire to live in the mainstream. Through their stories as well as their eyes, they explain why they choose to risk their safety for a few pictures on a page, and what draws them back to conflict time and time again. Some are convinced that by providing the public with the images of violence, tragedy, defeat, and victory, they can improve the world. Others are more cynical, believing that their pictures have no effect whatsoever on the course of history, but that bearing witness to the darkest moments of human behavior serves to prevent distortions of truth, now and in the future. Whatever their motivation, it is through their bravery and commitment that those of us who live safer and more normal lives can know the sinister side of our planet. The evidence of man's barbarity they provide is the low-water mark above which our civilization should always rise; the moments of courage and compassion they capture are models to which we should aspire. As their stories will show, they are a rare and extraordinary group of men and women. ■

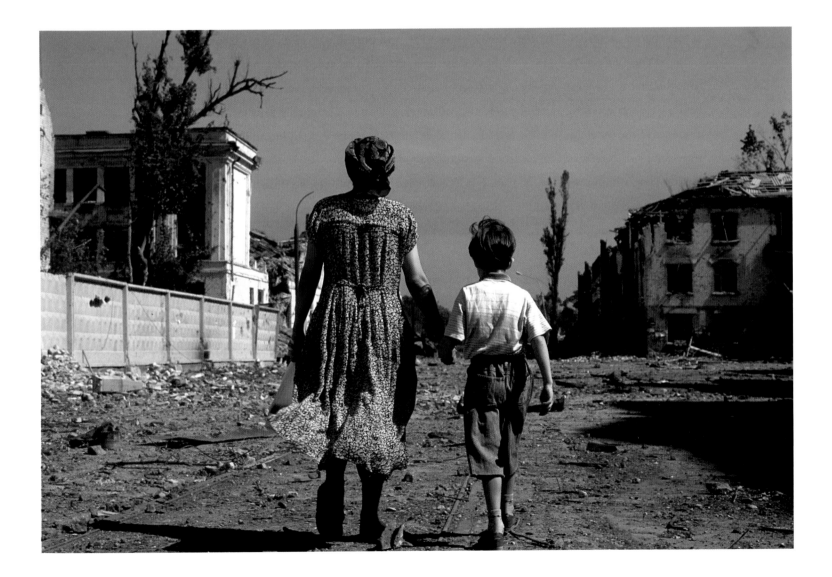

For Every War a Witness

THE LEGENDARY PHOTOGRAPHER ROBERT CAPA ONCE SAID, "THE WAR photographer's most fervent wish is for unemployment." Despite this noble sentiment, combat photographers are always busy. It would be comforting to think of war as an aberration, an occasional, albeit tragic, deviation from our normal, peaceful lives, but nothing could be further from the truth. In the twentieth century, an estimated 87 million people perished in more than 150 wars. The majority of those who died were civilians. The nineteenth century, during which photography was invented, had even more conflicts—two hundred wars in one hundred years. Given these statistics, it isn't surprising that since the invention of photography, war has been one of its great themes.

The first war photographers didn't really photograph war at all. Because of the bulk of their equipment and the length of time it took to make an exposure, they were limited to battleground landscapes, posed pictures of fighters, simulated combat, and portraits of soldiers prior to battle.

The Crimean War (1854–1856) was the first war to be recorded in depth photographically, and thus the first that we can experience as twenty-first-century observers. For this we have to thank Roger Fenton. Fenton was a member of the British ruling class who was originally sent to the war to provide evidence of the excellent conditions under which the British troops were living and of the successes they were achieving. The results of his labors were to be used as propaganda on the home front. Unfortunately, neither supposition proved to be true, but like all good propagandists, he didn't let reality stand in his way. His posed photographs of the officer class portray them as relaxed, prosperous, and confident. What his propaganda couldn't conceal was the bleak reality of nineteenth-century combat. One of his battlefield photographs, entitled *The Valley of Death*, remains a classic reminder of the brutality of battle. It shows a forlorn landscape devoid of vegetation and human existence and littered with hundreds of spent cannonballs, and is a precursor of similar images that every subsequent war would provide.

TABLECLOTHS OVER BERLIN

As Soviet troops approached Berlin, Ukrainian photographer Yevgeni Khaldei wanted to make a heroic picture of the Red Flag being hoisted over the captured city, but there were no flags at the front. He flew back to Moscow, had the stars, hammers, and sickles sewn on three red tablecloths, and on May 2, 1945, photographed two soldiers hoisting the result above the Reichstag. Soviet authorities ordered the photo to be retouched, as the man supporting the flag bearer was wearing more than one wristwatch, clear evidence of looting.

Even with the latest equipment, Fenton had to haul a horse-drawn darkroom from location to location. His technique, the wet collodion process, allowed him to use shorter exposure times, get much higher definition, and produce hundreds of copies from the same negative. But the plates inserted into the camera had to be coated with a light-sensitive solution, which dried out in ten minutes, after which it was useless. It wasn't something you could do in the middle of a cavalry charge.

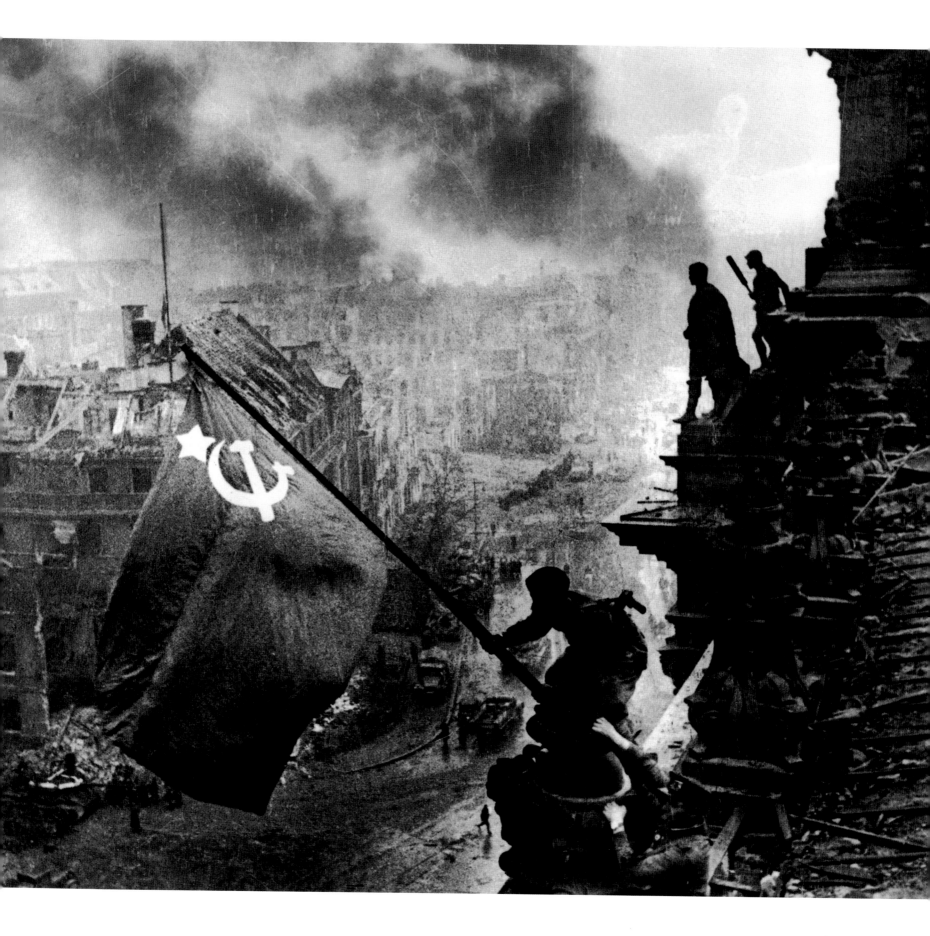

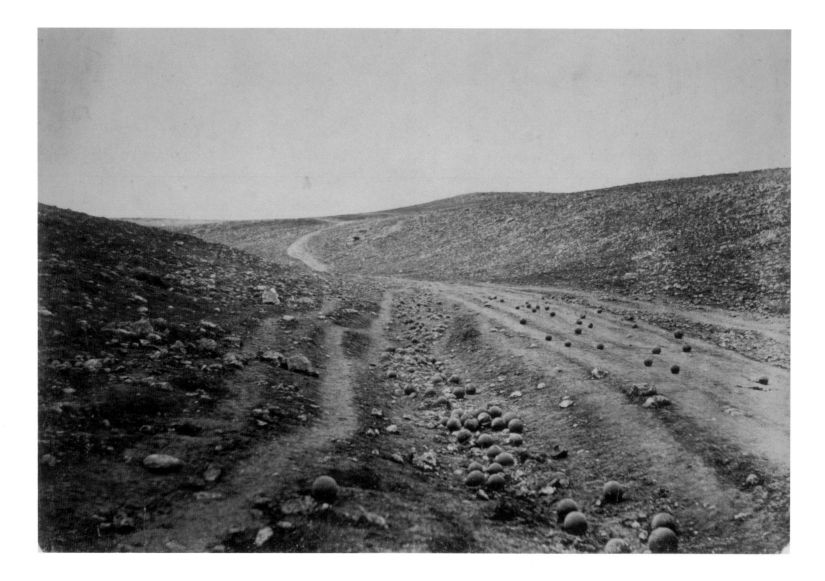

Fenton wasn't the only person witnessing the hostilities. The danger of combat was contained within a relatively small geographical area, and as a result war became a sort of tourist attraction. Wealthy Europeans on the Grand Tour of the Continent would "take in" a couple of battles whenever possible, and some even took photographs. The horror of war was thus reduced to the same level of experience as visiting the pyramids or the Parthenon.

War as a tourist attraction wasn't restricted to Europe. During the American Civil War (1861–1865), carriage loads of affluent Washingtonians went to the first battle of Manassas with champagne picnics. As in the Crimea, one photographer stood out through his dedication to the task of recording the war. The Civil War's Roger Fenton was Mathew

RECYCLING CRIMEA STYLE

This is not the Valley of Death immortalized in Tennyson's poem "The Charge of the Light Brigade," but a ravine near the Battlefield of Inkermann littered with spent Russian cannonballs. On several occasions when ammunition was getting low, British soldiers were paid for every used cannonball they retrieved. Fenton's horse-drawn darkroom was frequently fired upon when mistaken for an ammunition cart.

Brady, a New York portrait photographer who left his very successful business to record the war. He seemed unconcerned by warnings of personal danger and financial disaster ("I had to go. A spirit in my feet said 'Go,' and I went"). Most of the work that is credited to him today was not taken by his camera, but was the result of his compilation of the work of several photographers. Nevertheless, the collection that he formed is one of the greatest collections of war photography in existence. He was the first photographer to show civilians the real cost of war through his pictures of the fallen at the bloody battle of Antietam, where more than five thousand were killed and eighteen thousand wounded.

Brady's gamble that the collection would have commercial value in peacetime failed to pay off. The American public was weary of war and had no appetite for reminders of the tortures the country had endured. Eventually, he sold the collection to Congress in 1875 for $25,000, which helped him pay off some of his debts, but he died penniless and disillusioned.

As the nature of war changed, so did photography. Technology was creeping forward, and by the outbreak of the First World War there were lenses and film fast enough to capture the action of

BRADY'S SAD MEMORIES

Brady and his photographers were the first to show the public the harsh reality of war. Brady himself was one of the first to express the schism between the war photographer and those viewing his work: "To one who has moved in the scenes represented, these pictures are pregnant with strange, sad reminiscences . . . You recognize the very sycamore to whose base a young Lieutenant had crawled to die. You knew him."

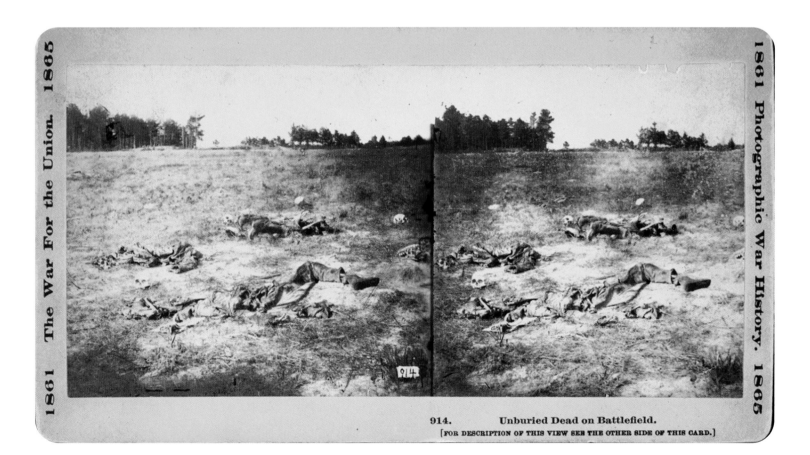

914. Unburied Dead on Battlefield.
[FOR DESCRIPTION OF THIS VIEW SEE THE OTHER SIDE OF THIS CARD.]

combat in cameras that were portable enough to carry into battle. But the film still had to be inserted into the camera in cut film holders. Before the exposure could be made, the dark slide had to be removed, then the shutter released, the slide replaced, the film holder reversed, and the procedure repeated. This process meant that there were always several seconds between shots, precious time that could be crucial in capturing a critical moment in the action of combat.

This all changed with the invention of the Leica in 1925. At last there was a small camera with fast interchangeable lenses that used cassettes of 35-mm film, a combination that allowed a series of pictures to be made in very low light. The war photographer could now work with complete freedom in the very center of the action, shoulder to shoulder with fighting troops. The war photographer had become a combat photographer.

One of the first of this new breed was Robert Capa. Handsome, charming, devil-may-care, he was born André Friedman in Budapest in 1913. Because of his political activities, he ended up in the files of the Hungarian secret police, and in 1933 left for Paris. There he met a photographer and journalist named Gerda Taro. Between them they "invented" the famous photographer Robert Capa in order to sell his prints at higher prices, claiming that he was independently wealthy and wouldn't sell his work for less. Using his new name, he got his first taste of combat during the Spanish Civil War (1936–1939).

It was his 1936 photograph of a Spanish militiaman at the point of death that brought Capa international recognition. It vividly illustrates the new opportunities and new dangers afforded by the photographer's greater mobility and access. The figure of the Loyalist soldier falling backward under the force of the deadly bullet is an image that has become one of the iconic photographs of war. It would not have been taken if Capa had not had the ability to react quickly at close range. This of course put him in a position where if the bullet had been a few degrees to the left, the photograph wouldn't have been taken at all. But as he famously once said, "If your pictures aren't good enough, you aren't close enough." Capa was always at least close enough.

Nineteen thirty-six was also the year that Capa's most important client, *Life* magazine, was born, and it was for this groundbreaking publication that he did much of his finest work. Within three years of its first issue, Europe was embroiled in the Second World War. In 1941 the magazine sent Capa, who had been living in New York City since 1939, to England. However, because he was still officially an enemy alien, he wasn't allowed to cover combat until 1943. He saw action in North Africa, Sicily, and Naples. It was his coverage of the D day landings that gave the world another lasting icon of war. On June 6, 1944, he accompanied company E of the Sixteenth Regiment, First Infantry Division onto the beach in Normandy

PHOTOGRAPH AT YOUR PERIL

World War I was the first war to be photographed by military-appointed photographers. There were few of them, and most of their efforts remain anonymous. The Imperial War Museum in London houses one of the finest collections of images of this conflict—all of the official work produced by the British, Australian, and Canadian photographers—and it amounts to only forty thousand images. Some soldiers took their own photographs, although the penalty for doing so was death by firing squad.

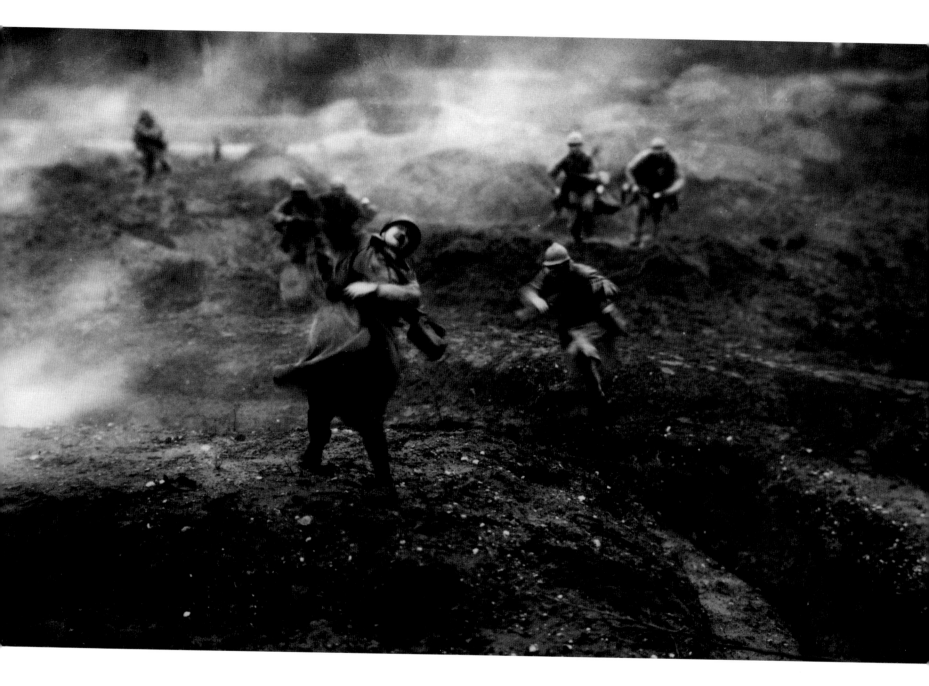

code-named Omaha. He was to land near the village of Saint-Laurent-sur-Mer in the section ironically designated "Easy Red." The landing craft left the soldiers and Capa more than one hundred yards from the beach, exposed to raking German machine-gun fire. Although by this time he was a veteran of many battles, he admitted to "a new kind of fear shaking my body from toe to hair, and twisting my face." His hands shook as he changed film, and he repeated the Spanish Civil War phrase *"Es una cosa muy seria"* (This is a very serious business) over and over as a sort of mantra. When the opportunity arose to board a departing landing vessel, he took it, persuading himself initially that he needed to get his film back to London but knowing deep inside that he was running away.

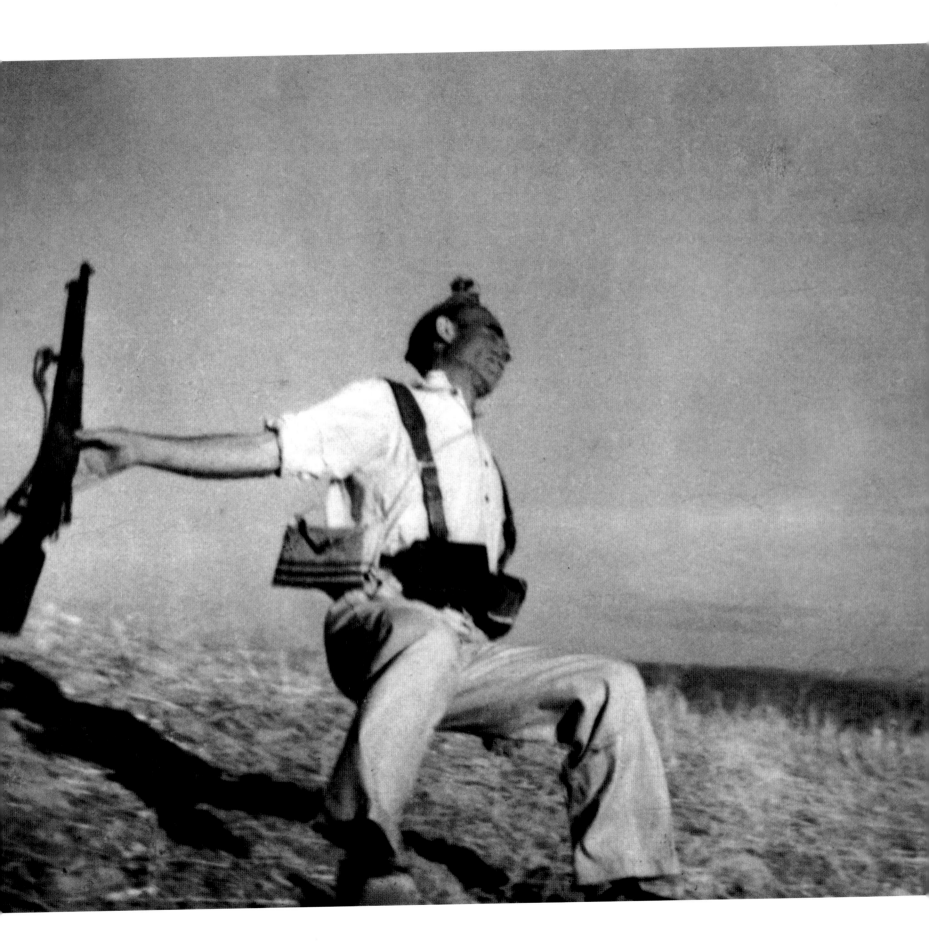

THE MYSTERY OF THE MILITIAMAN

Until recently, there was a swirl of controversy around Capa's photograph of the Spanish militiaman (left). It was originally printed in *Vu* magazine without a caption; there were no contact sheets to show the sequence of events, there was no visible wound, and the negatives disappeared. This led to charges that the picture was set up. Recent work by Spanish historian Richard Bano, Capa biographer Richard Whelan, and a former militiaman, Mario Brotons, has validated the picture as showing the death of Federico Borrell García, the only member of the Alcoy militia to have been killed at Cerro Muriano on September 5, 1936.

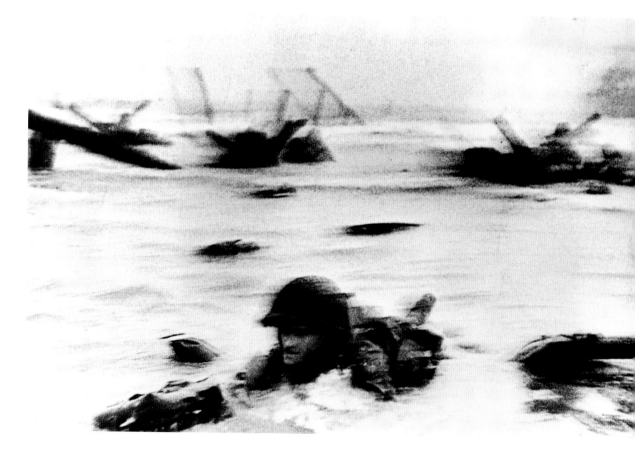

D DAY DISASTER

One of the reasons for Capa's early departure on June 6 was to get the film that he had shot of the landings back to London. But an overly enthusiastic *Life* lab technician, eager to see the photos, dried the negatives at too high a temperature. Only 10 of the 106 frames Capa shot that day survived. The partially melted emulsion of those 10 gives them a blurred and eerie quality that expresses the chaos and nightmarish reality of the event (above).

Capa's dilemma was one every combat photographer eventually faces: Are you leaving because you have to get your film back or because you're not tough enough or brave enough? Are you a parasite because you'll be enjoying a hot meal while the men with whom you went into battle are still being shot at? Is your role that of an honorable witness or a reckless voyeur? To choose to be in a place of extreme physical discomfort and danger is often more stressful than being ordered there. To be able to leave that place compounds the stress.

It's a rare gambler who doesn't sometimes overplay his hand, and Capa placed one bet too many. In 1954 in Vietnam, a land that was to claim the lives of so many journalists, he stepped into a rice paddy to get a better angle and onto a land mine. He died with his camera clutched in his hand, the first American photographer killed in that country.

The First World War might not have been "the war to end all wars," but Korea was surely "the forgotten war." Wedged in between the glorious achievements of the Second World War and the disaster of Vietnam, it was a vicious encounter that achieved nothing. At the end of three bloody years of conflict, the boundaries separating North from South were essentially the same.

David Douglas Duncan's experience of combat photography began as a marine second lieutenant in 1943 in the Second World War. He eventually retired with the rank of lieutenant colonel, and then rejoined the marines in Korea as a civilian photographer for *Life*. Some of the most moving images of combat ever made are from his cameras—achieving their power without showing combat at all. Many of his pictures are close-up headshots that reveal the numbing effects of combat exposure through the dull expressions and glazed eyes that speak more eloquently about war than any scenes of battlefield carnage.

Duncan respected the fighting man and was respected by him. He shot combat only in black and white because he thought color would be a distraction. "War is the ultimate human tragedy," he once told a reporter. "You'll never find one of my photographs that violates your privacy, or if you're knocked off, your mother's privacy. I never show you any corpses or shot-up bodies. These sons of bitches today, you know, after a typhoon, after an earthquake, anything, they're right in there. That's not my privilege. I want you to feel the story of fatigue and tragedy and heartbreak. If they're dead, you'll never see their faces."

There are many reasons photographers are drawn to war as a subject. Sometimes young photographers see it as a way to jump-start their careers, which tragically often ends them prematurely. Others are adrenaline junkies for whom the thrill of living at the very edge of life is an experience without parallel. Duncan's kind

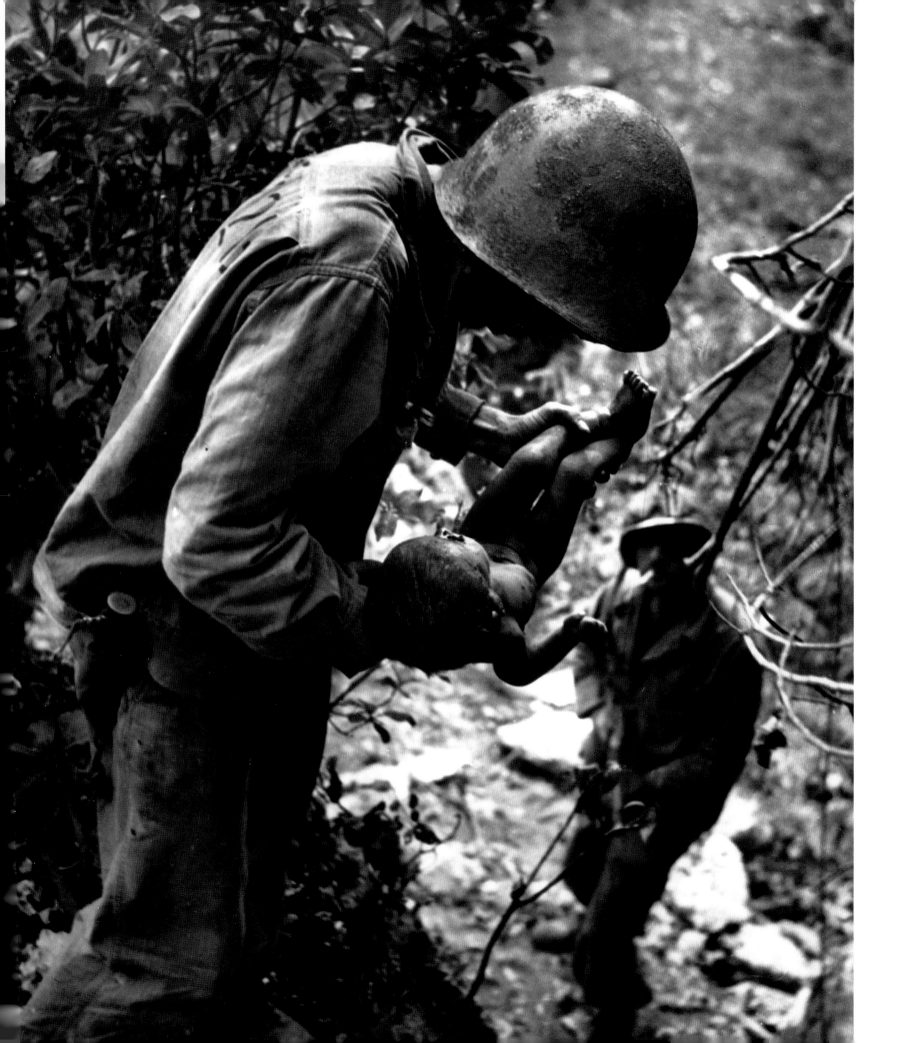

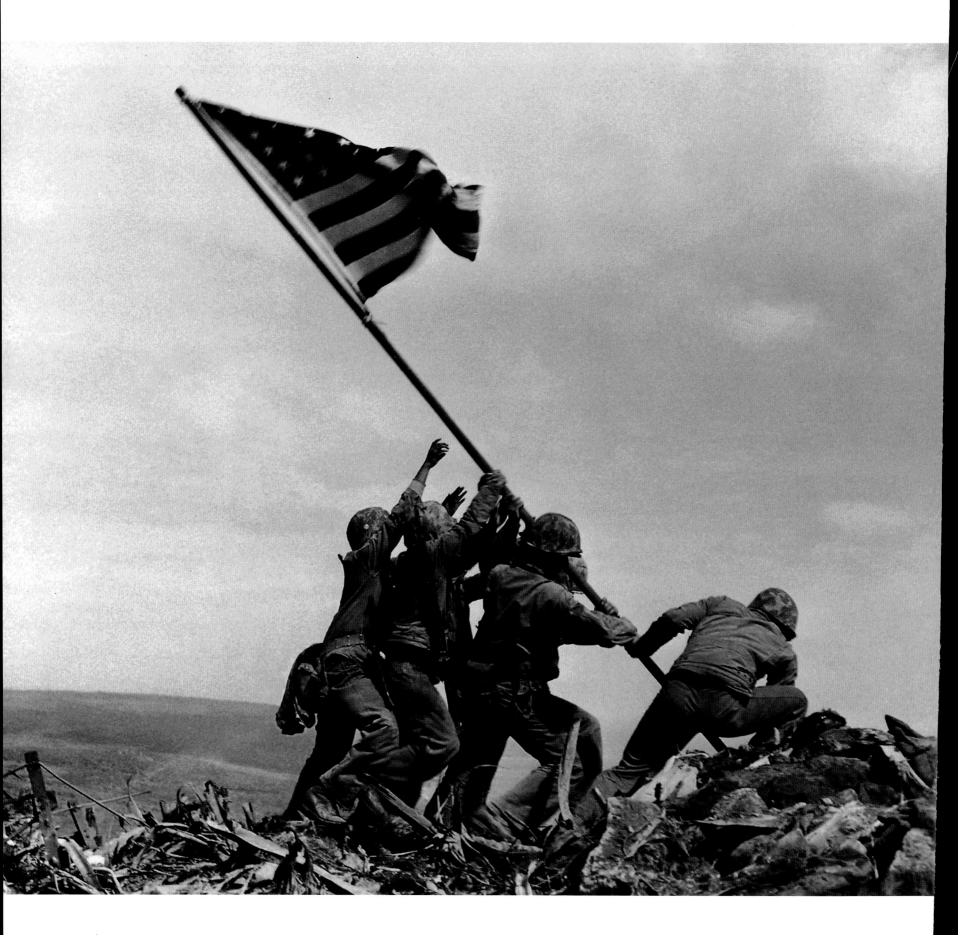

of idealism is also a common motivation. One of the most idealistic and uncompromising throughout his career was W. Eugene Smith. Ernie Pyle, the famous war correspondent, once described Smith as "an idealist, trying to do great good with his work but it will either break him or kill him." His involvement in World War II from 1942 to 1945 nearly did end his life, but it certainly didn't break him. He continued after the war to produce some of the finest photo essays ever created.

Smith gave Pyle a photo depicting a mother and child on Saipan, on which he wrote the following: "Saipan: I do not believe I could have reached this close without my family, for these people of the pictures were my family—reflected in the tortured faces of another race. Accident of birth, accident of home—the bloody dying child I held momentarily while the life fluid seeped through my shirt and burned my heart. That child was my child. And each time I pressed the shutter release, it was a shouted condemnation hurled with the hope that the pictures might survive through the years and at last echo through the minds of men in the future. One faint ray of hope, I found then, was the shine of tenderness in the eyes of battle-tired men who could yet give tenderness and gentleness to the innocent of the enemy."

If ever a picture can be called iconic, it is Joe Rosenthal's of the raising of the flag on Iwo Jima. The invasion of Iwo Jima on February 19, 1945, was one of the bloodiest of the war in the Pacific. Twenty-two thousand Japanese defenders were burrowed into a warren of volcanic rock caves and bunkers they had constructed throughout the tiny island with its three precious airfields. Against them was deployed the largest force of marines ever sent into a single battle, 110,000 in 880 ships. Casualties were huge; the invaders couldn't see the Japanese in their caves and fortifications, whereas the defenders had an uninterrupted view of the marines, and through carefully placed overlapping fields of fire they were able to shoot any target anywhere on the island.

After four days of intense fighting, the American troops finally prevailed, and on February 23 the order was given to mount the American flag on the top of Mount Suribachi, a 550-foot hill, the scene of the bloodiest combat. It was the first time the Stars and Stripes would fly on Japanese soil. Associated Press photographer Rosenthal was there to record the event. But the picture that was to immortalize this battle and represent American courage and endurance was the second raising of the flag, on the same day but with a bigger one than the original.

Despite the fact that the photo showed the replacement flag, and false allegations that it was posed, Rosenthal was awarded the Pulitzer Prize for his work. The image appeared on stamps, was sold as framed prints, and was reproduced in a huge bronze sculpture that became the U.S. Marine Corps Memorial in Arlington, Virginia.

THE SECOND RAISING

The Secretary of the Navy, who was observing the battle of Iwo Jima, decided he wanted to keep the original flag raised on Mount Suribachi as a souvenir. Colonel Chandler Johnson, Commander of the Second Battalion, was so incensed that he ordered another flag to replace it, to be kept by the Marine Corps. Sergeant Mike Strank and his men from Easy company got the order to find a bigger flag so that, as Strank put it, "every son of a bitch on this whole cruddy island can see it."

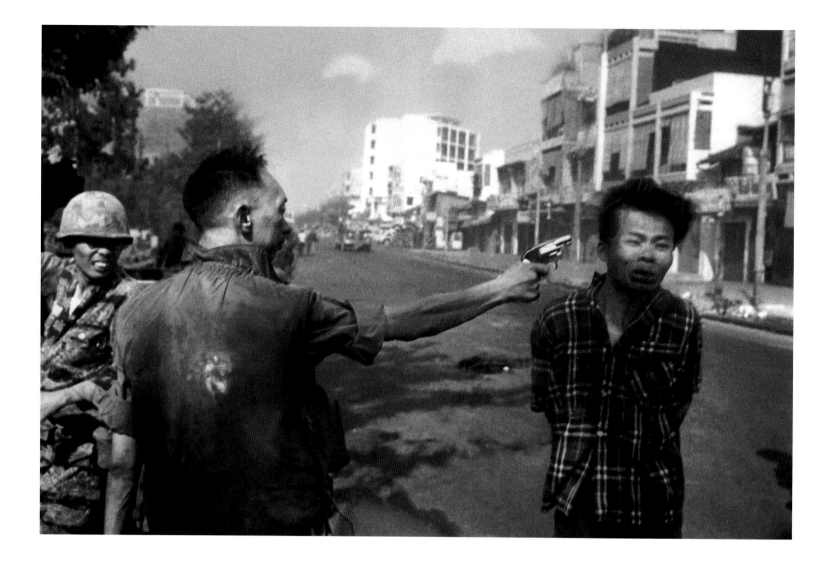

It was also the icon that inspired the American public to contribute $26.3 billion toward the war effort during the Seventh War Bond Tour.

While Joe Rosenthal's photograph inspires feelings of gratitude and patriotic pride, two photographs from the Vietnam War have exactly the opposite effect. One of them, by Eddie Adams, then an Associated Press photographer, depicts the execution of a Vietcong suspect by Vietnam's Chief of Police, Nguyen Ngoc Loan, in 1968. The victim was shot in the street with his hands bound behind his back. Loan claimed that he was a known Vietcong captain in civilian clothing who had been captured in the act of murdering a police sergeant and his family. It proved to be one of the key images of the war, contributing to the American public's gathering disillusion with the conflict.

THE UNLIKELY HERO

"Loan gave no indication that he was to shoot the prisoner until he did it," Eddie Adams said. "As his hand came up with the revolver, so did my camera, but I still didn't expect him to shoot. When he fired, I fired." Loan was a popular figure with both his troops and the South Vietnamese, and had fought for money for the construction of hospitals. "He was fighting our war, not their war, and all the blame is on this guy."

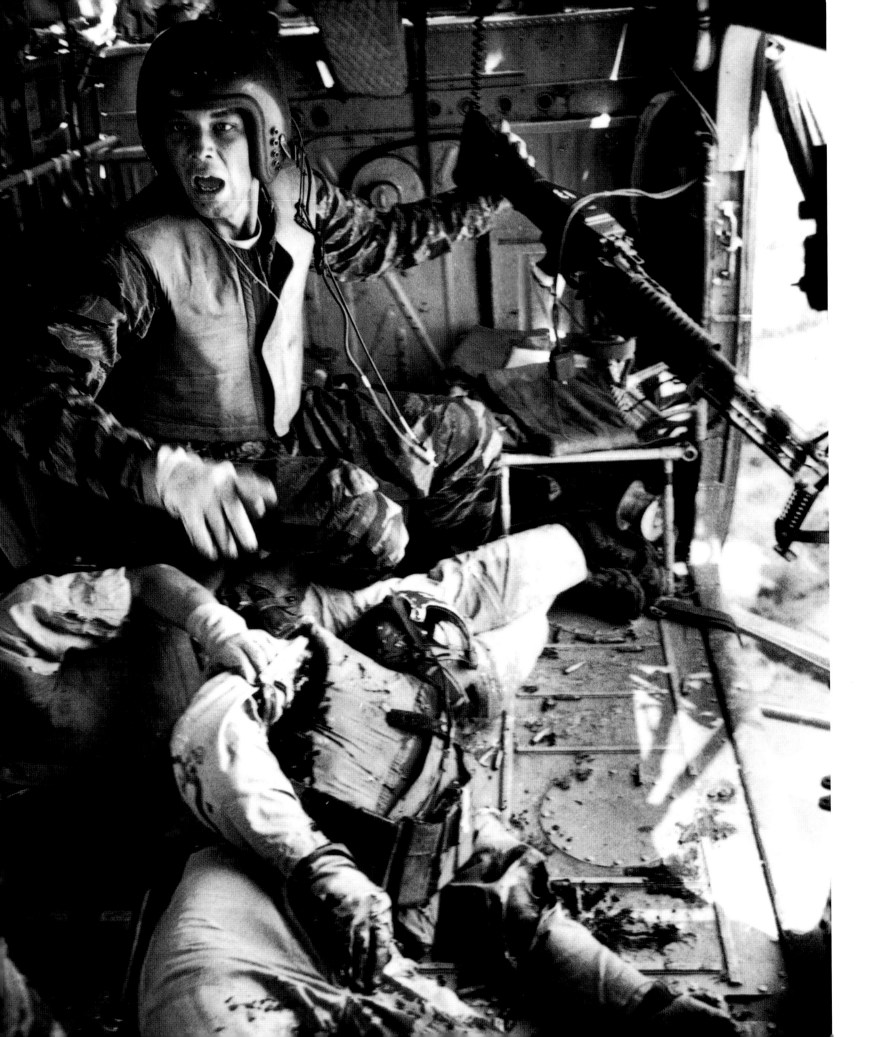

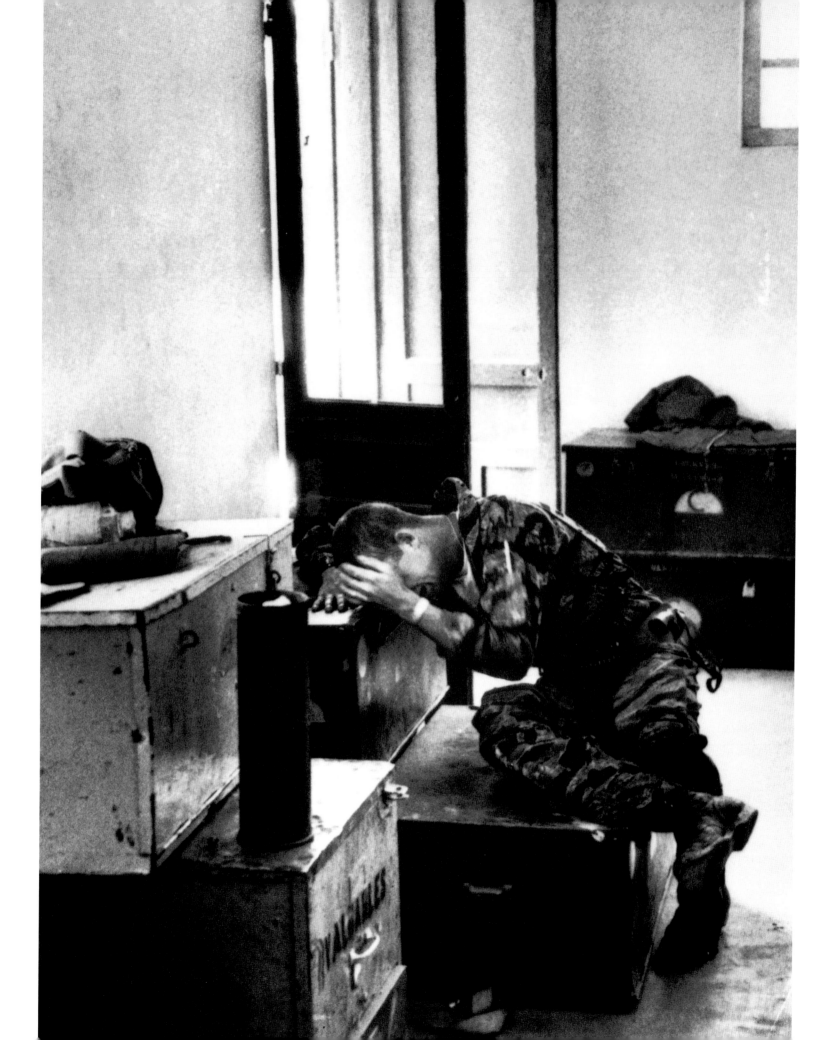

process of war. In his book about the Vietnam War, *Dispatches*, Michael Herr describes Burrows photographing a Chinook helicopter during the battle of Khe Sanh as it unloaded its dead and wounded: "When it was gone, he looked at me, and he seemed to be in the most open distress. 'Sometimes one feels like such a bastard,' he said."

Fellow photographer Henri Huet took a photograph of this "bastard" helping to carry a wounded GI to an evacuation helicopter during action in Cambodia. Huet and Burrows were two of the photographers who spent several days in February 1971 at the border between Vietnam and Laos trying to persuade the South Vietnamese military to give them a helicopter ride so they could photograph Operation Lam Son 719, an operation entirely under the command of South Vietnam. Their persuasive determination finally paid off, and they, along with fellow photographers Kent Potter and Keizaburo Shimamoto, got their ride. But the pilot got lost and flew into North Vietnamese antiaircraft fire. All on board were killed. Vietnam was a costly conflict for photojournalists. During the twenty-year period of fighting, 135 photographers died, 80 in the time that America was involved. Of this figure, several disappeared; one of these was Errol Flynn's son Sean, who vanished in the jungles of Cambodia.

Burrows and his colleagues were on a South Vietnamese helicopter for two reasons. The first was because South Vietnam was running the operation, with the Americans at this stage playing a supporting role. The second was that by this time the U.S. military had adopted a much more restrictive attitude toward the press. The generals could see the effect that photographs were having on the American public and the erosion of support that was occurring as a result. Vietnam was a helicopter war. There were thousands of them in the country. They transported troops, supplies, heavy armaments, ammunition, photographers, and casualties, both dead and alive. It was relatively easy to hitch a ride to and from the action, which enabled them to shoot and return to their offices in Saigon within a short period of time. On any given day, dozens of photographers would be crisscrossing the country looking for the hottest and most significant encounters. As the military brass became more concerned about the home front, they started to control the journalists' access, minimizing the likelihood of "bad press."

Vietnam was a lesson the U.S. military learned well. It resulted in its enforcement of strict controls and censorship over access to future conflicts, especially the Gulf War, when the Pentagon controlled almost every aspect of the coverage the American public saw. Some photographers tried to evade this restraint, and there were some situations that were so chaotic that they were uncontrollable, but for the most part very little got through. In fact, the weapons themselves took some of the most dramatic combat images through cameras mounted in the so-called smart bombs.

BREAKDOWN OF A FRIEND

As the drama and tension build through the twenty-two photographs in this essay, the reader is led to the final moment in this day in Farley's life. This picture was simply captioned *Farley Gives Way* in the *Life* layout. "It's not easy to photograph a pilot dying in a friend's arms and later to photograph the breakdown of the friend," Burrows said. "I didn't know what to do. Was I merely capitalizing on someone else's grief?"

One of the two most memorable images not taken by a bomb during this period is a widely published photograph by David Turnley. It is of a U.S. soldier, in tears, who has just learned that the body bag in the medical evacuation helicopter contains the body of his friend killed by "friendly fire."

Ken Jarecke's photograph of the charred body of an Iraqi soldier is a horrific image, a grinning charcoal replica of a man. It was a result of the American campaign, and it is a reminder that war is brutal. The picture was published in Europe, but to this date it has been published in the United States only a handful of times.

An effective tool that the military authorities use to control photographers is the pool system. This is where photographic coverage of an event is restricted to one representative from each of the various media (wire service, newsmagazine, newspaper, and so forth) and the photography that they produce is shared with the publications that request it. In this way, not only is the number of photographers minimized—making it easier for them to be physically controlled—but the amount of work that has to be censored, or "reviewed," as it is now euphemistically described, is substantially reduced. This procedure puts photographers on their best behavior—something that never comes easily to them. If they penetrate a forbidden area, or take photographs that show the operation in a negative light, they are simply removed from the pool.

During the Gulf War, *Life* published a weekly edition covering the conflict as well as its effects on the home front. The magazine put a team consisting of a photographer and writer in the Middle East, and they both begged that their names not be entered into the pool system. They preferred to risk the wrath of the U.S. military and the Iraqi army rather than have such limitations imposed on their ability to work. Two things a military commander can't control are the chaos of battle and the character of photojournalists.

The war against the Taliban pinpointed yet another growing danger for the war correspondent, that of assassination. As of the date of writing, hostile forces in Afghanistan have killed more journalists than U.S. military personnel—all of them murdered, not killed in the line of fire. As the power of the camera, still or video, is more widely understood, its operator becomes a target both in firefights and while traveling around the country. There are many instances of the Israeli army specifically targeting journalists, either individually with rifle fire or in groups with tear gas and stun grenades—too many for them not to have at least the tacit approval of the Israeli military authorities. In Chechnya, kidnap for ransom is yet another danger facing the war photographer.

The rules of warfare changed radically in the closing years of the twentieth century. Indeed, now there seem to be no rules at all. Set battles and classic military strategy have been

THE PEARL EARRING

One of the most moving photographs of the Vietnam War is of a priest giving last rights to photographer Dickey Chapelle, who had stepped on a land mine. Her hair has fallen away from her face to reveal a pearl earring. Although she covered combat in the same dirt- and sweat-covered fatigues as her male colleagues, this touch of feminine adornment brings an immense poignancy to the picture of the dying woman.

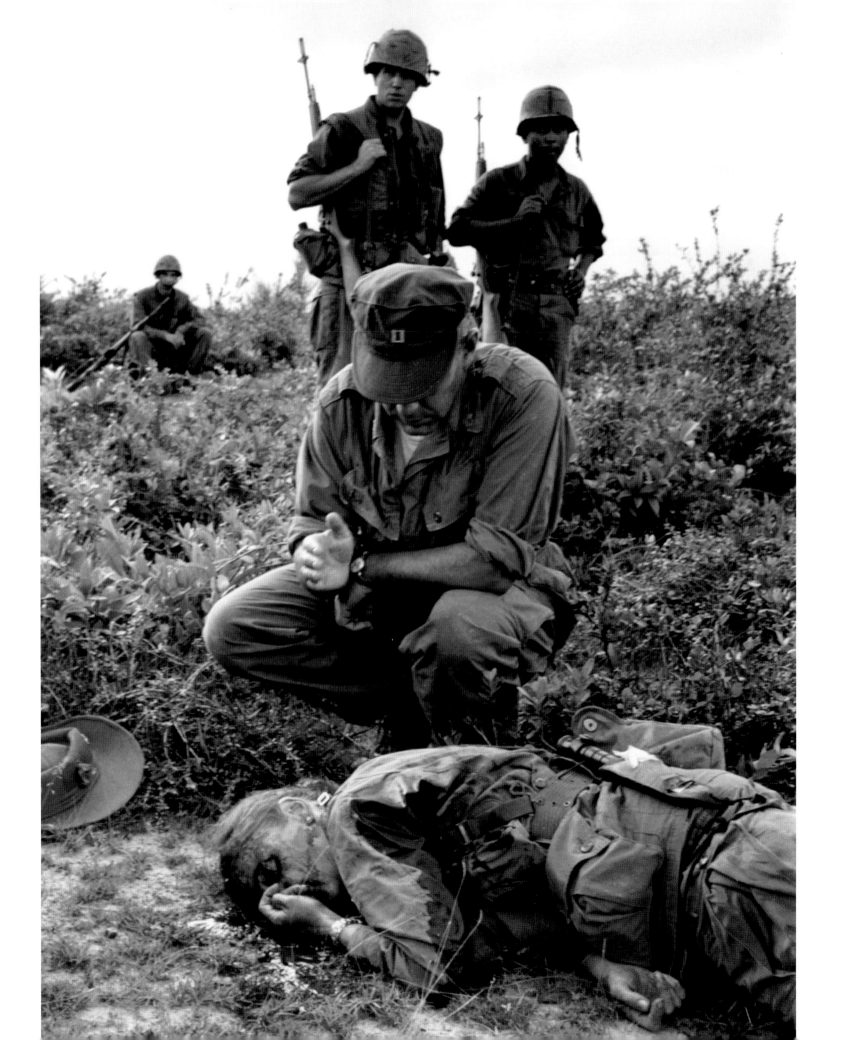

replaced by suicide bombers and cave complexes, bioterrorism and famine. Military intelligence services struggle through a maze of subterfuge and secrecy just to identify the enemy, let alone engage him. Combat itself is becoming increasingly difficult to define, ranging from the organized election violence that occurred in Haiti and Zimbabwe to the almost conventional warfare in the Gulf War, or a combination of a traditional army fighting loosely organized guerrillas as in Chechnya. The rules of the Berne Convention regarding the treatment of prisoners of war and noncombatants are virtually ignored. Hospitals, Red Cross trucks, and civilian populations have joined airfields and ammunition dumps as acceptable military targets. For the contemporary combat

WHERE IS THE BLOOD OF WAR?

David Turnley took this photograph on a helicopter ride with the Fifth MASH unit inside Iraq. The weeping soldier is Sgt. Ken Kozakiewicz, who discovered that the body beside him was the driver of his vehicle only after a medic handed him the dead man's ID card. When Kozakiewicz's father, himself a Vietnam veteran, was questioned about the picture, he said that the military was "trying to make us think this is antiseptic. But this is war. Where is the blood and the reality of what is happening over there? Finally we have a picture of what really happens in war."

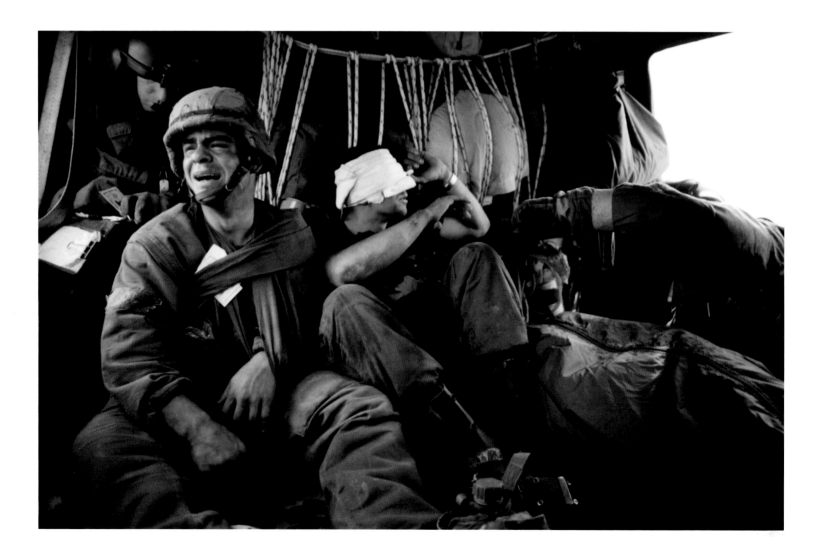

photographer, this adds another level of stress, the stress of confusion. Warfare has always been chaotic, but there were always lines of demarcation and the opportunity to leave and rejoin the areas they defined. Now the lines have been eradicated, and along with them any sense of security or escape.

THE CENSORSHIP WITHIN

This powerful image was pulled from the AP wire because it was considered too graphically violent. When it was published in the London *Observer*, it created an outcry of controversy. Harold Evans, former editor of the *Times*, defended its publication: "No action can be moral if we close our eyes to its consequences. Would those who object to the Iraqi photograph have decried a lack of 'taste' if a newspaper had published pictures smuggled out of Belsen in 1944?"

One aspect of warfare that hasn't changed, and with any luck never will, is the willingness of courageous men and women to go to the battlefield to gather the evidence that prevents anyone from saying "I knew nothing about that" or "That never happened." If we agree with Georges Clemenceau that war is too serious a matter to leave to soldiers, then these brave messengers are among civilization's best allies. ∎

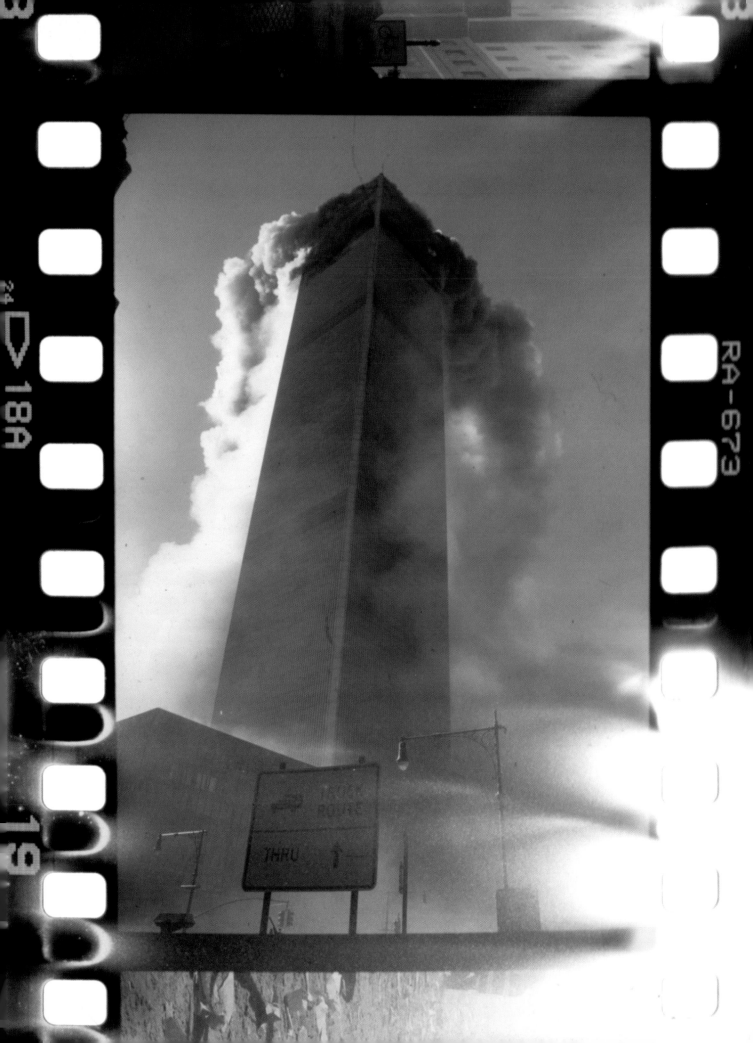

I don't know if you want to call it combat photography, but it's certainly war photography. At least if you're going to Grozny, you have to get on a plane, fly for twelve hours, and then get in a car. You kind of know where you're going. The photographers who worked that morning didn't know what they were getting into. The first on the scene were shooting the burning tower, with people jumping out of the building. And then they found themselves in a war situation when the second plane hit because of all the debris. Shrapnel can just as easily be a piece of steel or a piece of glass; it can all decapitate you. Debris like that falling on you is the same as somebody shooting at you, especially when the buildings collapsed. As I watched on TV, I knew that both Jim Nachtwey and Allan Tannenbaum lived in that neighborhood, and when I saw the buildings burning, I figured that any photographer would be trying to get as close as possible. I wouldn't necessarily have tried to go into the building, because I think the better pictures would be outside. But you have to be close. So when I saw the buildings collapse, my initial reaction was that maybe ten to twenty photographers had been killed. I figured Jim was probably dead, because I know Jim likes to get very close. So, yeah, these guys were in a war. Absolutely.

CHRISTOPHER MORRIS ON 9/11

This image is from the last roll of film shot by combat-experienced photojournalist Bill Biggart just before his death at the World Trade Center, September 11, 2001. He had called his wife, Wendy, on his cell phone after the first tower fell and arranged to meet her twenty minutes later. He never made the appointment; his body was later discovered with his cameras. He was fifty-three and the father of three children. "Bill was kind of an ornery guy," his widow has said. "Luckily, he went out doing what he loved—and it took two of the world's largest buildings to do it."

Patrick Chauvel

Born in Paris in 1949, Patrick Chauvel is a veteran of more than twenty armed conflicts, beginning with the Six-Day War and Vietnam in the 1960s. He has continued to photograph hostilities to the present day with his coverage in Mozambique, Angola, El Salvador, Iran/Iraq, Chechnya, the Persian Gulf, the former Yugoslavia, Panama, and many other locations. Although he remains committed to working in still photography, in 2000 he created a documentary film production company, Films et Marguerite, and to date has produced or coproduced four films dealing with such subjects as the struggles in Chechnya and Ramallah. | He has been the recipient of several prestigious awards for his still photography, including the World Press Photo Award and the University of Missouri Pictures of the Year award. He lives in Paris.

Manipulating the Media

Governments and their armies understand how they can use photography and the press. We used to be witnesses, but now we're part of the war. So are civilians. Innocent people are dying, and it's only worth killing them if the press is there to witness it. We've become one of the new weapons, and that's why I don't like photography as much as I used to. When I started out, it wasn't a job, really, it was a way of living. But it's become a job, and we're becoming a tool. Before, we were almost invisible to the military. In Vietnam, the Americans didn't try to control us because to them we were nonexistent; their only interest in us was to take a picture for Mom. What they didn't realize was that Mom was reading the newspaper—that in fact there were lots of Moms reading the newspaper.

Everything now is so pressworthy. Under these circumstances, photographers need to be very adult, strong, intelligent to avoid being manipulated. But how are you going to get new guys if all they want to be is famous and make money? Then they're going to fall into all these traps. It's hard. ∎

Journalists with government forces, El Salvador, 1989

First Combat, No Pictures

My first experience of combat was during the Six-Day War in 1967. There was political turmoil in the area, and everyone knew that something was going to happen. Most of the young Israeli men had been mobilized, and the kibbutzes were looking for people to replace them in the fields. I saw an ad in the French newspapers asking for young people, preferably Jewish, to go to Israel. I was seventeen and a half, I wanted to travel, I didn't have any money, I wanted to be in a "hot" area, and they were paying for everything. So I went. I took the train from Paris to Brindisi, then went by boat to Israel, and when we arrived they gave us flowers and said we were real heroes for working in the fields.

It was terribly hard work, which actually came as somewhat of a surprise. I was picking cotton when the war broke out. I immediately fled the kibbutz and hitchhiked to the combat zone. In those days, the Israeli army was very open. There were no press officers or credentials; you just jumped onto a tank or a jeep, whatever you could find. That's how I saw my first combat, and my first dead. But when I got back to Paris, the two best pictures I had were pictures of me; all the ones I had taken were so bad. I had given my camera to an Israeli paratrooper to take pictures of my fiancée and myself. She was a lieutenant, very small and fat, but I was very happy. She was my first lieutenant—sexually, I mean. And they were the only good pictures of the whole story. At least I had proof I was there, but there were no good pictures of combat.

This first experience of warfare appealed to me a lot, although I didn't understand anything about what was happening. I saw lots of things, but I couldn't translate. I just knew I felt incredibly good when I was there. The action was very quick and very big. The heavier the fighting, the more I could feel—even why I had fingers. Everything came into place. My eyes could see what I needed them to see; I could hear, and I needed to hear fast; I could run fast, walk fast; I wasn't tired, hungry, or thirsty. I felt so alive. Everything existed. There was no bullshit with the people I met; words meant exactly what they said, and there were few of them. I thought it was an incredible world, and when I came back to Paris, something was missing. I didn't understand some of it, but I knew I liked it, and I wanted to go back. ■

Unrequited Love

On one of my trips to Chechnya, I stayed for two weeks in the same house as this beautiful American woman photographer. Did you see the film *Out of Africa,* when Robert Redford washes Meryl Streep's hair in the bush, and just after that they have dinner under the stars and she puts her hand on his shoulder, strokes his head, and they make love? Well, this photographer had long red hair, and she had gotten so much stuff in it that I said, "Do you want me to wash your hair?" She was a bit surprised by my offer, but she said okay; I think she was amused. So I took this water jug and washed her hair. Then we had dinner, which meant we had a little bit of cheese and crackers. And then, well—I don't think she saw the film. She probably still wonders why I washed her hair. I suppose I should send her the tape. ■

The Miami Office

At one point in the early 1980s, I was going to Salvador and Nicaragua all the time, so I suggested that my agency open an office in Miami. They made a deal with *Newsweek*, and I wound up with this little office there. My house became the place where everyone stopped on the way to Central America. I thought it was going to be *tranquille;* instead it was like a train station.

Living in Miami is very inexpensive. It's very boring, too. But you have a pool, you have a '67 convertible Mustang, you have a girlfriend who's eighteen and who'll be eighteen for the next twenty years—it's incredible. It's like the movies. It's also ridiculous, because there's no feeling to it. Even when you make love, you think you're watching yourself doing it; nothing is happening. It's a total rest. It's like dying for a few years, and when you come back to life you feel much better; you're young again. I died in Miami; it was great. I felt alive in Salvador, and I died in Miami. ■

The Sailor of Panama

Panama was so quick; it was like a car accident. I was in Miami, and I realized the situation was deteriorating when I heard that the Panamanians had killed an American soldier coming out of a nightclub. I called Sygma in Paris, and I said, "It's going to happen. Give me a thousand dollars and I'll cover it." They said, "Forget it. Nobody will give you a thousand dollars for that." So I decided to pay for my own plane ticket, as well as for that of a young Frenchwoman I was with. I said to her, "Please come with me because they don't like the press in this country, and I'm going to say I'm a sailor." I bought these Nikon camera straps, very colorful, touristy, and very wide. She wore a yellow miniskirt, and I wore a shirt with palm trees. I also bought an amateur Hi 8 video camera, which was $900.

When we landed in Panama, we saw that the CBS guys and their crews had all been turned back. The Panamanian immigration official said to me, "You have a lot of cameras and film," and I answered, "I'm a sailor, and I'm about to take a boat and leave for nine months. I'm with my girlfriend, and I want to take pictures of her before I leave." He laughed and said okay, and I got through. I was the only guy to do so in the first two days. Then I saw Chris Morris. He had made it through, and he was with his girlfriend, too.

So even though the producers from the networks were allowed in, they were without cameramen. I had my little plastic movie camera, and I was making about $800 a day just filming the streets for them. And then it happened. One night Chris, the two women, and I went to the American air base. We decided that if anyone asked what we were doing there, we would say we were going to the beach. In between the base and the beach we would park the cars, run and photograph the big planes coming in. The sentry at the entrance probably thought we were down on the beach making love.

The next night, I could feel that something was wrong and that something was going to happen. I could feel it in the street. The four of us were in the hotel coffee shop. When I announced that I was going to bed, Chris looked at me a bit suspiciously, but my girlfriend had nice legs, so maybe he thought I really *was* going to bed. As soon as we got to the room, I put on dark clothes and called the taxi driver I was using. It was about eleven-thirty, and I went for a tour in the city. At midnight the action started.

I had the streets to myself, because by this time Chris was stuck in the hotel and couldn't get out. I made eighty thousand dollars selling my film at six o'clock the following morning. Later the same day, Chris and I met up again, but then some local fighters stripped us of all our cameras; they were taking anything they could get their hands on before the end. I remember Chris saying, "We've got no more cameras. You and I are the only international press photographers here, it's a scoop, and we don't have a camera." It was very dangerous, with armed groups of civilians everywhere. Chris picked up a few cameras that he had left at the hotel, but all I had was a stupid yellow Minolta Weathermatic—you know, the kind of thing that floats in the pool. ■

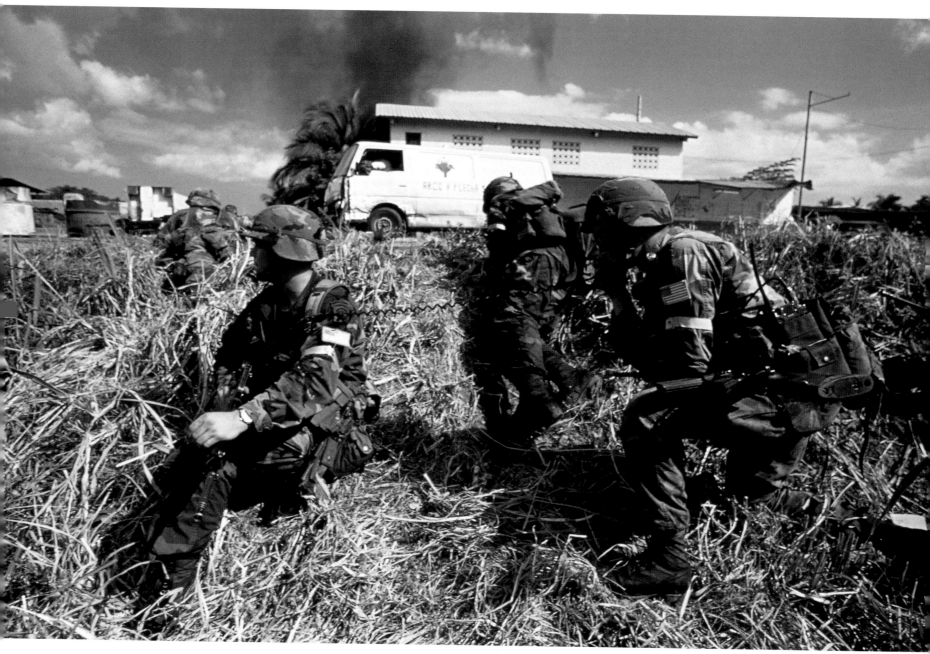

U.S. invasion forces, Panama, 1989

Conversations with a Dead Photographer

When I got shot in the stomach in Panama, I had that yellow Minolta Weathermatic camera around my neck, the only one I had left after being robbed earlier. I looked like an idiot with a hole in my stomach and this dumb camera. I thought the Americans wouldn't pick me up when they saw it. "I'm press," I'd say. "Bullshit," they'd say. "No way. You're a tourist." It would have been terrible to die with that camera.

I was shot by mistake by the Eighty-second Airborne. Chris Morris was in back of our hotel, so he didn't see me go down in front of it. Actually, for a few hours he didn't know I was shot even though he was only about ten meters away. I lay there for hours because the fighting was so intense that they couldn't get to me, and also because I was pretty low priority. I was shot at about eight-thirty in the morning; a Black Hawk picked me up at noon. That's a long time. I had taken two bullets; one had gone right through my stomach and left a large hole. When I eventually got to the hospital, I didn't have much blood left; it's amazing that after four hours I didn't lose more. I knew I was close to death because I was cold, and yet I knew it was hot because I could see the sun reflecting off the concrete. I was getting really cold and sleepy, and I was bathed in my own blood.

The only person with me was a dead Spanish photographer called Pancho Rodriguez. Even though he was lifeless, I had a very long conversation with him. It kept me going. He was a really unlucky guy. He had been working in Panama for two months photographing a story called "The New Conquistadores" for *El País*, the Spanish newspaper, so he had nothing to do with combat photography. He didn't want to get involved in the fighting; when it broke out, he went to the Spanish embassy. But he had left all his stuff at the Marriott Hotel, so when he heard that the Eighty-second Airborne had secured the building, he jumped in a taxi. When he got there, he wasn't allowed in. I was at the hotel when he arrived, and he just followed me because he had nothing else to do, and he got killed. He kept saying to me, "Patrick, what do I do?" and I said, "Whatever you do, don't run," because they had started shooting again. I saw him drop. The bullet blew the whole top of his head off. He had no reason to be there, and he was out of luck.

When the Black Hawk finally arrived, it took me to a field hospital. As we landed, the blades of the helicopter blew off a big plastic cover that was covering maybe fifteen or twenty dead American soldiers. It looked like Vietnam. I knew that this

was *the* picture, and I couldn't take it. Then it was just like *M*A*S*H*—they put me on a table, and I said, "I think it's in my stomach." One of the doctors told me he was going to turn me over and that it would hurt. Then he turned me over, and it did hurt. He also asked me if I had eaten fried eggs that morning. I said, "That's not funny," to which he replied, "I'm not being funny."

Then he told the pilot that he couldn't keep me there. So they put me back in the helicopter and took me to Gorgas, the main army hospital. It was like being in a race car—you get taken off the helicopter by four guys who put you on a stretcher with wheels; then three guys are on each side, running with it. One woman is cutting your jeans with a pair of scissors, shaving your hair, painting you orange; somebody else is putting something in your finger and up your nose. Everyone's running, asking questions—your mother's name, your blood type, your allergies. You see the lights going by, whoosh, whoosh, whoosh. A door opens and a medic wearing surgical gloves says, "Okay, you're going to be with me, you're going to help me. It's the end of the pain." It was incredible.

When I woke up, the surgeon was sitting on the bed, and he said, "Well, if you don't have an infection, you'll make it. Otherwise you won't." He thought I was a soldier, because I came in naked on the gurney. After he was done with me, they sent me to a psychiatrist, who told me that as a result of the wound I would have a libido problem and a problem with uniforms. Because my body had suffered a deadly wound, he told me that I should expect a big reaction and that I should be prepared for it. Then a priest came by and other strange people, including someone from *Stars and Stripes*. When I told him what had happened to me, he said, "What a story!" But what was even stranger was that my father was in the French army during the Second World War, and he got hit very badly. He had 185 shrapnel fragments in him, and the unit that evacuated him was the Eighty-second Airborne.

Later on, I ran into someone I'd known in Vietnam; I think by this time he was a general. He told me that he was sorry for what had happened to me, and that—unofficially—four GIs had their balls hanging from the ceiling because of it. He just wanted me to know that they were paying for their big mistake. The same guys who had killed the Spanish photographer shot a British photographer called Malcolm Linton, who I think was with Reuters, and me. ■

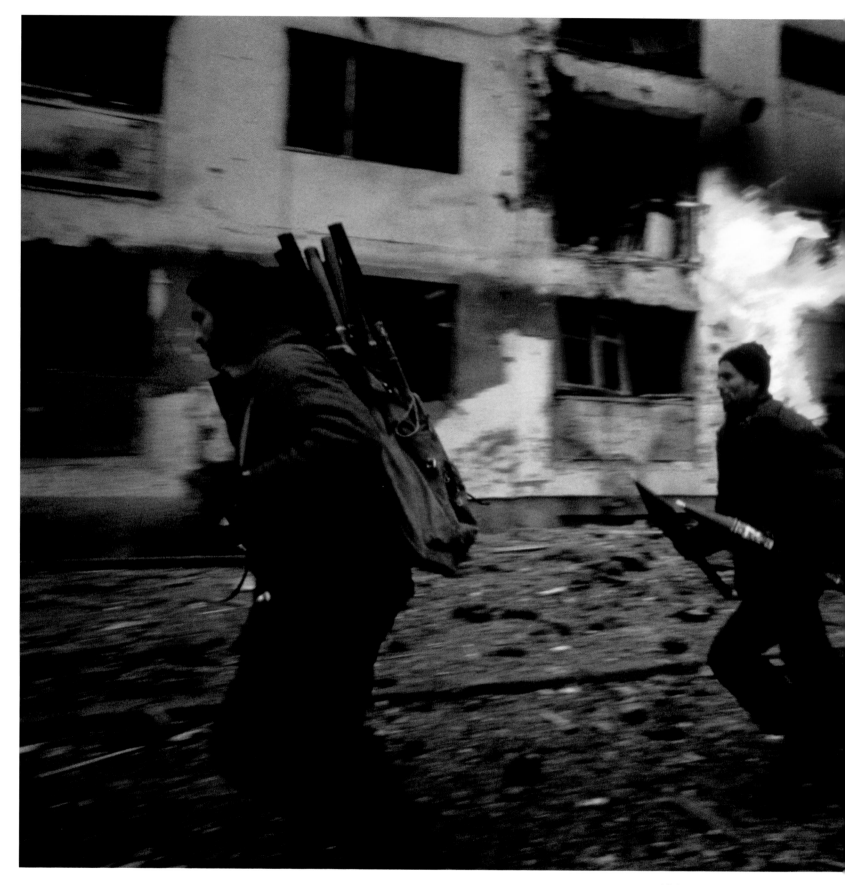

Armed fighters, Kosovo, 1993

Just the Messenger

Lots of photographers who've been in two wars put on their business cards "I did wars" and make money photographing movie stars. It's ridiculous. A lot of the guys I met in Vietnam were either crazy or on drugs. They weren't war photographers; they were photographers who went to war sometimes. I think the difference is the approach, the attitude they have when they're over there. It's not about how many wars you go to, because you can be a combat photographer of only one war. Gilles Peress once said to me, "You're a combat photographer, Patrick, that's why you don't burn yourself out. You take pictures of the action. I'm a photographer in a war situation, and that means I take pictures of wounded civilians and hurt kids."

If I had to give advice to someone starting out, it would be to do something else or be rich when you do this. It's like being a diplomat when America was a new country. It wasn't a paid job in those days, it was a passion. Combat photography is like that. You have to be strong, too, and it's not something you can do at the beginning of your career just so you can have it in your credentials. It's a life job, because you will change; war makes you change. The more war you experience, the more professional your work becomes. And the people you photograph need you to be professional. They don't care about your emotions; they have their own. You're just the messenger. You have to be able to put all your emotions aside, and it's not easy; it takes time. So unless you're rich, you have to be ready to have no possessions, to lose all your girlfriends, and to be strong enough to live with no sense of comfort or clothing or food. Even though I supposedly live here, I'm actually visiting Paris. I'm having a good sandwich in a good hotel, but that's not my life; that's my vacation. ∎

The Most Difficult War

The most difficult war I ever covered was Yugoslavia. You'd walk out of the hotel and you'd be fired on by snipers. You could die just trying to make a phone call at the post office building when the snipers were out. You would be fired at, shelled at, and bothered by guys at roadblocks to within one mile of the front line. And then when you finally got there, the leaders would turn you away. They were assholes, real assholes. Finally, you'd be allowed one hour with the fighters, mostly when there was no combat. If you were lucky, something would happen; otherwise nothing. The fighting was very sporadic and spread out. You were freezing, there was no electricity, and the guys had an attitude. I didn't like either side. I didn't like the Serbs, I didn't like the Bosnians, and I *hated* the Croats. I didn't like the mission of the French army. I think we were all lying to everybody; everybody was lying. I hated that place. That was probably the most . . . not really hard, but miserable war. ■

Children at play, Sarajevo, 1993

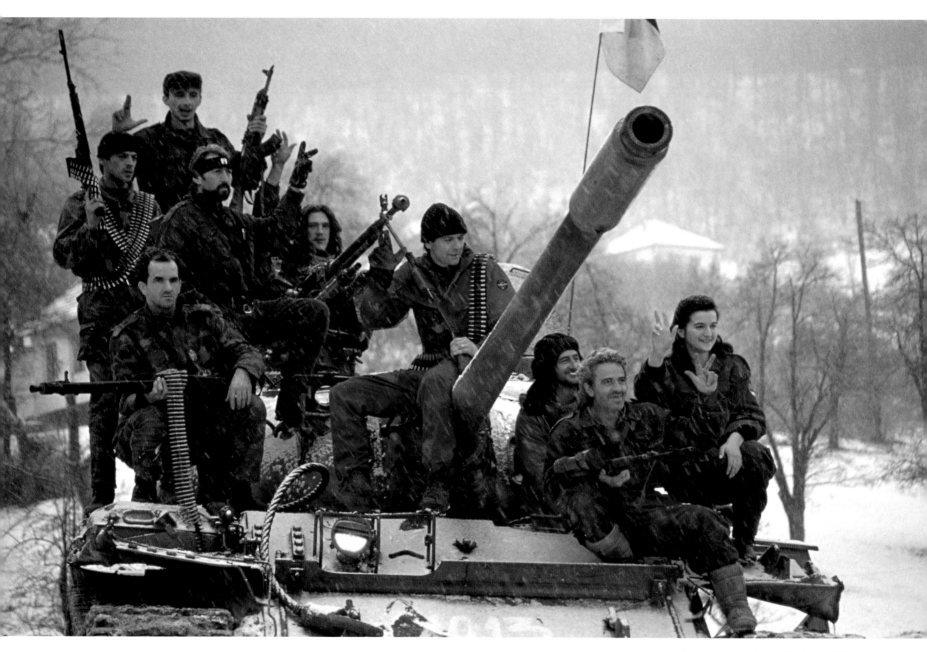

Serb troops encircling Sarajevo, 1993

A Walking Million Dollars

The attitude of both the Serbs and the Bosnians to photographers was the same. It would take you maybe a week of going every day to the front line, and just when you thought they would let you through, some guy would come out of the trench and say, "What's he doing here?" and you're out.

The problems in Chechnya were different. It was terrible because it was always seven below zero. There was no way you were going to survive if you were hit—there were no hospitals, there was no electricity, there was no food, there was nothing to drink. The Chechens speak a language you could never learn even if you tried from the age of one until you were eighty-five. It's not a language, it's noises. They're the only guys I met in the whole world who don't know what "okay" means, and they refuse to learn anything else but Chechen.

But it was great. They're so tough—you could feel how strong these guys were. They just love fighting, and they fight well. It was incredible to be with them, like in a movie. They had no fear; for them it doesn't exist. I've never seen a Chechen scared. Never. Even two minutes before dying, knowing that they were going to die, they would laugh. One time when I was with them, they said, "Gas! We're all going to die," and they began to laugh. But I said, "Hey, wait a minute; this isn't my country. Maybe we should put some masks on." I've rarely seen fighters like that.

I had this dentist who was translating for me. He wasn't a fighter, but he was alone and he needed a house, so he just followed me because he spoke a few words of English. He was the only Chechen I ever saw who was scared, and he was scared all the time. He was so frightened that his face was gray. He was brave—he was always in the front line with me—but sometimes he was so frightened that he couldn't translate.

When you go there now, you could be taken hostage if you don't know who you're talking to. That didn't used to happen. I've been there five or six times, and I still meet the same guys. They'll protect me from the other Chechens, at least, but I can feel that even they have changed. They're more into business, and hostages are big business. You're a walking million dollars, so it's hard for them to not take you hostage. At one point, they even offered to share the ransom with me—"Five hundred thousand for you. Then just sit there with the girls and have a drink." I declined. "I'm sorry, but I think I would just be abandoned." ■

Palestinian fighter, Lebanon, 1982

Don't Cry, It's Not Going to Change

I'll help civilians, but I won't take a picture of them. My camera just doesn't want to do it. It pisses me off that they're so sad. If you're born in a place of pain, take it. Don't cry, it's not going to change. The only thing that will make it change is to take the pain and do something about it. Their suffering bores me, and I don't want to take pictures of things that bore me. There will always be photographers who will take pictures of them.

I think my responsibility is to cover the stories of people who are trying to do something for change, and putting everything at risk for it even if they're wrong. They may be going in the wrong direction, but at least they're going forward. My grandfather used to tell me, "You're on a boat, you're holding the tiller, you're going straight for a storm. You know it, and there's nothing you can do about it. The only thing you can do is to have a firm hand." He's right. So don't start crying, "My God, there's going to be a storm." No, keep the engine forward and go through the storm.

I prefer guys like that. That's why I like the Chechens. I saw them lose their wives, their kids, and they would look in my eyes and at my camera, and I didn't take a picture. And then they would show me their Kalashnikov, and I would take a picture, and they would smile and let me go.

I don't take dead people either, or very rarely. I'll take them killing the guy, but not when he's dead. ∎

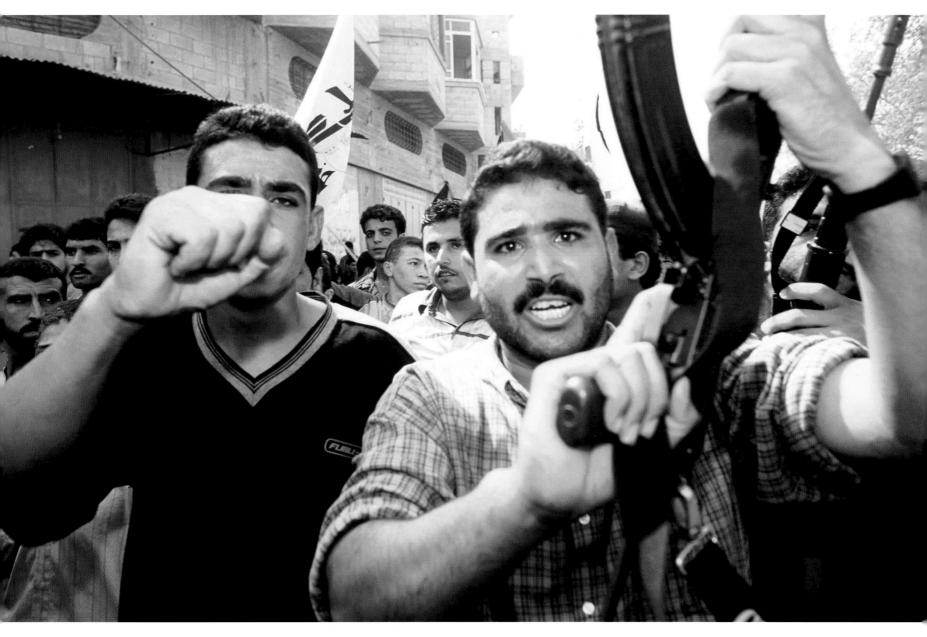

Palestinian demonstrators, West Bank, 2002

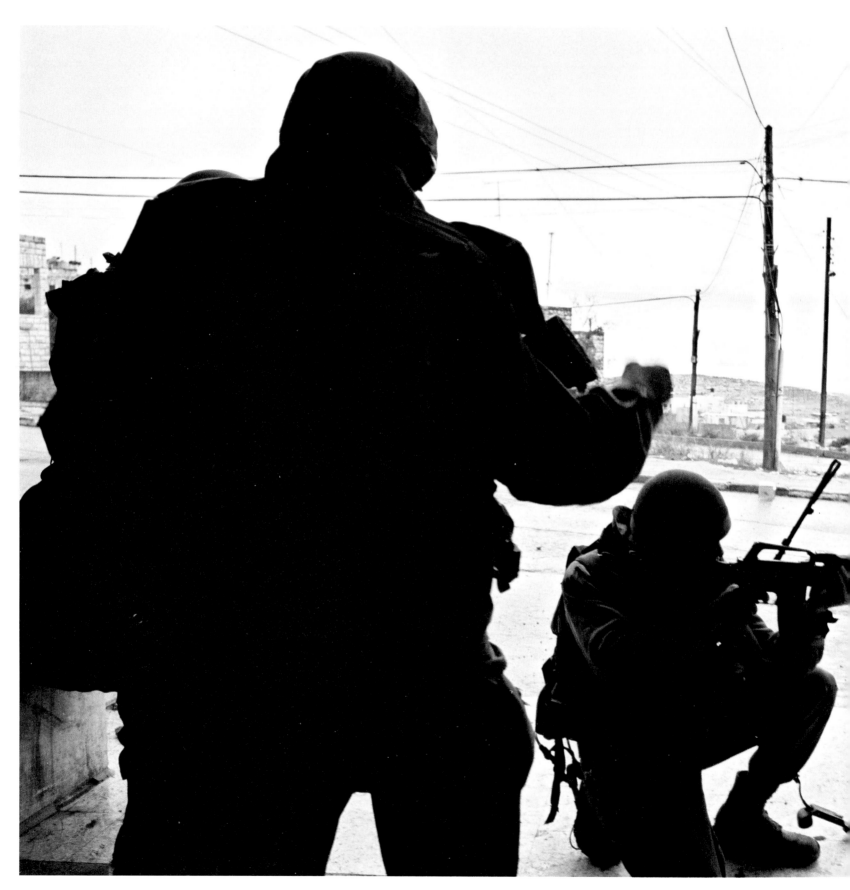

Israeli soldiers, West Bank, 2001

Targeted by the Israelis

The big mistake that the Israelis make nowadays is not allowing journalists access. They have this paranoia about the press, which means that most of us work on the Palestinian side, and then the Israelis complain that our coverage is biased. Of course it is. If I see a kid getting shot by an Israeli paratrooper, it's a good story, but it's not the real story. It's true he got shot, but who sent him, and why? That's the real story.

I've worked with the paratroopers, and they're very professional. If they have no orders to shoot, they don't shoot; if they have orders to shoot in the leg, they shoot in the leg; if they have orders to kill, they kill. Usually, they're only shooting at a distance of fifty meters or so, and they have scopes on their rifles. When Laurent Van der Stockt got shot in the knee in Ramallah, it was no mistake. There was only one shot. They know this guy's not going to come back, and that's what they want. On the other hand, sometimes you get some guy panicking, and then he'll fire randomly. If it's guys doing their two months' service every year—scared, worried about what their girlfriend's doing while they're there—then that's different, too. And sometimes when the Palestinians start throwing stones, the Israelis begin to panic and open up and burp a few bullets. If any one of these was the scenario, then Laurent would have been just unlucky. But I think that there was just the one shot that day.

The Israelis are losing their soul in this story now. They're not defending Israel anymore. They think they are, but they're not; they're attacking. In 1973, during the second war, I was with a lot of the guys I had met in 1968, except now they were colonels. I was with them all the way to the Suez Canal, and it was like a big party. It was dangerous, but there was so much joy, so much strength. I used to love these guys, but now I'm a little bit suspicious about their politics. The people in the army today are not the same people. You've got Russians, Ethiopians, Somalians—these guys don't want to die for Israel, they just want to live in Israel. ■

Philip Jones Griffiths

Philip Jones Griffiths was born in Rhuddlan, Wales, in 1936. A practicing pharmacist in London, he began photographing part-time for the *Manchester Guardian*. In 1961 he became a full-time free-lancer for *The Observer* in London, covering such stories as the Algerian war in 1962, and then was based in Central Africa and Asia. He was in Vietnam from 1966 to 1968, then returned in 1970 to complete work on his book *Vietnam Inc.*, which was published in 1971. The book sold out in its first printing, and was one of the photographic works that indisputably influenced public opinion of the war. | Griffiths covered the Yom Kippur War in 1973, worked in Cambodia from 1973 to 1975, and continued to cover Asia from Bangkok from 1977 to 1980. He has been a contributor to almost every major magazine in the world, and has worked in more than 120 different countries. He became an associate member of the photo agency Magnum in 1967 and a full-time member in 1971. He lives in New York City. | Griffiths's photography has been exhibited widely in both the United States and Europe. He has a disdain for awards; the only one that he will readily acknowledge is a medal that was given to him by coal miners in South Wales.

Village People

When I first arrived in Vietnam in 1966, I found the equivalent of my village in Wales. The country is unusual, in many ways unique—it's a collection of villages set like islands in a sea of rice fields. In a Welsh village, you're taught to keep quiet, to keep your eyes open, to listen, and not to give too much away. I felt that was the ethic that the Vietnamese themselves lived by. I found them to be highly intelligent, observant people. I also found that everything we were being told about them by the Americans didn't seem to be true—that they were basically subhuman, or that they were human but not like us. That they hadn't reached our level of civilization or intelligence. Then we were told that if they weren't actually killing you, they must

Vietnamese peasants, 1967

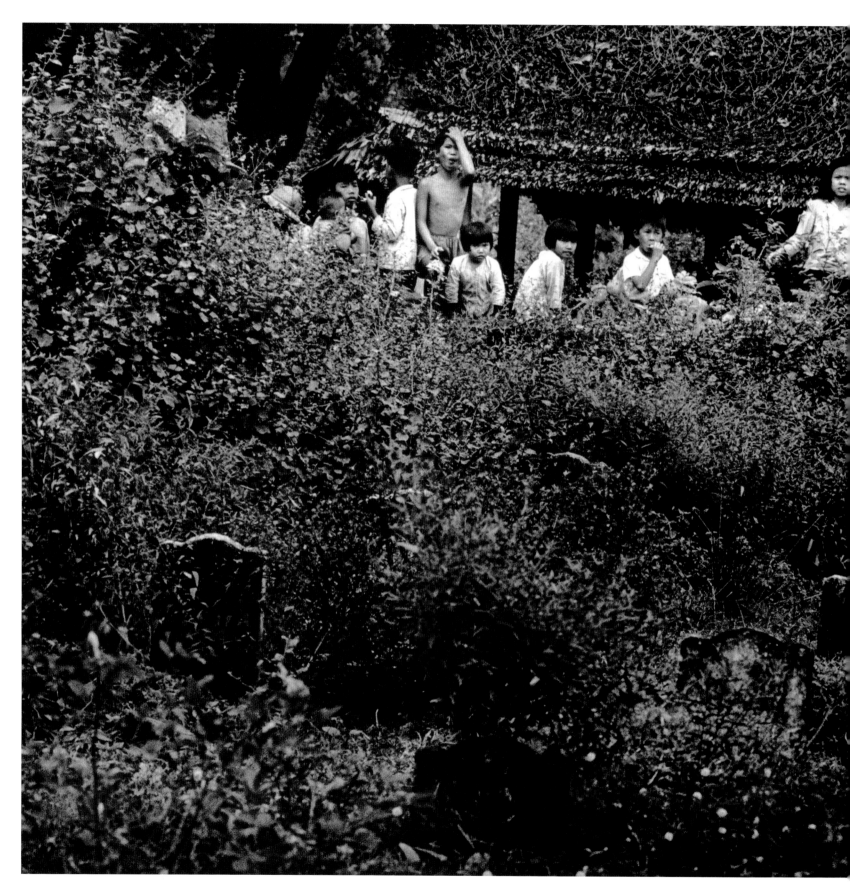

Vietnamese children at graveyard, 1967

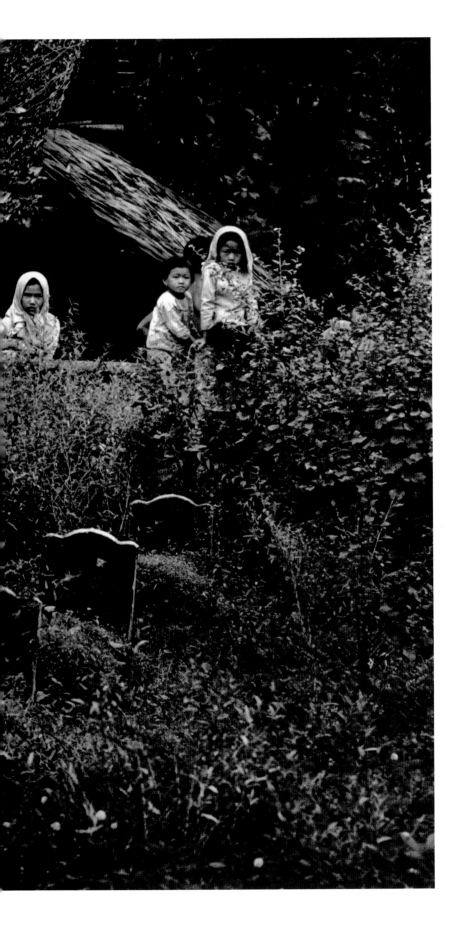

love you. I knew from my experience with the young ladies in my village that this was absolutely not the case. Here was the most powerful nation on earth, with a military might never before seen, totally unaware of what was going on and regularly being hoodwinked by rice farmers. Because my ancestors were mostly farmers, I suppose I was a bit biased, but I thought the Vietnamese were very wise people.

For me, Vietnam was the most intense experience imaginable, and one that was filled with a kind of macabre humor, which of course didn't detract from the tragedy of the whole thing. But most of the time, it was the ultimate clash of civilizations—the wise, smart little David running around irritating the hell out of this huge Goliath. That's an inspiring thing to observe.

In the third year I was there, I met an American who was working for a voluntary service who spoke perfect Vietnamese. I made a deal with him to go on a trip with me from one end of Vietnam to the other, but he had to promise never to speak Vietnamese, just to listen. It was amazing. There were so many times he had to leave a room choking with laughter because he couldn't believe what he was hearing. Once, he heard an American talking in front of two young Vietnamese women: "This young lady, my God, she had to sit and watch while the Vietcong cut her father's head off and stuck it on a stake in the middle of the village." Then my friend heard one of the girls saying in Vietnamese, "There he goes again. My father laughs every time I tell this story. Do you think he's put on more weight? I wouldn't want to be his wife. He'd crush her to death."

That trip confirmed what I'd suspected all along—that the Americans were being toyed with by a very smart group of people. Of course, that didn't mean that this group was capable of stopping the bombing and the carnage that was taking place. But because the Vietnamese have never been powerful enough to evict an enemy, the method they've always used is to make things so unfriendly that the foreigner "decides" to leave. And that's what happened this time. ∎

Missing the Decoys

In Vietnam, it was pretty obvious straightaway that combat photography in a Korean War–World War II context of brave soldiers didn't mean much. However, when the Ninth Division was finally let loose in the highly populated Mekong Delta to commit the carnage that it did, then the photography became interesting, because it reflected the genocidal nature of the conflict.

Some of the best combat photography in the war came from the battles that took place at the end of 1967—some of which I covered, by the way—but the pictures are meaningless, because the battles were meaningless. All they show are GIs running up and down the hills, which of course was an enemy lure to get them away from the populated lowlands in preparation for the Tet offensive. The brilliance of the North Vietnamese commander, General Giap, was that he said, "I will give the American army what they understand, which is taking a hilltop." That is in every military textbook. The U.S. high command understood that. I'm glad I missed most of those battles, because they were a distraction. In fact they were decoys.

The Vietcong were very clever—they allowed Americans to feel that they were winning the war during 1967. Washington believed, the military believed, everybody believed that they were winning. The Vietcong weren't attacking; they weren't making any progress taking land, so America must be winning. And then on one fateful day, Americans woke up to find that the enemy was on the American embassy grounds in Saigon. A few days later, Eddie Adams's picture of the street execution of a Vietcong suspect came out, and it marked a seminal point in changing people's opinion. It came at the right moment, at the height of the Tet offensive, and it was a bombshell; it really worked.

Although the press coverage had a gripping effect, I vehemently object to the idea that the press lost the war. The truth is that the press was always way behind the American people, who were antiwar long before it was. In general, 95 percent of the press was totally in favor of the war; 4.999 percent was in favor of the war but not in favor of the way it was being fought. And then there was me and two Frenchmen. ■

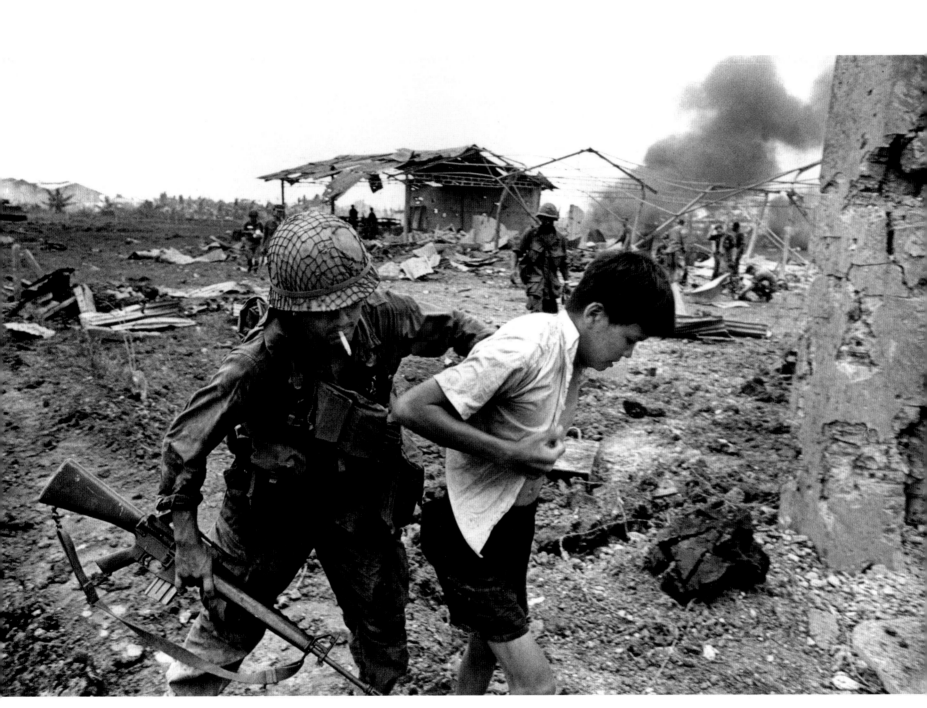

U.S. troops and Vietnamese civilian, Mekong Delta, 1967

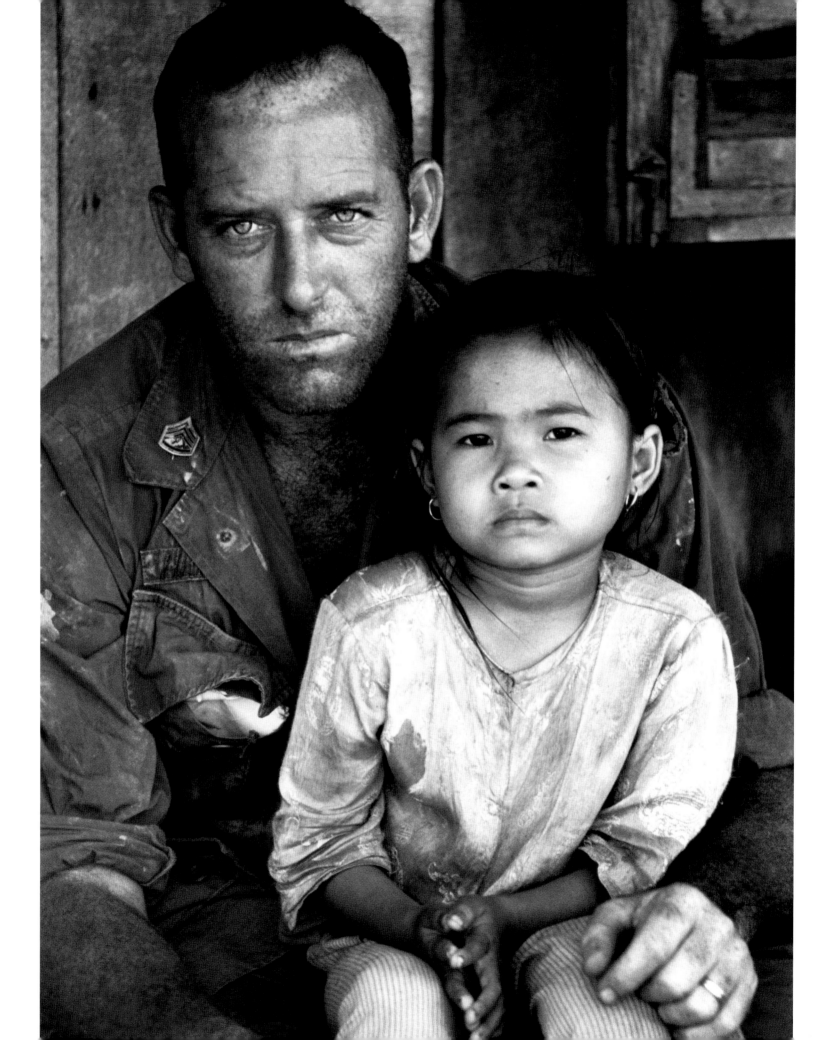

On Being a Photographer

I believe that one of the great benefits of being a photographer is that you're there and you see with your own eyes, you hear things, you discover things, and sure enough, you learn. That's the whole point—that's why we do it in the first place. I had a privileged grandstand view of this conflict, and for that I'm very grateful. It was almost worth doing without film in the camera. But I think the problem with photography is that you can decontextualize it. What does a picture of a wounded body or a mother clasping her wounded child mean? Why is it happening? I want to know that. I'm not satisfied just photographing little sorts of visual climaxes of a conflict. I want to know what led up to it and what's going to happen next. I cannot believe in the sort of fireman approach to doing this kind of work—just automatically going to the next war not knowing where you are, what the background or the history is. It's like watching a movie with the lights on and everybody talking. It seems to me that you're losing such a valuable opportunity to learn the truth of what is happening.

I'd never been enamored of the system of journalism. I never really expected much from it. I take pictures for myself. A colleague of mine was doing a story on Goa for the German magazine *Stern*. And at one point he was on the beach, and there were these guys lying around smoking pot. He's crouching over them with his 21-mm lens, shooting away, and one of them opens his eyes and says, "Hey, man, who's your guru?" And the photographer says, "The double-page spread is my guru." I never ever thought along those lines. I'm a photographer because I want to find out. I'm a doubting Thomas, someone who doesn't believe anything that he's told; I'm going to find out for myself. That's the main reason for doing what I do. The second is that when I've found out for myself, I want to share my findings. ■

American soldier and Vietnamese child, Mekong Delta, 1967

What Post-traumatic Stress?

Bravery is something I think about a lot. I joke that I'm a card-carrying coward—in other words, I don't like pain, and violence doesn't turn me on. When the bullets started flying, the eyes of some of my colleagues began to glow. They didn't walk, they didn't run, they danced—they got high on adrenaline. That's not me. And yet, why was I running into the action when some of these great photojournalists were running away? Did I crack up? No; what's the point of cracking up? Fainting at the sight of blood? Can you imagine a surgeon fainting at the sight of blood? As for tears—how can you focus? I cried, but I made sure I cried when I was editing the contact sheets or in the darkroom, not when I was taking the picture. The closest that I can give as an explanation is that when one has a job to do that one believes in, everything is possible.

There were only a couple of times when I almost passed out. One was when I saw a woman pick up a baby's leg and put it into a plastic bag. That was pretty horrible. The other was one night when I hadn't had much sleep and I was at a little hospital near the front line, an area that was seeing a lot of action. They brought in a big black guy, very strong. I photographed everything that happened: The surgeons took a huge sort of hand drill and drilled a hole in the top of his head and pulled out a chunk. The surgeon's got his finger inside the skull, and he's feeling around, and he says, "I can't find anything. I can't find anything." And then another doctor looks at the tag and says, "Oh, shit, it's not his head, it's his arm." At that moment I felt myself passing out. Considering all the sights I saw in Vietnam, this was a very minor point, but I think that's the way humans respond to things. So that's the closest I came to post-traumatic stress syndrome.

The only truly sleepless night I had in Vietnam was when I thought they weren't going to renew my visa. I had a calling of a semireligious nature, because I knew I had to do a book about the war. I didn't exactly believe that the bullets would bounce off me, but I just set out to do the book, and nothing would stop me. The only catastrophic event happened after the book was published and I had left Vietnam. I had an assignment to go back, but I was banned. President Thieu uttered the immortal words, "There are many people I don't want to see back in my country, but I can assure you that Mr. Griffiths's name is at the top of the list." I begged *Life* magazine, which had given me the assignment, to get that in writing! ■

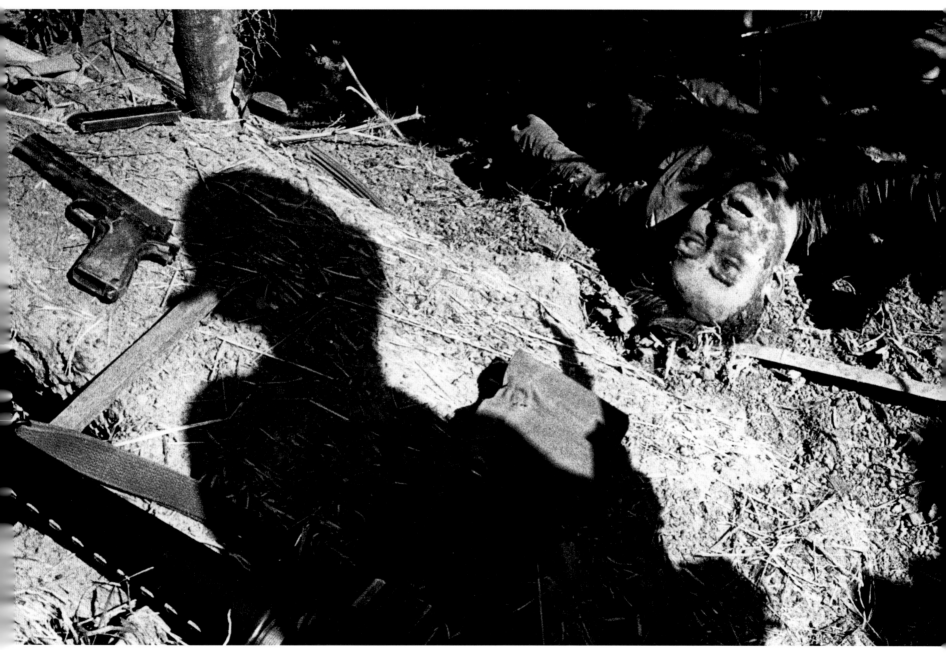

Quang Ngai province, South Vietnam, 1967

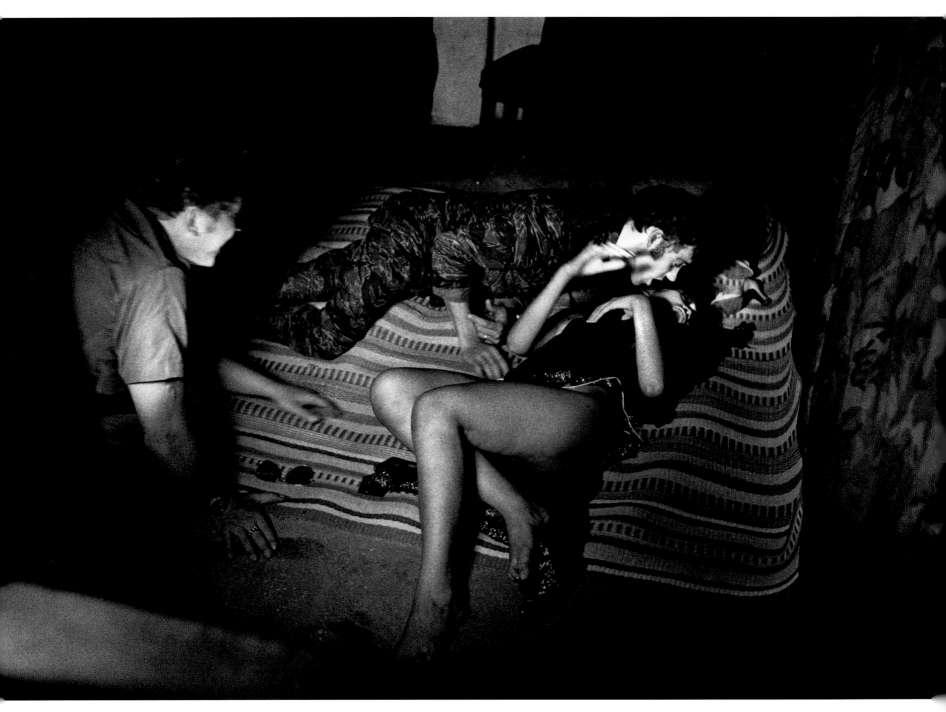

U.S. naval base, Nha Be, 1970

The Entertainer

This picture has often been miscaptioned—everything from it having been taken in some kind of a brothel to several of my colleagues kindly suggesting that it occurred in my hotel room. The truth is that this all took place at the reviewing stand of the South Vietnamese navy base, about ten miles outside of Saigon. The men are navy SEALs. The girl is not a hooker—well, she may have been a hooker, she's certainly not an innocent farm girl—but she was there dancing for the troops, and these chaps got a little out of hand.

The naval base was a fascinating place, because the Americans were allowed off base only between four and eight P.M. If you were a good-looking young woman in Saigon and you disappeared at ten in the morning and came back at midnight, there's only one thing you could be, and that was a prostitute. But if you left at three-thirty in the afternoon and were home by nine, then you were okay, you were still respectable. The family could explain that you had a job as a secretary or something. The result was that the base became a flourishing brothel area, inhabited by young ladies who had a remarkable grasp of politics, world history, and English literature, because they were often university students. It was an interesting place to hang out. You could discover a lot about what the Vietnamese were thinking because it was a catchment for those Vietnamese who spoke English, had intimate contact with Americans, and were willing to talk to somebody with long hair and a funny accent. ■

War Is Unbelievable

A group of soldiers had been caught in the crossfire from the Vietcong who were positioned in a nearby hut less than a hundred yards away. We were under fire; there's no question about it. The guy in the chair is giving covering fire, and he's sitting as casually as you please, as if he's off on holiday somewhere. And there's a doll on the floor under his chair. That's war. It's unbelievable; it's just unbelievable.

Moments after the picture was taken, the Vietcong fired a rocket into the house, but we were very lucky. Those rockets had a slight delay so that they'd explode after they'd gone through the wall, in order to kill everybody inside. But the guy who shot this one wasn't very good, and it landed in a ditch just under the house. The terrain was very muddy; the rocket went under the ground and exploded. The whole house came down, but nobody was hurt, just a few scratches.

This same group had had a lot of incoming sniper fire. Our guys were shooting back, but nobody had been killed at that point. Then they decided that they would bring in artillery. They didn't know the location of the firebase, but they still got on the radio and gave the coordinates of the target. The artillery lobbed in a lot of shells. The first one landed amongst us and killed a couple of our soldiers. Everybody rushed inside the armored personnel carriers for a bit of protection, and someone started screaming into the radio, "Stop it, you motherfuckers! Stop it, stop it, stop it! You're killing us!" I'd already crouched down behind an APC when that first shell came in, because one of the men had told me the artillery was at a firebase that I knew was about twelve miles away. Over that distance, the area of error is huge. ∎

Saigon, 1968

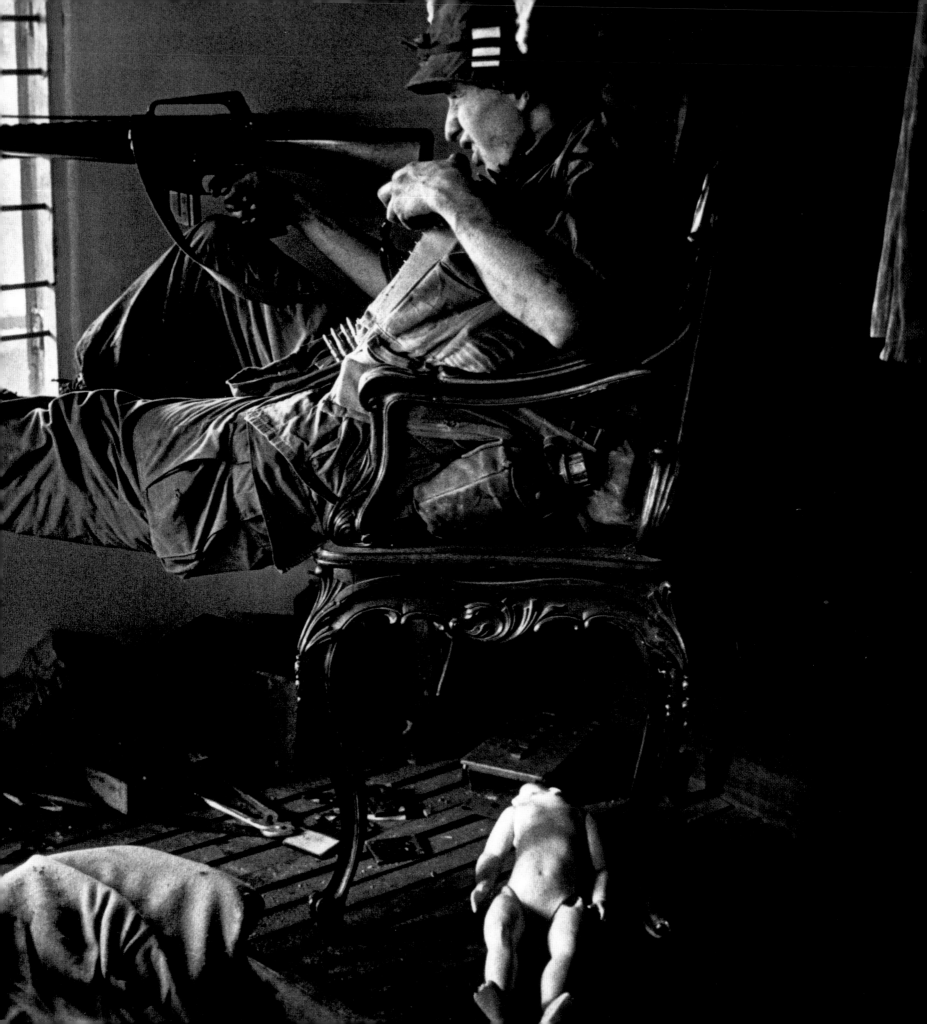

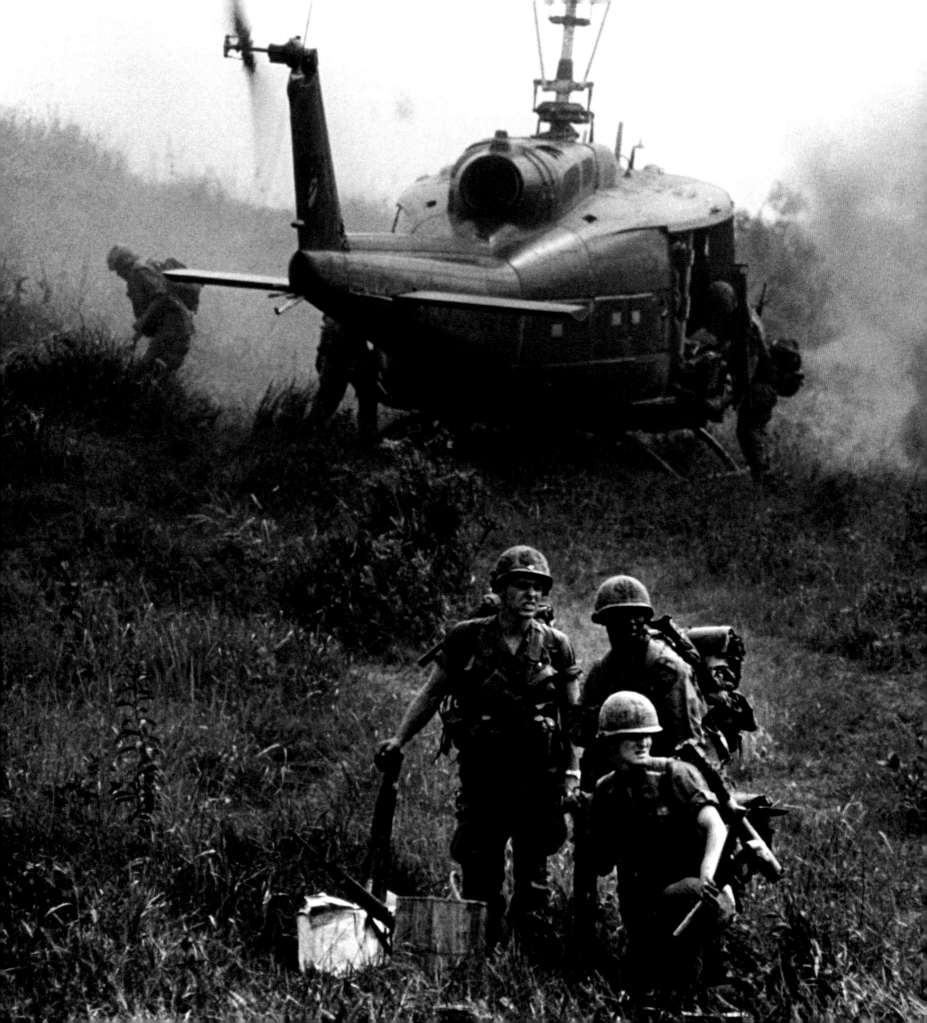

TRAVELING AROUND VIETNAM

I found traveling around South Vietnam actually very easy, although there were rules you had to follow and games you had to play. Once, I wanted to get to a certain location, and this PIO—Press Information Officer—led me to a helicopter and said to the pilot, "Take Mr. Griffiths to Hanoi." "What? Hanoi?" the pilot says. "Take him to Hanoi!" the PIO says. And the guy takes off his helmet and says, "Repeat that, sir, I——" "Hanoi," the PIO insisted. Then, "Oh, no, no, I'm sorry— Hoyan," which is this rather beautiful little town on the coast. But generally it was easy. During the Tet offensive, I got from Saigon to inside the citadel in Hue in less than twelve hours—though it took me five changes of helicopters and planes to get there. You had to know your geography, which was the first thing I did when I arrived in Vietnam—I learned where all the air bases were, where all the helicopter pads were, and I acquired an overview of the country. When I found out where units were moving to, I knew how to jump up the chessboard to get to where I needed to be. I was once on an air base and I wanted to get back to Saigon. One of the pilots there said, "Okay, I'll fly you," and he took me to this C-130, which was the biggest plane they had in Vietnam, and flew me all the way down there. I was the only passenger on a plane that holds something in the region of two hundred troops. I have a feeling, although I've never had confirmation of this, that the more hours the pilots flew, the more bonus points they got—a bit like frequent flyer miles. (Near the DMZ, 1968)

Search and Destroy

This is in Quang Ngai province, an area that had been solidly Communist for years; in fact, it had been Vietminh before there was the Vietcong. I spent a week or so with these soldiers in this small, densely populated region. There were no forests, no barren areas, just rice fields and villages. The operation was your typical search and destroy. We went into the village, let off a couple of rounds, a few people were killed. Then they brought out the women and children—this is what you see here. There were no men, of course, because they were all off fighting somewhere. The villagers had been taken outside while the Americans blew up any bunkers and tunnels where the men could have been hiding. After this, we moved a little bit less than a kilometer away, then called in artillery. Some people might have escaped by running very fast, but it was so unexpected that it's unlikely. Within minutes the whole village had been pulverized; there was nothing left of it to show. It was a very typical day in the life of that particular unit.

Every photographer dreams of being invisible, although in my case it's rather difficult due to a size problem. But basically I am an observer. I didn't want to get that close to the GIs I was photographing. If I was the sort of exuberant personality who talked to a chap and asked him lots of questions, then I think he would want to know what I felt, and it would be very difficult for me to hide my feelings. And I didn't want to become their pal because the first thing they say are things like, "Where are you from? Can you get my picture in the *New York Post*? Look, I'll take that VC bunker—get your camera ready. I know they've got a machine gun, but I think I can get a grenade in the first time." No, no, no, you didn't want to get that kind of intimacy. So in the case of this particular village, when the shelling started, the lieutenant looked at me and expected a reaction. I sort of rolled my eyes as if to say, You know and I know. We knew that what happened wasn't right, but I didn't say, "I'm going to go out on the next chopper, and I'm going to report you all to the War Crimes Tribunal in The Hague." That wasn't my job. It would have been a meaningless gesture, because in fact these guys weren't particularly bad. If I hadn't been there, they may well have just shot these people anyway.

The soldier in the photograph is a little bit older. In fact, my best pictures of GIs are the ones who are older than nineteen, which was the average age. This one was smarter, too, and he kind of knew what was happening. He also knew what I was up to with my camera. Many GIs were very unhappy about what they were told to do. Somebody recently asked me what I thought stopped the war in the end. I think one factor it's impossible to overlook is that all these guys were writing letters home. Every town, every village, every city in America— the parents, the brothers and sisters, the families of these GIs were getting letters describing what was being done in Vietnam. Often the letters would say no more than we did some terrible things, and not talk about them. But that would be enough to sow the seeds of doubt in the recipients' minds. And when they saw the body bags coming back, that really pushed public opinion over the edge.

I very rarely came across a GI who was excited about being in Vietnam; if they were, it was because they'd been in the country for less than a week. It only took a few days before they became somber. ■

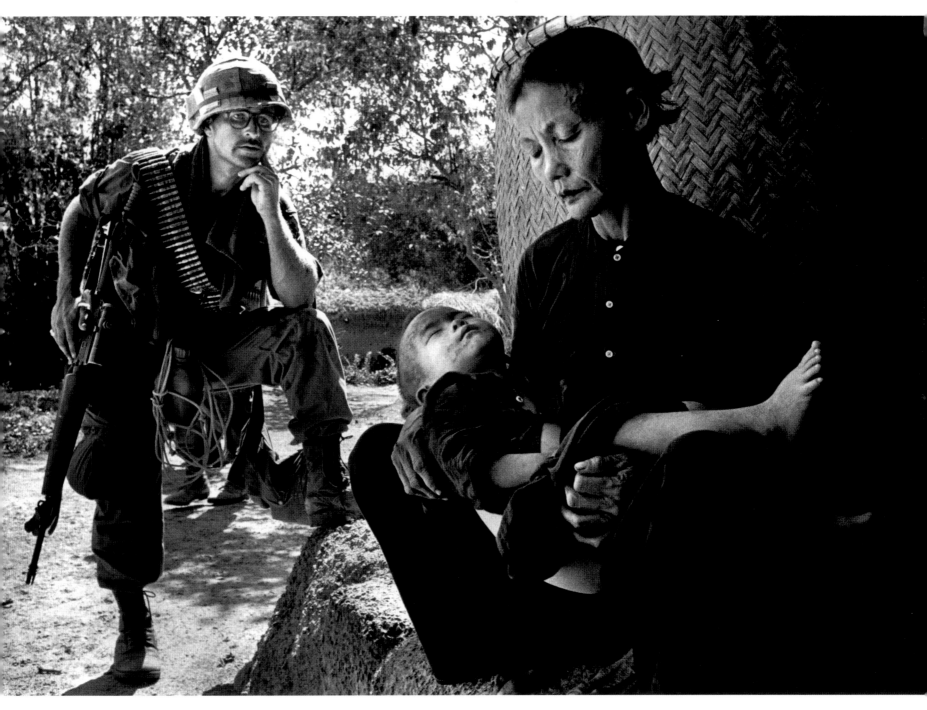

Quang Ngai province, 1967

THE FRENCH BREAD VAN

I never cracked up, I never ran away, I made
calculated decisions: Is the risk worth it? Should I
stay or should I move? Is there a better way? I was
traveling in this funny little French delivery van,
probably bread or something, with marines going
into Hue, and we came upon a Vietcong machine-
gun post. The first burst of fire hit the vehicle's
tires. I had made sure I wasn't inside; I was sitting
on the back with my feet hanging over the edge,
and as soon as that first burst came I made sure I
ran to my right, because I saw all the others going
to the left, and Vietcong are obviously going to
fire on the marines first. I ran until I finally got into
the protection of a doorway. So I made decisions
like that, quite often. But I never felt, This is too
much, or That was too close.

After that experience, which *was* pretty close,
the same night I had to sleep with a crowd of
other people on the floor of a house. I thought I'd
wake up in the middle of the night crying for my
mother or something. In the morning, I got up
and asked the others if I'd slept okay, and one of
them said, "Did you sleep okay? If you could only
hear yourself snoring! The Vietcong could hear
you across the river!"

So I said, "Sorry about that," and I thought,
Probably a delayed reaction. Wait until tonight.
Tonight I'm going to freak out. I've been waiting
ever since—I've never freaked out. I don't know
what the explanation is. The closest I can think of
is that if you have a job to do, a mission, a
passionate mission, then you don't get scared. You
can do it. You find you can do it. It's the people
who are insecure or don't really know why they're
there, and don't know what they're doing, who
suffer, but I knew. I did all of this half for me and
half to show the world. (Hue, 1968)

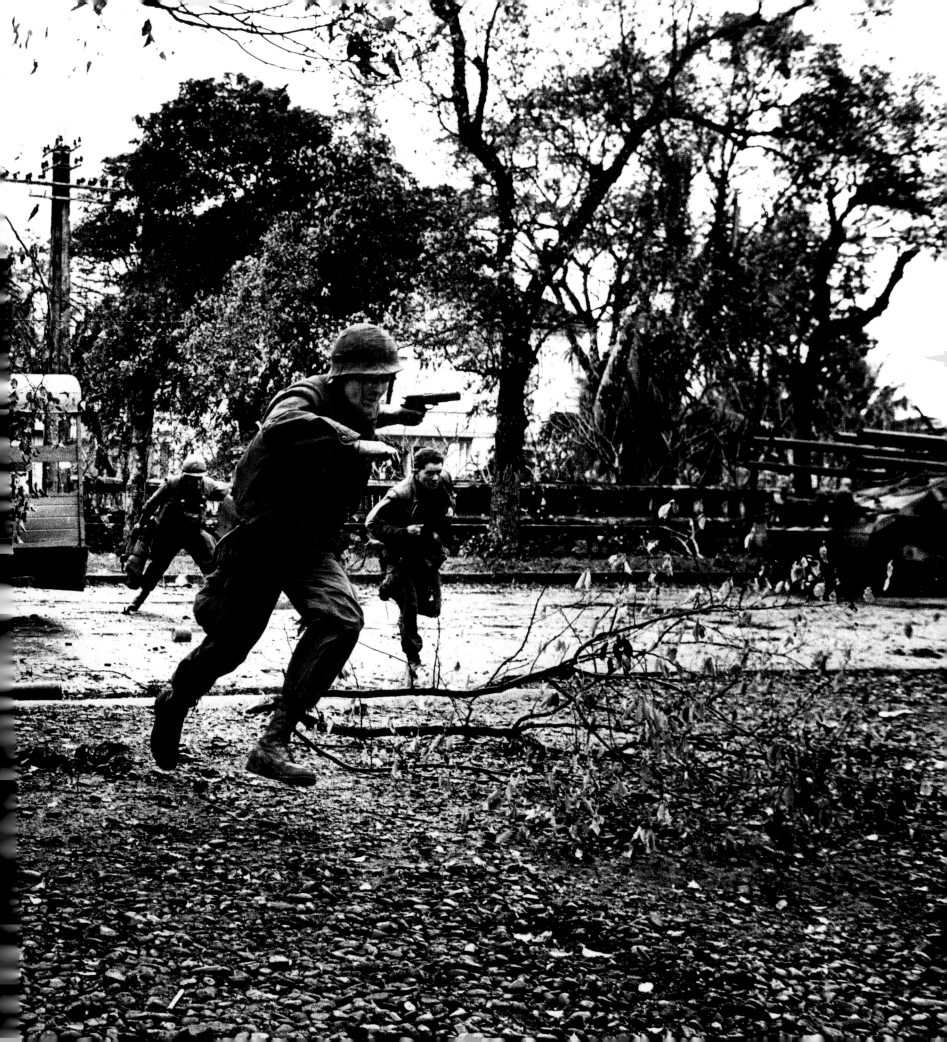

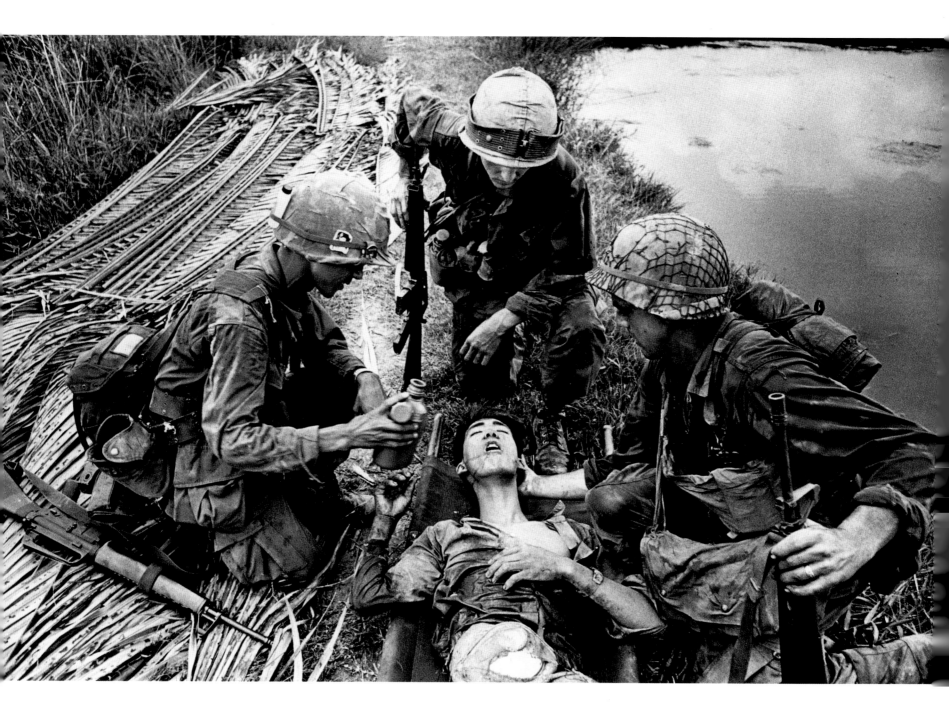

SYMPATHY FOR THE ENEMY

These GIs had captured a Vietcong fighter, only to discover that his belly had been blown out. He had dropped his intestines into a little washing-up bowl that he probably got from some farmer's wife, put the bowl over his wound, and wrapped a cloth around it to keep it in place. He kept fighting for two or three days like this; when he was captured, he was very thirsty, which often happens with a stomach wound. The Vietnamese interpreter said, "He's Vietcong; let him drink the paddy water." And the GI on the left said, "Anybody who can fight like this for three days can drink out of my canteen any time." Years later Francis Ford Coppola re-created this scene in a movie that is still the best ever made about the Vietnam War. He'd also used a lot of my photographs in the film, and Magnum asked him for payment. He replied with the two immortal words of Hollywood: "Sue me." And that was the end of that. But the moment was immortalized in *Apocalypse Now*. (West of Saigon, 1968)

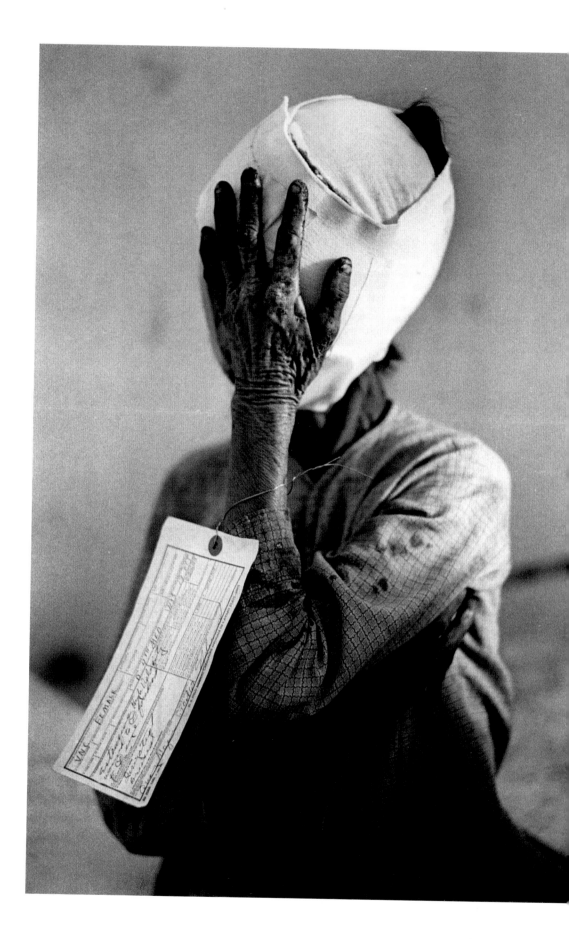

TAGGED LIKE AN ANIMAL

I've been asked a few times what I think my best photograph from Vietnam is. It's very difficult; it's like choosing between your children. Certainly the most famous one in terms of the number of times it's been reproduced is this picture of a woman holding her hand up to her face. She's been tagged like an animal, the way they were tagged in Auschwitz. But if you decipher the tag, you discover that the guy who made it out was antiwar—a lot of medics were conscientious objectors who were more antiwar than the average soldier. The rule in Vietnam was that anybody who had been wounded was VCS, a Vietcong suspect, and anybody who was dead—any villager, farmer, or baby—was tagged VCC, "Vietcong Confirmed." This was obviously a wounded civilian, yet the medic wrote down VMC Female, meaning Vietnamese civilian. Unfortunately, few picture editors ever read the tag because the woman is always described as a napalm victim. In fact, the tag says "Extensive High-Velocity Wound to the Left Forehead and Left Eye." (Vietnam, 1967)

Ron Haviv

Ron Haviv, an American, was born in 1965. He took up photography as a hobby as an undergraduate at New York University, where he majored in journalism, then started his professional career picking up assignments while working as a Good Humor man and a bicycle messenger. His break came in 1989, when he went to Panama to cover the reelection of Noriega and his photograph of a bloodied and beaten vice presidential candidate gained worldwide recognition. | Since that time, Haviv himself has been beaten, imprisoned, and put on a Serbian death list. He has covered conflicts in Latin America, the Caribbean, the Balkans, Russia, with the Iraqi Kurds, in the Gulf War, and recently with the Northern Alliance troops in Afghanistan. He has won the Overseas Press Club award twice, two World Press Photo awards, a University of Missouri Pictures of the Year award four times, and the Leica Medal of Excellence. He has published two books, *Blood and Honey: A Balkan War Journal* and *Afghanistan: The Road to Kabul.* He is a contract photographer for *Newsweek* magazine and a founding member of the photographic agency VII.

It Should Be Seen

There are two main reasons I do this kind of work. The first is completely selfish: It's amazing to be in a place where the history of a country is unfolding before your eyes. To be able to photograph it, and then to be able to show people my vision of what happened, is an incredible privilege. The other, more altruistic reason is that photography can play a role in helping to protect people and that it can be a voice for people who have no other way of speaking.

I felt that way in Yugoslavia, although it was incredibly frustrating. Over and over again, the same pictures were being published, with absolutely no reaction. But the solution was not to stop; the solution was to keep doing it, to build on the existing evidence, and to make sure that eventually people were going to be held responsible for what was happening. Anger and

Prisoners of war, Trnopolje camp, Bosnia, 1992

frustration became the impetus to keep going. In 1994, I was photographing the same poor refugee woman I photographed in 1991. It was a different woman in a different part of the country, but it was the same exact picture. And the people for whom you were working would say, "Yes, it's the same picture. That's why we're really bored with it and why we don't want to publish it." But the whole point was that it was the same picture.

Then in 1995, the work of journalists started to take effect. The combination of the fall of Srebrenica and increased American involvement with the NATO bombing led to the end of the war within six months. It was something that could have happened much earlier, but I still feel that my colleagues and I were able to play some role in bringing it about. This became much more evident in Kosovo in 1999. Once again, same pictures, same woman, same soldiers, some of the same commanders, actually—it was happening all over again. But at this point, the politicians and the public were fed up with the situation. They couldn't believe they were seeing the same pictures—the war in Yugoslavia was supposed to be over. They thought, Kosovo! I thought we dealt with that already.

When pictures from the first Kosovo massacre appeared, boom, it was top of the news. There was an instant diplomatic push from the West, and when that failed, immediate military action. In a way, I think Kosovo benefited from the limit on the number of images and television reports people could digest. And then East Timor happened, and there the international reaction was almost instantaneous.

The images photographers produced didn't end the war in Yugoslavia, but our photography did have an effect. We provided evidence that didn't exist before. There's a big difference between somebody writing on a piece of paper that they saw this soldier killing this person and seeing an image of it happening. The War Crimes Tribunal said the images from Yugoslavia filled in a lot of gaps that would have remained if photographers hadn't been there risking their lives.

Some people feel that photographers are participants in what's happening, but we're not. We're merely on the sidelines watching the action. To me, this makes it a lot easier. It's not the same as being a soldier, because soldiers are active participants; they're pulling the triggers, they're killing people. It's an absolutely horrible thing to see somebody die in front of you, but it's not the same thing as killing him. When you're taking that photograph, and your picture is able to help the next person or the next generation, you feel there's a reason for you to be there. Whatever is happening in front of me, whatever I'm photographing, people have a right to know about it. It should be seen. ■

Blood of Serb casualty, Kosovo, 1999

Panama City, 1989

The Vice President and the Dingbats

The first time anyone shot at me was in 1989 in Panama. I was there covering the elections that the dictator Manuel Noriega had decided to hold in order to legitimize his position, and which he lost by a large margin. The day after the elections, he decided that they had been a mistake, and he nullified them. He also sent in the army and paramilitary squads to suppress an uprising by supporters of the victor, Guillermo Endara. There was fighting in the streets; tear gas was used, and Panama City was in chaos. I was following the candidates and wound up in a small park, separated from the rest of the journalists and the rest of the crowd. Suddenly, we were surrounded by the army, and for a few moments nobody knew what was going to happen. Then I looked over my shoulder, and the scene I saw was straight out of a banana republic movie: a bunch of guys with flags, baseball bats, torn jeans, and purple T-shirts running over the hill toward us. They were members of what was known as the Dignity Battalion—mockingly called the Dingbats—and they went straight for the candidates.

All of a sudden guns appeared and the Dingbats attempted to kill the candidates. At one point, one of them went up to a car, stuck his pistol inside, and opened fire; a few moments later, the occupant stumbled out. He was wearing a light shirt that was completely covered in blood. One of the Dingbats stabbed him in the arm. I ran over and began taking pictures. I heard someone say in Spanish, "Excuse me." I turned around, and a man stepped past me, took out an iron pipe, and

started beating the man who had been shot just moments before. As I was photographing this incident, I realized that the blood-covered man was actually Guillermo Ford, one of the two vice presidential candidates. An army soldier was standing off to the side watching, but it was several minutes before an officer finally intervened. He grabbed Ford, threw him in the back of the car, and drove him off.

I had gone to Panama to cover the elections, with no plans of becoming a combat photographer. I was so inexperienced at that point that it wasn't until later, when I'd been shot at again in another situation, that I recognized what an incoming bullet sounded like. I was lucky not to have been hit by all the ammunition that was flying around.

The biggest impact of this incident was not so much on my own personal experience there; it was what happened to the photograph I took. The picture of the bloodied vice president was on the cover of *Time*, *Newsweek*, and *US News & World Report*, as well as in dozens of newspapers. It was then that I realized that photography can play a role in educating people and helping to shape public opinion. When President Bush eventually invaded Panama, he opened his speech to the nation with, "You all remember those pictures from Panama of the bloody vice president . . ." Whether I agree politically with what he did isn't the point. The point for me is that photography can really be an active participant in determining what's happening in our lives. ∎

Dealing with the Plumber

People often ask me, "How do you live in New York after having such an adrenaline-filled life? It must be so boring dealing with the plumber after all that." I think there's a slight schizophrenic quality to the life of a war photographer. When I was starting out, there's no question that I damaged personal relationships because I didn't know how to resume my life in New York when I returned from a trip. Eventually I realized that there are different types of reality, and that each exists as itself. It's important for me to participate fully in my New York life. I can't just shut down and say, "Oh, I'm a war photographer. I only deal with extreme situations." It would be very dangerous for me to return home and sit in a dark room until the phone rang, sending me back to the next war. It would also damage the quality of the photography that I produce in that war, because if you don't understand the sensibilities of your audience, the photographs won't succeed.

I hope that my photography says, This is the reality of places that in many ways are like New York—Sarajevo is what New York could be if things became absolutely horrific—and I want you to feel that in my photographs. In that way the war in Sarajevo is going to mean something to you, and maybe you'll try to do something to stop it.

My experience giving lectures and participating in discussions in America is that there are a lot of people who are interested in what's happening in the world. After September 11, this became much more so. I think Americans are realizing that the world is interconnected and that they need to understand what's happening. Understanding war photography is part of it. That's not to say that every newspaper and magazine needs to be filled every week with images of conflict. But they should be there. They're what the world is about. There are happy things and there are bad things, and you need to see both of them. ∎

Serb forces, first battle for Bosnia, 1992

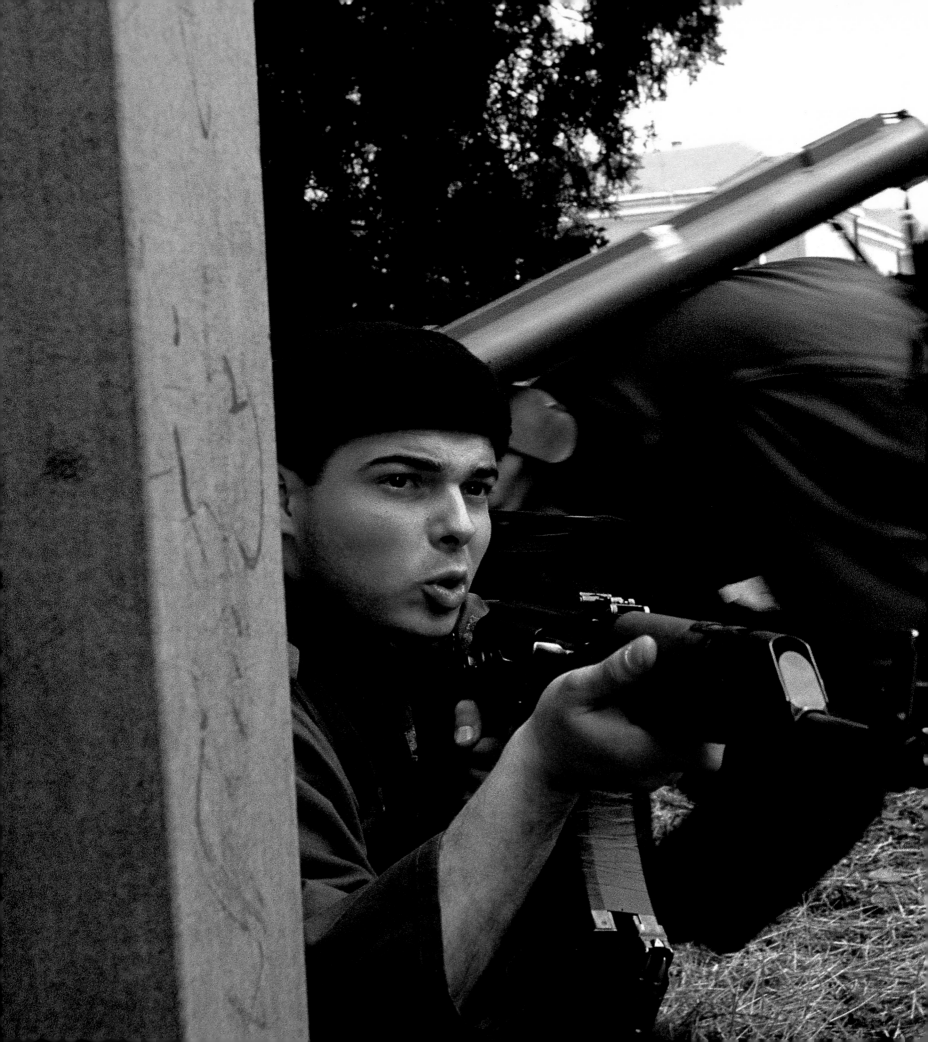

The Value of Experience

I try to be as careful as possible in a war zone and to follow my gut instincts. When I travel with other people, my rule of thumb is to do what's best for me. I try to think as logically as possible and not to lose my head and get overly excited, which is often the reason people get hurt or killed. Even so, I've made many stupid mistakes. Luckily, I've survived them all.

During the war in Croatia, it was very difficult to go from one side of the front line to the other. We actually asked for a cease-fire while we drove through no-man's-land with our hands out of the car, hoping that the one side wouldn't shoot us so we could go and photograph the other. And then we did the same thing to get back. It was a romantically brave concept, but a profoundly stupid thing to have done. And we wound up doing it a number of times!

The longer you survive in this business, the more you learn. This knowledge protects you, but it also makes you realize the gravity of what can happen, which sometimes makes you more cautious. Over time I've become much more methodical in making decisions, and I let my experience from previous wars dictate where I should be and at what time. ∎

Serb paramilitaries, Bosnia, 1992

My Friends the Commanders

There's always some sort of bonding that needs to happen between the photographer and the soldiers, a mutual trust before going into battle together. I have to know whether this guy is a complete idiot, and he has to know that I'm not someone who's going to do something stupid that would get both of us killed. This camaraderie is especially important with commanders. It's always easier to bond with the foot soldiers, because they love being photographed; they're happy to see you, and if they trust you, things are fine. But if the commander doesn't want you there, you won't work, and that's

that. In every war, you'll see photographers going out into different sections of the front, trying to find a commander to befriend in order to get access, to be allowed to be there, to be able to document what's happening. When I was in Bosnia, I photographed a man being taken prisoner and soldiers executing civilians. I was there because I had befriended the commander, who was a notorious warlord. He let me go with the soldiers because he'd met me six months before. If I hadn't had that history with him, I never would have been allowed anywhere near the front line. ∎

Serb paramilitary leader Zelijko Raznatovic and his "Tiger" unit, 1991

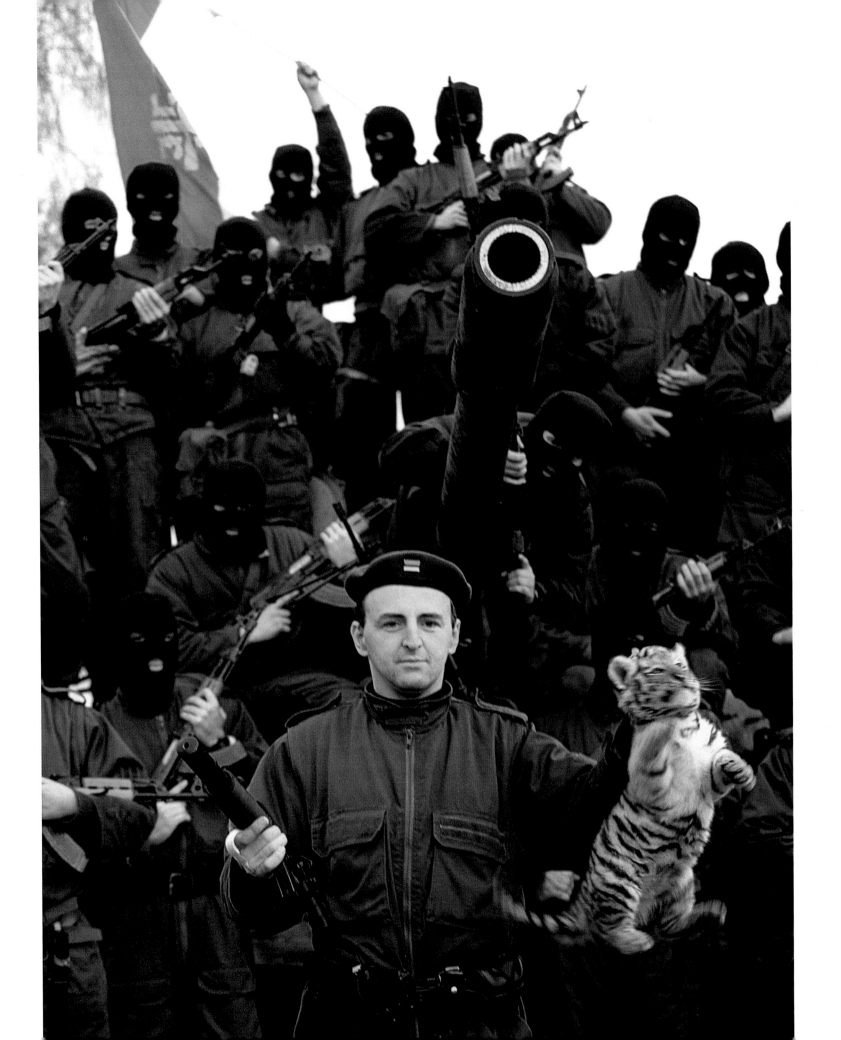

The Eyes of Dying Men

In Bosnia, I photographed a young Muslim as he was being captured by Serbian paramilitaries who had taken over his town. The soldiers forced him to his knees. He put his hands up in self-defense, and he looked me straight in the eyes, pleading for help, but there was absolutely nothing I could do except photograph him. Later, the Serbs took him to headquarters and interrogated him. Then they threw him out of a window; he literally landed at my feet. I was actually trying to get out of town before they realized I had taken photographs of this man and of several executions. The Serbs beat him up, then dragged him back into the building; amazingly, he could still walk. I had a fruitless confrontation with the commander on his behalf, then got out of there as quickly as I could. The next day, after I had shipped the film, I went back to the man's house and to the hospital, but he was nowhere to be found. I always remember that connection with his eyes. It's a memory that will stay with me forever. ■

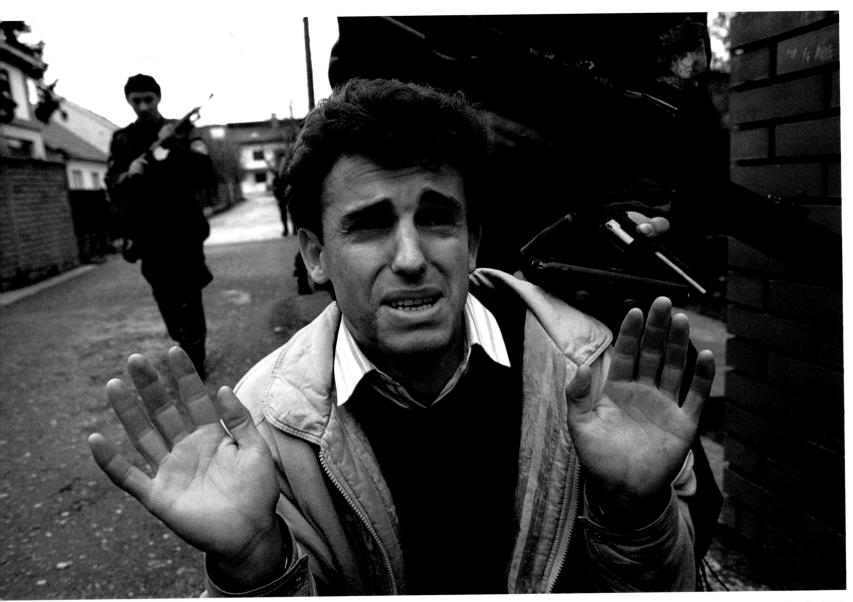

Bosnia, 1992

Outside Kabul, 2001

BATTLES IN AFGHANISTAN don't resemble Western warfare. Everybody sort of runs forward, helter-skelter, with no apparent order. On one occasion I was running with a group of soldiers, and as we reached the top of a hill, we came under enemy fire that kept us pinned down in a ditch for over two hours. At one point, a commander got hit a couple of feet away from me. During all the combat I've been involved in, there haven't been many times when a soldier next to me was killed. It was a frightening experience.

One of the things the Afghans are known for is laughing constantly. Sniper fire would come in or a shell would land nearby, and I'd hit the ground. The soldiers would be wandering around laughing, and when I'd get up, they'd say, "Why are you so dirty?" And they'd all come over, clean me off, and say, "Don't be so dirty around us!" They've always been at war, and unless things are incredibly dangerous, their attitude is, Whatever. But in this situation, nobody was laughing. There I was, stuck in a ditch with these guys. As he was dying, the commander looked straight at me; I think I was the last person he saw alive. It's odd—I photographed him before he was shot, and he was happy that journalists were covering the fight against the Taliban, so I knew he didn't mind that I was there. He was very proud, very helpful, and now he was looking at a photographer taking a picture as he was dying. ■

With the Northern Alliance at the Fall of Kabul

My first visit to Afghanistan was in 2001 with the fighters of the Northern Alliance. Each day I said to myself, I can't believe that I've never come here before. It was so beautiful, and it was amazing for me to photograph the mix of twenty-first- and seventeenth-century warfare. The soldiers wear more or less the same type of clothing that their ancestors wore—some even carry swords—except that they're also carrying rocket-propelled grenades and Kalashnikov rifles, and communicate through portable satellite phones and walkie-talkies.

The landscape and the mud villages added a surreal atmosphere to working there. The terrain varies enormously; I went through mountainous regions and then dry plains, where there has been a drought for the last four or five years. Dust was constantly being kicked up, no matter whether we were walking, biking, or traveling by car, and added a brown tone to everything. The sky, on the other hand, was incredibly blue. So you had these two predominant colors of brown and blue. The women were dressed in blue burkas, adding another element of blue. With blue people walking around on brown ground and a blue sky over them—photographically, it's really amazing. When you moved from one plain to another, the color of the ground would change from brown to red to pink, to the point that when I looked at the photographs on the computer screen or in prints, I couldn't believe the colors were real.

In the beginning, Afghanistan was probably the freest place I've ever worked in terms of access. You want to go to the front line? Sure, go to the front line. You want to take a soldier? Take a soldier! The best example of this was the day of the offensive on Kabul. I was in a front line position, where I'd been spending a lot of time waiting for the attack to begin. It was morning, the soldiers arrived, and the artillery was being set up. From experience, I was very nervous that the commanding officer was going to throw me out, especially because the American military was involved and they usually limit access. When the Northern Alliance commander arrived, he walked over to me with a huge smile on his face. Because he was a very egotistical guy, I took some pictures of him. He slapped me on the back and said, "Nice to see you," and just kept walking. And that was it. As the offensive moved forward, a lower-ranking commander appeared, and again I thought I was really in trouble. But he said, "Which car do you want to get in? We'll drive you to wherever you want to go."

That was the way it was throughout the country. The Afghans liked to be photographed, and they also acknowledged, to some degree, that American planes were flying overhead and that they weren't doing this on their own. This helped create a sense of camaraderie between them and the journalists, because they felt that everybody was helping them in their goal of retaking Kabul.

I was there for almost three months, and as we moved toward Kabul, this attitude prevailed. I like to describe it as a bubble. We all had the same goal of getting to the capital, and were all on the same team. When the city was finally taken, the bubble burst, and the camaraderie started to dissipate. The soldiers began to fight over land, and the attitude toward journalists changed; it was during this period that the four journalists were killed on the road from Jalalabad to Kabul. At the time, this was a shock, but looking back, it was obvious that something like this would happen. Kabul had been taken, the Taliban had fled, and now everything was fair game—the natural way of things in Afghanistan.

Kabul fell quickly from the hands of the Taliban. What I saw mostly were Northern Alliance soldiers moving through, taking prisoners. They did execute a number of people, but there was very little hand-to-hand combat. That appears to be typical in Afghanistan—when one side feels the other side is stronger, it just leaves. The shift of power isn't always the result of heavy fighting. When Kabul fell, the casualties were extremely low. The battle was over in twenty-four hours.

The Northern Alliance was thrilled when all of a sudden they could call the Taliban terrorists. For five years, they'd been saying Taliban, Taliban, and the rest of the world didn't care. But now they were fighting the Taliban under this new label, they got new uniforms, new weapons, new training, and things were great. They realized they finally had an opportunity to use the West to fight the battle that basically they had been losing for the last five years. They played it really well from both a PR and a military point of view because they let the Americans do almost everything from the air. Day after day you'd watch American planes bombing the Taliban positions, and you'd say to the local commanders, "Are you going to move forward?" And they would reply, "Oh, maybe tomorrow." They had no real desire to fight unless it was guaranteed that they would be victorious. It was a very strange war in that sense. ■

Overleaf: Northern Alliance troops on the road to Kandahar, 2001

TEENAGERS OF THE TALIBAN

Two young Taliban prisoners, captured right outside the
gates of Kabul, were being held on a bus by Northern Alliance
soldiers. One of the soldiers came up to me and said,
"Come in and see our prisoners." Inside the bus, his comrades
were terrorizing these kids, pretending to shoot them. The
boys looked about fifteen or sixteen, which was pretty
much consistent with reports of lots of young kids on the
Taliban front line. For all I knew, they were about to be
executed. One soldier was pointing an RPG [rocket-propelled
grenade] at them; had he used it, it would have killed us all.
But they're Afghans; they have a whole other concept of
brutality. There are all sorts of gruesome legends about the
things the Taliban did, like putting people in the soccer stadium
and chopping off their heads or tying somebody to two
tanks and driving in opposite directions to tear them in half.

In broken Dari, I told the soldiers that the boys
shouldn't be killed. Being an American was helpful because
the Afghans thought that all Americans were either CIA
or Special Forces, so they said, "Okay, fine." I don't know
what happened after I left them.

But this touches on a bigger issue: when or if a war
photographer should intervene. The conclusion I've come
to is that there are times when you can and should. There are
also times when your intervention could result in your
being killed, and then the only thing you can do is make sure
the event is documented, so people will know about it and
the victims won't die in vain. (Outskirts of Kabul, 2001)

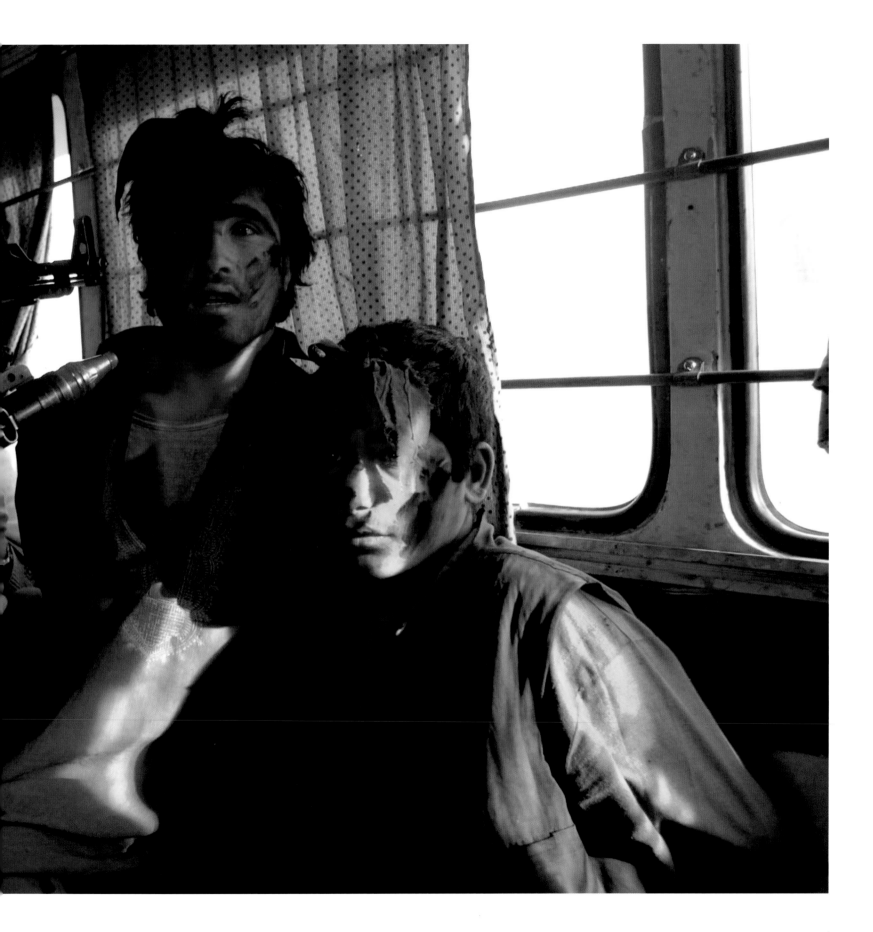

Catherine Leroy

Catherine Leroy was born in France in 1944. She went to Vietnam as a photographer at the age of twenty-one with little experience. She stayed from 1966 to 1968, during which time she was captured by the North Vietnamese and was wounded in action with the U.S. Marines. Her work was published in *Look*, *Life*, *Time*, *Paris Match*, *The Sunday Times* of London, *Epoca*, and *Stern*. | She went on to cover conflicts in Northern Ireland, Cyprus, and Lebanon, and was a *Time* magazine contract photographer from 1977 to 1986. In 1983 she and *Newsweek* correspondent Tony Clifton published a book on the Israeli invasion of Lebanon titled *God Cried*. | Leroy lives in Los Angeles. She has started a Website selling prints by Vietnam War photographers.

My Father's Tears

I was twenty-one years old when I went to Vietnam. I had always wanted to become a photojournalist. I practically learned how to read by reading the fabulous *Paris Match* of the 1950s. It came every week, and the photography was so tantalizing, such an opening on the world, that I realized this was what I wanted to do. Even though nobody in my family was in Indochina, I have a memory as a little girl of my father listening to the fall of Dien Bien Phu on the radio and crying. I don't know if this had any bearing on why I had to go to Indochina, but the only thing I wanted to do was buy a Leica and go to Vietnam, and this I did.

I had very little photographic experience, but from the moment I first picked up a camera, I could compose. It's not something I learned; it just was there. I walked into the AP office in Saigon, and there was Horst Faas in a small office on the right. I was a child, completely wide-eyed, and I said to him, "What do I need to photograph?" He opened a drawer, and inside there was a pile of wire photographs. I looked at this stack of pictures, and I knew immediately what I had to do. I got my accreditation, and I went to war. ■

Filled with the Sound of Death

I no longer want to photograph war. When I left Vietnam I was twenty-three, and I was extremely shell-shocked. It took years to get my head back together, because I was filled with the sound of death, and the smell of death. On the surface I was extremely cool under fire. I didn't show any emotion; in fact, I didn't show anything. But when I went back to Saigon, sometimes with human brain on my fatigues, the horror of it would hit me, and I would sleep for twenty, thirty hours straight.

When I returned to Paris, I couldn't cross the street without almost being run over. I couldn't sleep at night. I couldn't function in a normal manner. I couldn't express myself with my friends, and they couldn't understand me. They were very much opposed to the war, and they accused me of being pro-American. They were all leftist intellectuals, and the leftist intellectuals of the Left Bank in Paris never go anywhere but the Left Bank in Paris, so I didn't have anything to say to them anymore. During a big lunch in my honor, everyone started to have this big political discourse, and I felt I was being attacked. I was in such a fragile mental state that I started to cry, stood up, and left. I took it very personally.

I don't think that any of us who were in Vietnam for a long time were pro-war. We might have been antiwar, but we were never against the soldiers who were fighting it—how could we be? We shared the same miserable existence, we had established a bond with them. Anybody who spoke out against the war was also speaking out against those who were fighting the war, and those who were fighting the war were my friends. Friendship, camaraderie, generosity—all of this is what you have in time of war. The GIs were like my brothers. We were the same age, and I loved them. Besides, I cannot photograph anybody for whom I don't have any feelings. I would rather stay at home, smoke a cigarette, and drink a good glass of wine. ∎

Wounded U.S. Marine, Vietnam, 1966

Captured in Hue

I was working with François Mazure, a French journalist from Agence France-Presse, and we had decided to spend the Tet holidays in Da Nang. It had a press center and a beach, and it was a nice place to be for a couple of days. But as soon as we arrived, the Tet offensive began. The press center was saying that the situation was very much in control, but what we didn't know was that Hue had been taken by the North Vietnamese. At the same time, they had attacked the American embassy in Saigon—little guys running around in Ho Chi Minh sandals blowing holes in the embassy door with RPGs. All hell was breaking loose.

François and I decided to go to Hue. We went by helicopter with several other journalists to marine division headquarters in Phu Bai. I have no idea why—I suppose it was a kind of hunch—but I had suggested to François that we take civilian clothes. Normally, when we were with the marines, we wore fatigues. I had a pair of beige jeans and a T-shirt, and François had something similar. We changed our clothes and hitchhiked about thirty kilometers in an American jeep to the closest point we could get to Hue.

When we arrived in the city, everything was closed. Everyone was in hiding. We finally saw somebody and said, "We are French, can we rent a bicycle?" We ended up buying one. So there we were, François pedaling and me behind with my cameras. We eventually came to the cathedral. In front of us was a tree-lined avenue leading to the city center; on either side

were big rice paddies. We figured there were refugees inside; we found thousands of them. A priest warned us that the North Vietnamese Army was everywhere, and he let us spend the night in one of the priests' quarters. We could hear shooting all night long, and lots of activity in the garden next door.

The people in the cathedral were frightened because we were there. They felt that it would be very hard to convince the North Vietnamese that we were French, not Americans, so in the morning we decided to leave. We acquired a young guide who volunteered for the job. He made a big sign that said Phat Bao Chi Bale, which means French Press from Paris. So there I was with my beige jeans, shirt, and chic pigtails, and the sign, and François. We had gone only about 150 meters when suddenly we were surrounded by North Vietnamese soldiers. My camera was taken off my shoulders and my hands were tied behind my back, despite François's protests: "Don't tie up the woman; you shouldn't tie up a woman." They took us to this beautiful mansion. The NVA were everywhere, and I was shaking. I was really frightened.

We were pushed into the servants' quarters. Suddenly we were face-to-face with a European man, a Frenchman. I thought he was a prisoner, but it turned out it was his house. He was married to a Vietnamese woman, and that's what saved our lives, because she translated for us. Immediately we asked for an officer, and one came, a young man, twenty-two or twenty-three years old, tall and lean, handsome. It was a shock for me

North Vietnamese sniper near cathedral in Hue, 1968

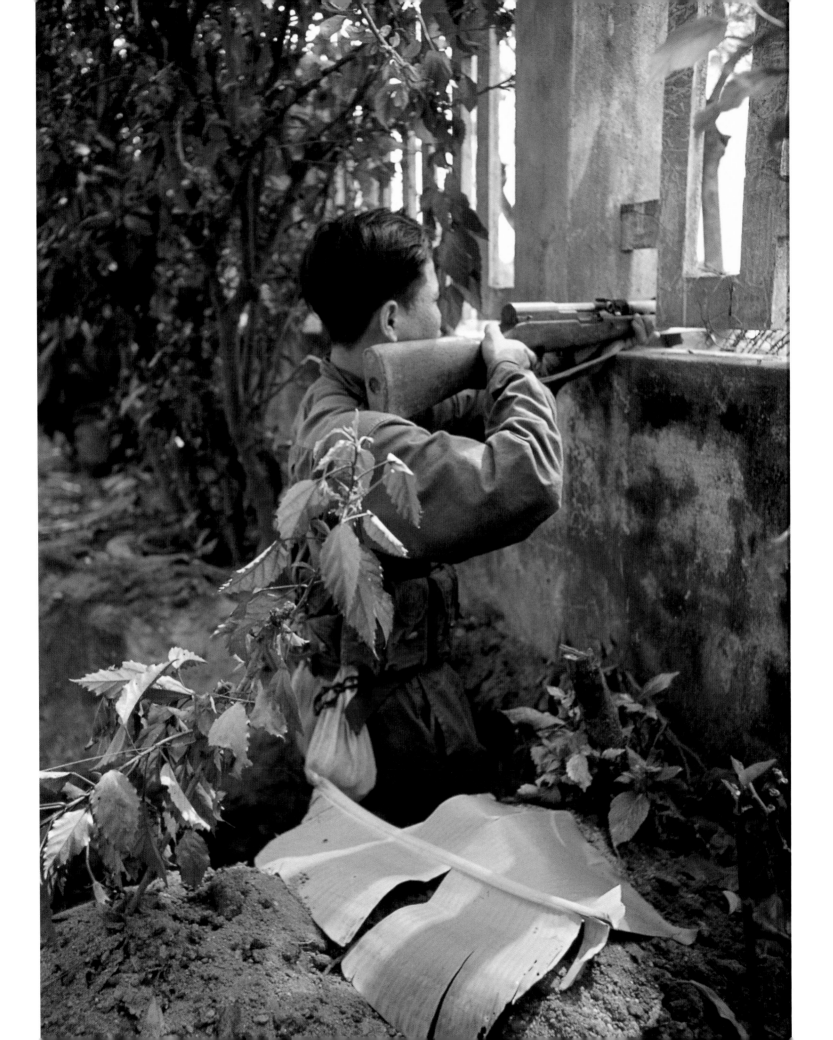

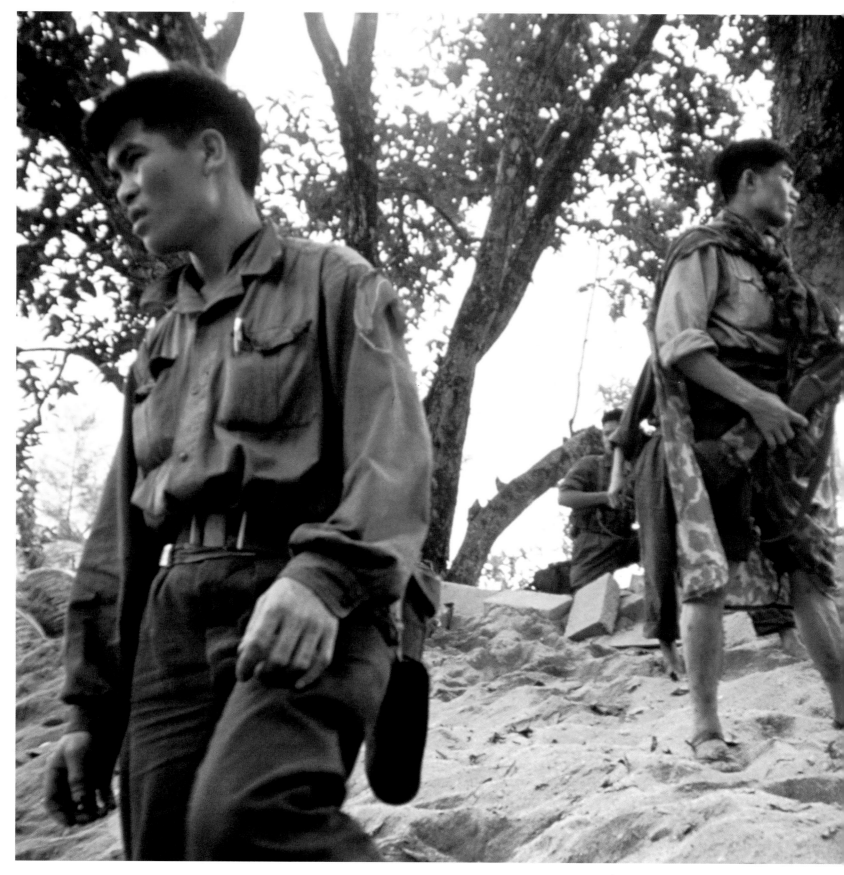

North Vietnamese soldiers, Hue, 1968

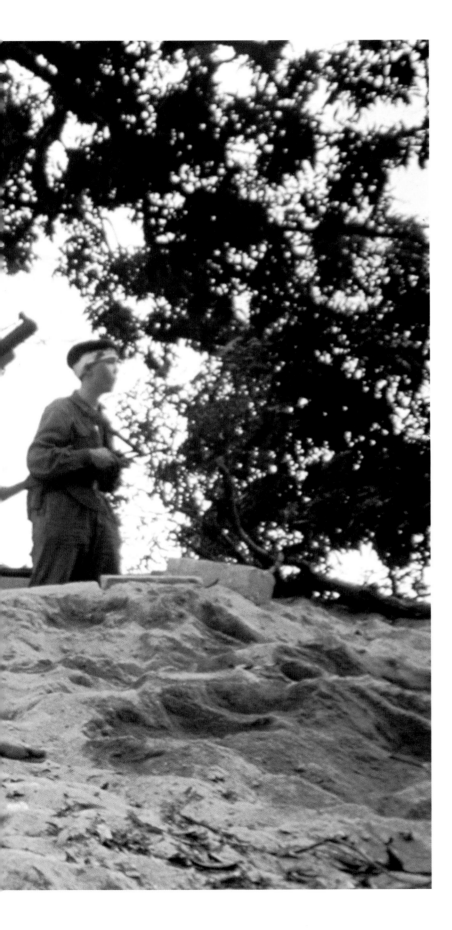

to see him—since I had been in Vietnam, the only North Vietnamese I had seen were wounded, dying, or dead. We said that we had come from Paris to do the story of the victorious North Vietnamese Army taking Hue, and that we were in a hurry to go back to Paris to file our report. Apparently, he believed us, because our hands were immediately untied and my cameras were returned. The young officer asked me several times if all my equipment was there and in good order, and then he took us around the perimeter to show us what was going on. I took a few pictures, but I was so scared that I wasn't trying to be the brilliant photojournalist.

While François interviewed the soldiers, I went back outside, and of course I ran into trouble. I started to photograph a North Vietnamese soldier who had a radio that I recognized as American. I photographed him listening to it, which made him furious, and he demanded the film. There was a commotion, and once again I was surrounded. I managed to give them a blank roll, but now we really had to leave. We left Hue exactly the same way that we had come in, and we could feel the NVA presence everywhere. Finally we came upon a South Vietnamese army post. I had put all my American press cards in my bra—it was one of the few times I had worn one—so I took them out and yelled, "French! Let us in!"

There were a few stranded Americans at the post, including a couple who had been wounded. As soon as we were inside, a firefight started. François had been in the French army, so he knew how to work the radio, which he used to explain that there were some Americans and two French journalists waiting to get out of there. After a couple of hours, transportation arrived. I had shot only about ten or twelve pictures, not even a full roll, but I got the cover of *Life* magazine. When we got back to Saigon, it was a huge story. I spent a couple of days there trying to get my wits back, and then I went back to Hue, this time with the marines, and spent seven days doing a story for *Look*. ∎

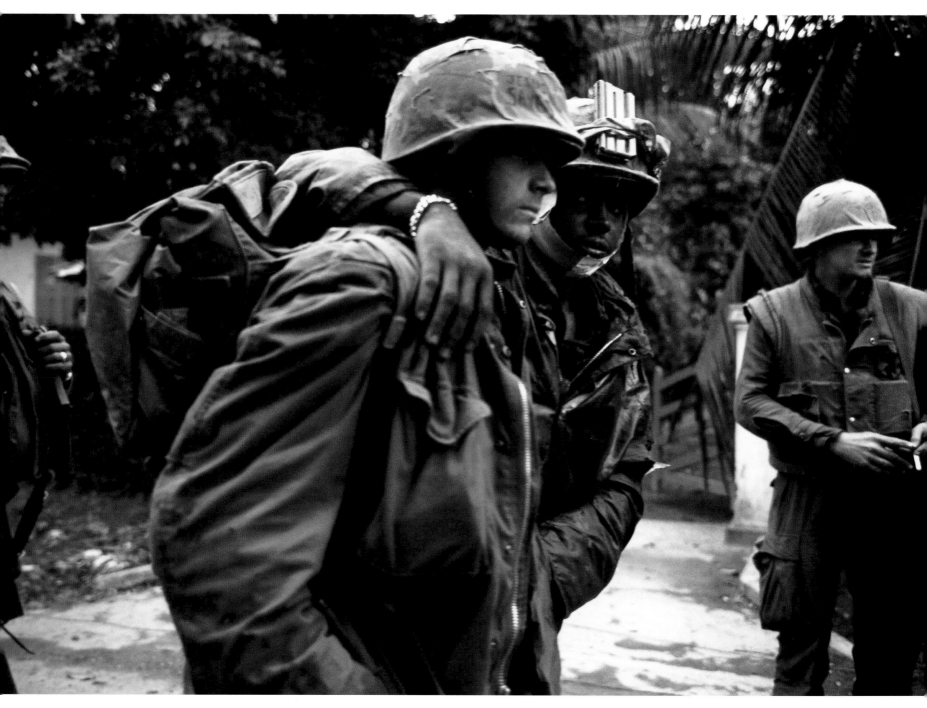

Evacuation of wounded, Battle of Hue, 1968

In a Brothel Without the Blues

I was a very difficult teenager. I had been running away since I was thirteen or fourteen. I disappeared in England—I was dancing bebop in a jazz club; I wanted to become a blues singer. My mother thought I was completely out of my mind. I was a gifted piano student, but I never worked as hard as I should have, because it was too easy. To become a blues singer, on the other hand, was a very big challenge. One day my mother said to me, "You'll end up singing in a brothel." I was so shocked that I closed the piano and swore I would never play it again.

As it turned out, I did end up in a brothel. I lived in a small room in Cholon, the Chinese section of Saigon, in a new building owned by a Vietnamese doctor who lived next door. I had a bed, an armoire, a desk, a chair, and a small bathroom, that's all. I was away all the time—I would spend ten days, two weeks on a trip and then come back to this tiny room on the third floor. I would take off my dirty fatigues, throw off my boots, take a shower, wrap myself with a big sarong, and crash. Then I would wake up, go to a restaurant, and prepare for my next trip. I was never there. I never saw what was going on.

One day I heard *boom, boom, boom* on the door. I woke up in a daze and opened it. Standing there was this military policeman whose shoulders were wider than the opening, and behind him were two other MPs. Then I heard screaming. The big MP looked around my room and said, "Sorry, ma'am, we're checking all the whorehouses." As he turned to leave, I went into the hall and saw all these guys trying to put their pants on. The young girls who lived in the building were screaming. I was so naive I thought they were students who had fled the war zones in order to study. So here I was in a brothel, and I wasn't even singing the blues. ■

The Woman with the Wine

I never really had any trouble being a woman in Vietnam. I was never propositioned or found myself in a difficult situation sexually. When you spend days and nights in the field, you're just as miserable as the men—and you smell so bad anyway. Basically, you're just trying to survive. But I made myself quite popular because I'm tiny. I'm five feet tall and I have no strength, so what I did instead of carrying C rations was bring the wine. I had found a place in Saigon that was importing Beaujolais in a can. I'd take a six-pack and maybe one or two C rations, which was the maximum I could carry, in my poncho liner. Each time I joined a company, I would choose my group of friends, my crew, and we would share everything—you know, you take care of your buddy and your buddy takes care of you. The fact that I was a woman didn't make any difference. I would help them dig a hole, and we would all sleep in it, and there was never any problem, ever. ■

MORE MUSCLE THAN CURLS

Claire Constant was an extraordinary woman. She was tall,
blond, very feminine but with a lot of physical strength—
more muscle than curls. Most of the time she worked in
Paris as an agency nurse, which is how she made her living,
but when needed she would be sent out on missions by
Médecins Sans Frontières. This photograph was taken in
Lebanon after she had just completed a tour of duty lasting
several months in Afghanistan. Here she's working in an
operating room that Médecins Sans Frontières had set up in
the basement of a parking lot in Burj el-Barajneh. The man
looking at her is a surgeon. They had the standard MSF field
equipment in the room—they could amputate a limb or
patch up a wound, but that was about it. The man on the
table is a Palestinian who had just been brought in by
ambulance. I don't remember what was wrong with him,
because it was more than twenty years ago, but I think
he had a leg wound. He had probably taken some shrapnel
in his leg. Claire was a very compassionate woman,
but always very professional. She was also a helicopter pilot.
After we both returned from Beirut, I did a story for *Elle*
magazine about flying over Paris with Claire as my pilot. She
was amazingly unafraid and courageous in all situations.
(Siege of Beirut, 1982)

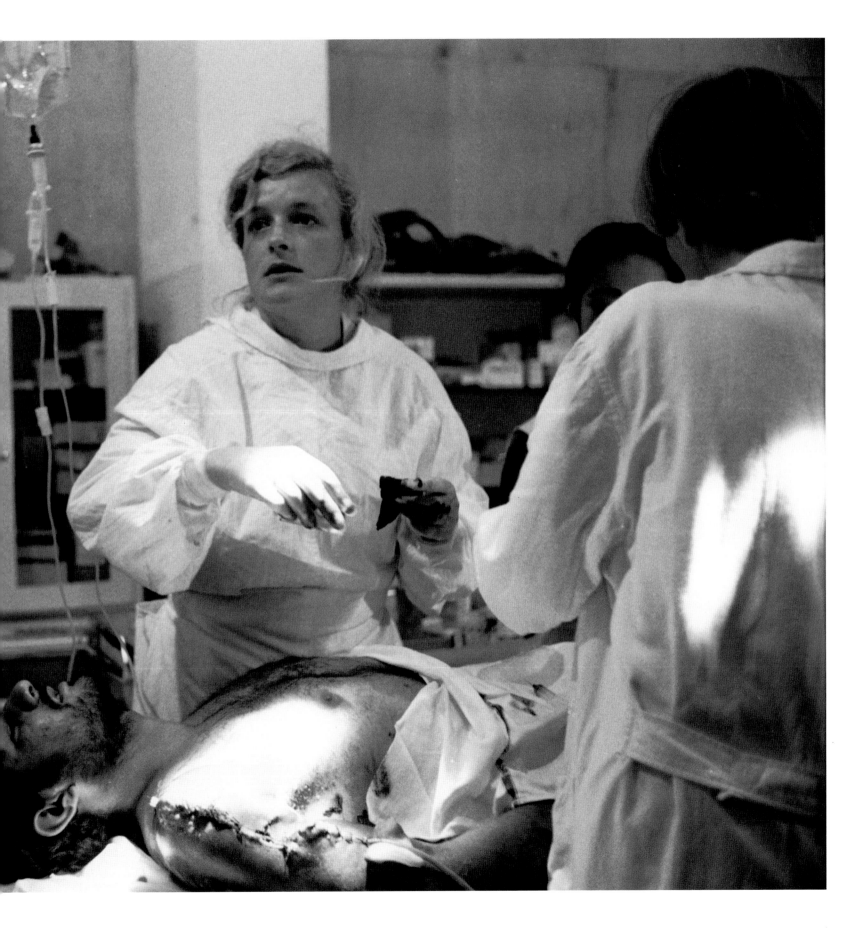

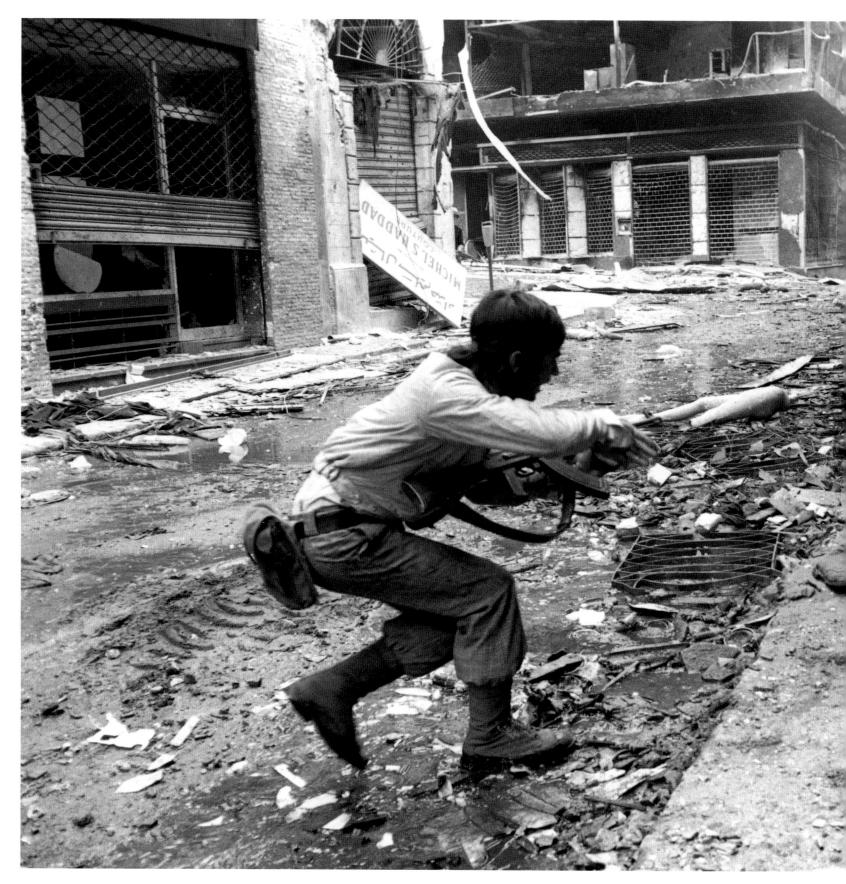

Gunmen, downtown Beirut, 1976

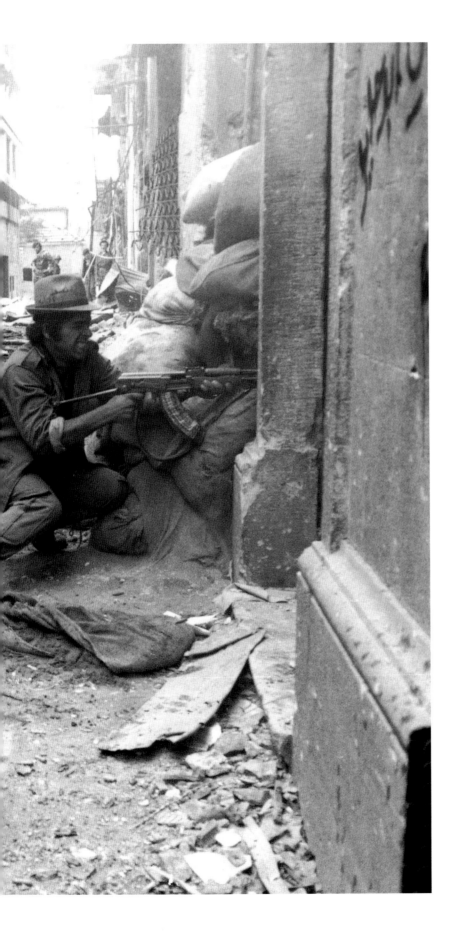

Alive Like You've Never Felt Alive

War is like mountain climbing or some other extreme sport—it gives you a high. It's like big game hunting, but it's the most exciting big game hunting of all because it's man-hunting.

On the other hand, I must admit that sometimes there's so much fear that you reach a crescendo of terror. I was so frightened sometimes, so frightened; I really never thought I was going to get out of this alive. But when it was all over, and when I *was* alive and unhurt—like the time I had a bullet in my canteen—the release of fear gives you a rush, a high of just being alive. You're alive like you've never felt alive before. It's not something that's pleasurable in a sensual sense. It's pleasurable in the sense of sheer animal survival. It's your primary brain, your reptilian brain. It's very low and very primal.

I'm certain that everybody who has been wounded thinks at some point that they're going to die. I was hit by several shrapnel fragments; I still have a few. There were about twenty pieces, and they were very tiny, but I couldn't breathe. Fortunately, I was given morphine, a lot of morphine, and when that happens you leave your body, you float in space, and you see yourself. I wasn't scared at all, only very tired. I've never been afraid to die. I love life, and I want to live it as fully as possible, but I'm not afraid to die at all. I'm afraid of being old and sick, yes, but not of dying. ■

The Driver's First Drink

My time in Beirut falls into two periods. The first was during the civil war, in 1975 and 1976. The second was during the Israeli siege in 1982. The civil war was very confusing, with all the different groups of militia fighting each other for power. It was extremely dangerous, because different blocks were controlled by different groups. It would be like being in New York and having one gang in control of Park Avenue between 59th and 79th Streets and another ruling 79th Street to 86th. I knew only the west part of the city, which was the domain of the Palestinians and their allies. I had a price on my head in East Beirut because I had photographed the Phalangists taking hostages, something they denied doing at the time.

Of the two periods when I was there, the Israeli invasion was the most frightening, especially the bombing. I was working with two other photographers, and I had this fabulous driver. We had found a building under construction that had a great view of the parts of the city that were being bombed, which of course were the Palestinian areas. After a couple of days, I began to recognize the pattern of the bombing runs, and I knew that we were perfectly safe because they were some distance away. I was shooting all the explosions. They were spectacular; the photographs looked like stills from a Hollywood movie. *Time* magazine loved them, but they never used a photograph of the people under attack. Apparently, the humanity of the victims of the bombing didn't exist. When the Israelis bombed a hospice containing old and mentally retarded people, that photograph was never shown. It's the same today. No American magazine ever shows

a photograph of Palestinians in their camps being wounded or shot by the Israeli army.

The building we were using was also an observation post for the Palestinians, and a Palestinian major and his platoon were stationed there. One morning he said to me, "Catherine, we're evacuating. It's dangerous; you shouldn't be here. You're taking your chances, my friend, you're taking your chances." Of course we stayed, but then suddenly the pattern of bombing changed. An Israeli plane started to attack a very small, antiquated antiaircraft gun located right across the street. This gun wasn't going to hit anything, trust me, but it was only about 150 meters from where we were, so we ran down the stairwell to the basement to get our car. But the basement was also filled with boxes of arms and explosives. The building was shaking, and the windshield of the car was blown out. I said to myself, We aren't going to survive. Suddenly we heard a telephone ringing. It was Mahmoud, the Palestinian major, on the line. "Catherine, are you still alive? I told you my friend, I told you."

I looked at my watch and counted how long it took for the plane to make its pass. It was eighteen seconds. Needless to say, within eighteen seconds we were out of the building. The plane dropped its bombs. Our car was lifted clean off the ground, but we made it back. We were out of the building, and my wonderful driver, father of five children, was crying. He had never touched a drop of alcohol before, but we took him back to the Commodore Hotel and for the first time he had a whiskey. My God, it was close. Very, very close. ■

THE EMOTION OF SILENCE

During the siege of Beirut, the Israelis bombed many residential buildings; they were looking for Arafat. It's bullshit when Sharon says he never wanted to kill Arafat; they tried to bomb him many times. One such building had been occupied by maybe three or four hundred Palestinian refugees—Christian Palestinians actually, not that it makes any difference. It's all about being Palestinian—if you're a Palestinian, you're doomed. The building was about ten stories high; when we arrived, it had been transformed into a pancake, a mille-feuille. The ten-story building was maybe ten meters high now. Of course, everybody was killed except one man who had been on the top floor. For weeks and weeks bulldozers were digging it out, recovering clothing, jewelry, glasses. The victims' relatives lined up to try to identify these items and to know if their relatives were dead.

For some reason, I was drawn to this place; it held a kind of emotion of silence. I wasn't even photographing, but I had to be there. I remember this young man I'd seen for a couple of days. He was eighteen or nineteen years old, very quiet at first. Then he came over to me and said, "Why are you here?" And I said, "I'm a journalist. I was here when it happened, just a couple of minutes after, and I have to be here." He said, "We don't care that you're here. I lost all my friends in here, I lost all my family, so why are you here? What good is it going to do? How is it going to help? Nobody cares about us." Suddenly, I wanted to cry because he was totally right. I thought, What am I doing here? It just didn't make sense anymore. Most of my photographs weren't being published, and the only ones that did appear in print showed the beautiful bombing landscapes. Nobody was publishing any photographs of the civilians. (Beirut, 1982)

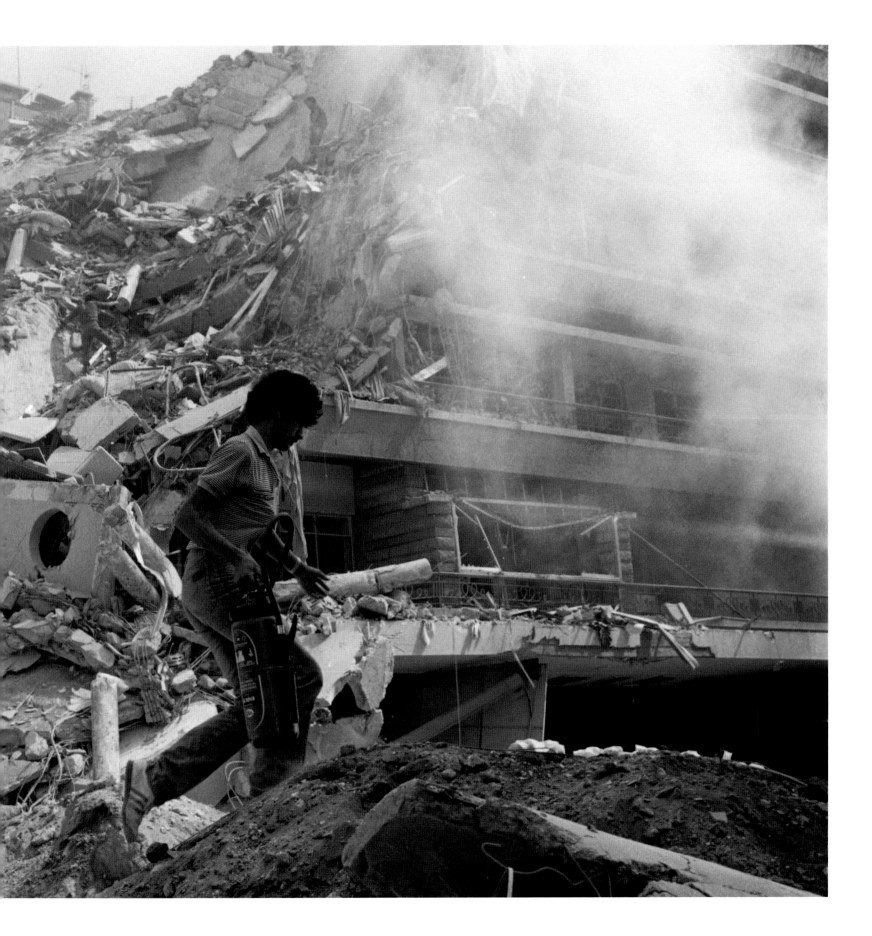

Don McCullin

Don McCullin was born in a working-class district of London in 1935. He left school at fifteen; his first experience with photography was during his National Service with the Royal Air Force, when he assisted in the printing of aerial reconnaissance photos. After returning to civilian life, he shot professionally for the Sunday newspaper *The Observer*, which gave him his first assignment in a combat zone when it sent him to Cyprus in 1964. Since then, he has covered many other areas for *The Observer* and the London *Sunday Times Magazine*, including Northern Ireland, Vietnam, Biafra, and Lebanon. McCullin has won the World Press Photo Award and the Warsaw Gold Medal and has twice been named Photographer of the Year. He lives in Somerset, England, where he photographs landscapes.

Bruised by War

People used to call me the war photographer, and they still do, but I find it really claustrophobic. It has a mercenary ring to it, and I'm not a mercenary. I went to war as a communicator, as somebody with a conscience. I'm not so sure that what I achieved meant anything to anybody, because wars are still raging and they're getting even more violent, but my intention was to discourage people from committing violations against other human beings. I picked up photography the way people pick up ice-skating or Rollerblading: Once I got upright, I thought, Right, I'm in photography now, here I go. It was exciting to suddenly get involved in a world of magic; I always thought that it was something I could dabble in and that I didn't have to be particularly bright. But in the end I realized that photography has statements to make. If you photograph someone being murdered in another country, that's a statement that definitely needs to be made.

Every time I went to war, I came back a little more damaged. I'm quite a resilient person, and I've got a lot of hardness

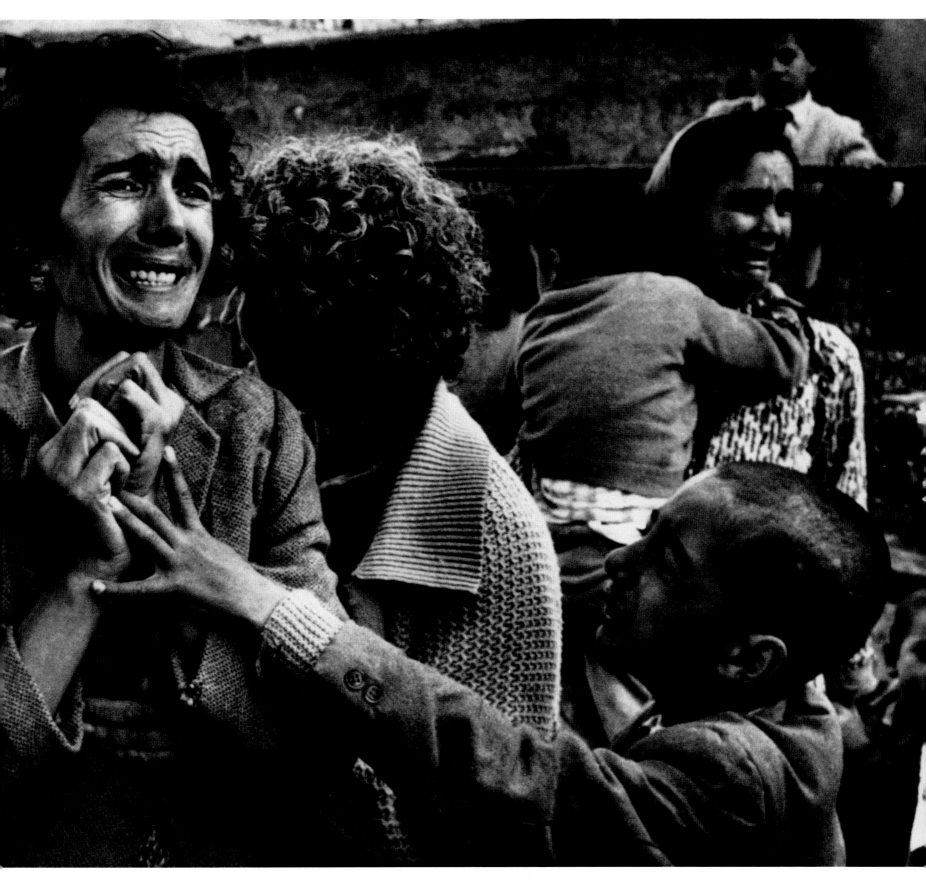

Widow and son, Cyprus, 1964

in me when called upon. But there's another side of me—not actually soft, but as if my nerve ends are hanging out. I met the photographer Eugene Smith once. When someone asked me what he was like, I replied that he was a man whose nerve ends were hanging out. I discovered later that I had become the same.

When I saw people suffering, I couldn't just press the button and walk away. I took a bit of that suffering away with me. I've always said that writers keep diaries; photographers keep negatives. All I need are the negatives correctly exposed. There's no point in getting killed if you don't get your exposures right and the last rolls of film they find on you are slightly underexposed. In battles, I'd stand up and take light readings because I used to be very contemptuous of the danger of war. It was like playing Russian roulette. I used to think, I'm going to take a chance here; the bastards won't get me, this is what I do for a living. It was a silly game I played. I've lost a lot of friends who didn't play those games. They used to take cover and shelter, and were scared.

Each war has different characteristics, and you have to tailor your thoughts and directions and movements according to how you best hope you can get through it. After a while you acquire certain rules and certain ways of dealing with each day as it comes. But at the end of that day, you're hoping that the big airplane that brought you in will take you home alive, even if slightly bruised, which you will be. Even if your flesh isn't bruised, you certainly will be mentally bruised by war.

Looking back on it now, I regret having been a war photographer. When I was very young, I was a big mouth, and I said once to somebody, "I'm going to be the best war photographer that ever was." It was such a stupid thing to say. I wish I could have distinguished myself the way Ansel Adams did by becoming the best landscape photographer that ever was. Now I'm being looked upon as a serious landscape photographer. And I will be.

I'm sixty-seven years of age this October, and I promise you, by the time I die, I hope I can eradicate most of the war photographer reputation. Now nothing gives me more pleasure than I had a few weeks ago—standing in a field for two hours freezing my bollocks off waiting for this wintry sky, which looked kind of like a chocolate bar melting as the sun came through, with crisp, powdery frosty snowy fields barely covered. I made three or four rolls of film. I was freezing to death, and I could not have been happier. But I was even happier when I processed the film. That was the supreme moment of excitement and joy in my life. And even when I don't achieve what I want in the pictures, nothing is taken away from that moment. I am a real photographer, and I love photography. I never want to be known as an artist or a war photographer. I'm neither. I'm the man and I'm the photographer. That's all I am. ■

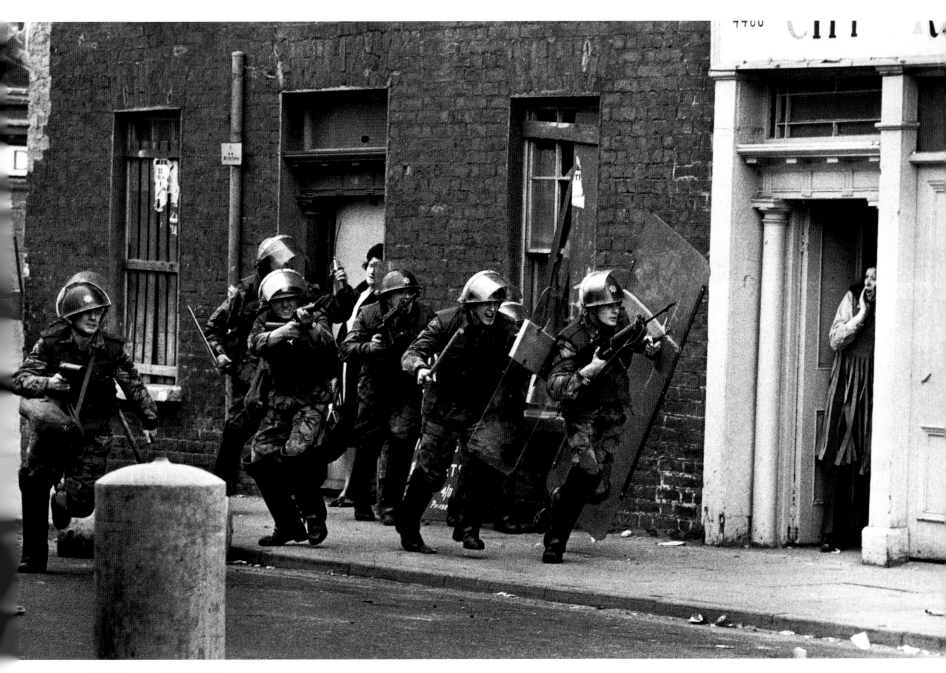

British troops, Belfast, 1970

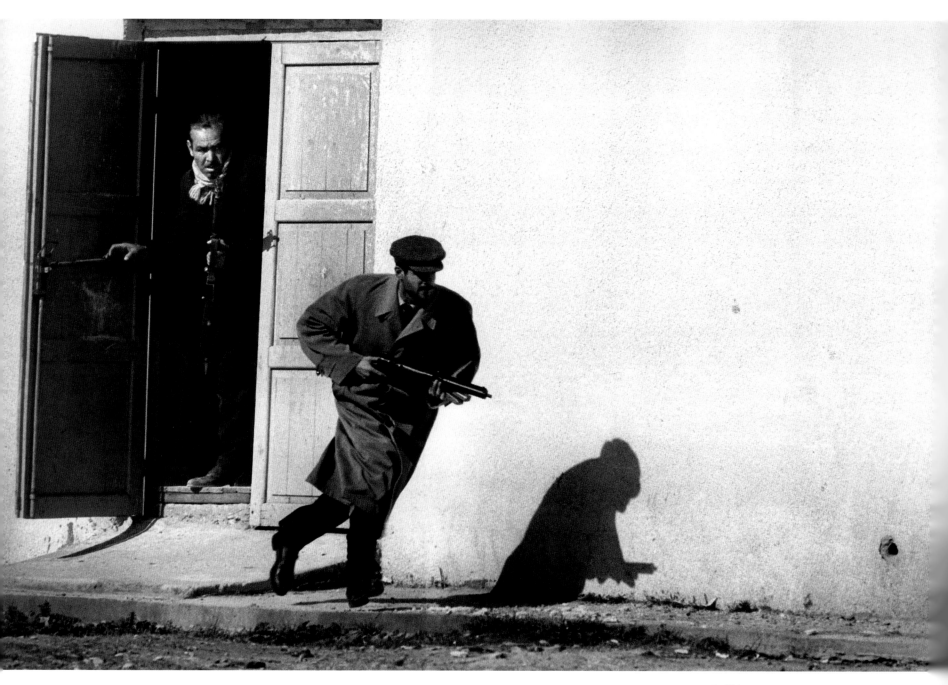

Turkish gunmen, Cyprus, 1964

Cyprus and the Ecclesiastical Correspondent

I had a contract with *The Observer* for fifteen guineas a week, and one day they said, "How do you feel about going to Cyprus?" Well, my feet never touched the ground after that. I was levitating with excitement, and my mind was running in all directions. I did the last six months of my national service with the Royal Air Force in Cyprus, so I was very familiar with the island. The next thing I knew I was on a plane going there. I went to a few village skirmishes, and then on to a place called Limassol, which was near my old air force base. When I got to the center of the town, a huge gun battle erupted. It was the first time that I had been in the middle of a serious firefight.

Oddly enough, the reporter I was with was the ecclesiastical correspondent for *The Observer*. He said to me, "I know this may sound strange to you, but I've got a dinner appointment in Nicosia tonight. I must get out of here." And I said, "Don't worry, Ivan, I'll get you out"—I was driving the car, you see. It was just like Evelyn Waugh's book *Scoop*—it was crazy. As we were going through the center of the town, I heard *brrrr, brrrr, brrrr* and I thought, Oh, shit, the exhaust has fallen off the car. The exhaust was okay, but I could see all these tracers coming in, and I said, "For fuck's sake, let's get out of here." I was swerving all over the road, but I managed to drive into an alleyway, where some Turks were crouching. They were armed with ancient Mark 3 Enfield rifles from the First World War and 9-mm Sten guns, which were pretty useless, good for only about thirty-five yards.

Once again Ivan reminded me about his dinner plans, so I drove him to an area of the town that hadn't come under the big part of the siege. Then I went back to the center of town and parked the car. The next thing I know I was jumped on by a whole load of Turkish irregulars, who said, "What are you doing here? Come with us." When I explained I was from *The Observer*, they said, "Okay, but you know the Greeks will attack very big tomorrow." By then it had got really dark, so I slept in the local jail for the night.

The next day the battle started in earnest. As far as equipment was concerned, I was in a muddle. I wasn't professionally kitted out, but I managed. I had a Novaflex lens that I'd bought from Larry Burrows. It was a 260-mm lens and I had it on a Pentax body, which Philip Jones Griffiths advised me to buy, and I had another Pentax, with a 35-mm lens on it. The battle raged for a day; then it calmed down and the Greeks backed off. The irony was that the RAF had organized a trip for all the press people to fly around the island from the air base in Akrotiri. I had decided not to go, because I wanted to go back to Limassol to see where I had been stationed a few years earlier, so I was the only photographer, or indeed any kind of newspaperman, there. And I had the whole battle to myself. To be honest, the experience was exhilarating. You can't really indulge yourself by talking like that when people are being killed and maimed, but for a young man—I was about twenty-four—it was exhilarating to be in what basically, if you bring it down to ground-floor level, looked like a bit of Hollywood. It was as if I was actually in a Hollywood film. ∎

Like Being in Hell

I went to Hue with the American Marines Fifth Battalion, but I got separated from them, so I had to wangle my way across the Perfumed River. The naval commander in charge of transporting the troops refused to let me across even though I looked like a marine and had all kinds of military accreditation cards—MACV cards. He said, "I don't give a damn; you are not going on these boats." I said to him, "So what does this card mean?" And he said, "It doesn't mean nothing to me." So I thought, Fuck you, and went down the river, because out of the corner of my eye I saw a whole load of Vietnamese rangers boarding amphibious craft. I did a big skirt-around, and I got on with them. As soon as I got to the other side, I found casualties. Snipers were wiping the marines down. I crawled up to a guy whose jaw was shattered. He had been hit in the face with a bullet, but he shook his head, dripping blood, because he didn't want to be photographed.

I walked away from that battle totally, totally insane. I had slept on the floor, on tables, near dead bodies. One day I went out of a building and there was a dead North Vietnamese soldier; another day there was a soldier who had been run over by a tank, so he looked like a Persian carpet. One day I found a naked Vietnamese foot, and I thought, This is like being in hell. I was having the most terrible nightmares, but what I didn't realize was that I wasn't sleeping, that I was actually living the nightmare. Every time we'd move an inch forward, if anyone moved—bang, a sniper would get him. It was extraordinary. I was filthy, I had a beard, and I looked about twenty-five years older. The pictures I took during this battle seem to gel well as a set because I was allowed for the very first time to be in the thick of combat, day in and day out. Normally, combat doesn't last very long. A firefight might last a couple of hours, maybe as little as ten or twenty minutes, but this battle went on for two weeks. It was like being in the Second World War.

A lot of the marines there used to call me sir, which I hated. I like to be called by my first name, Don. They'd say, "Excuse me, sir, do you have a weapon? Would you care for a weapon?" And I'd say, "No, I've got a weapon. I've got my camera." They'd laugh, but they'd think, This guy's crazy. I know it sounds a sort of daft thing to say, when there are thousands of rounds of ammunition flying around, but the fact is I felt a certain amount of trust in my cameras. I also put my faith in God, even though I've always had a tendency to be an atheist. My father died when I was fourteen and he was forty. I worshipped him. After he died, I thought, Forget God. But the irony, and the hypocrisy, was that I turned to God whenever I was in a really tight situation and shit was coming and it was getting hairy. I was in Cambodia one time and my camera got hit with a bullet. I was up to my neck in a slimy paddy with my cameras on the edge of the paddy field. I had gone there with a probing unit of ten men, and they all got chopped. I got behind the radio operator because I thought the radio would protect my head. And I'd say, "Please, God, give me another chance. Save me." ■

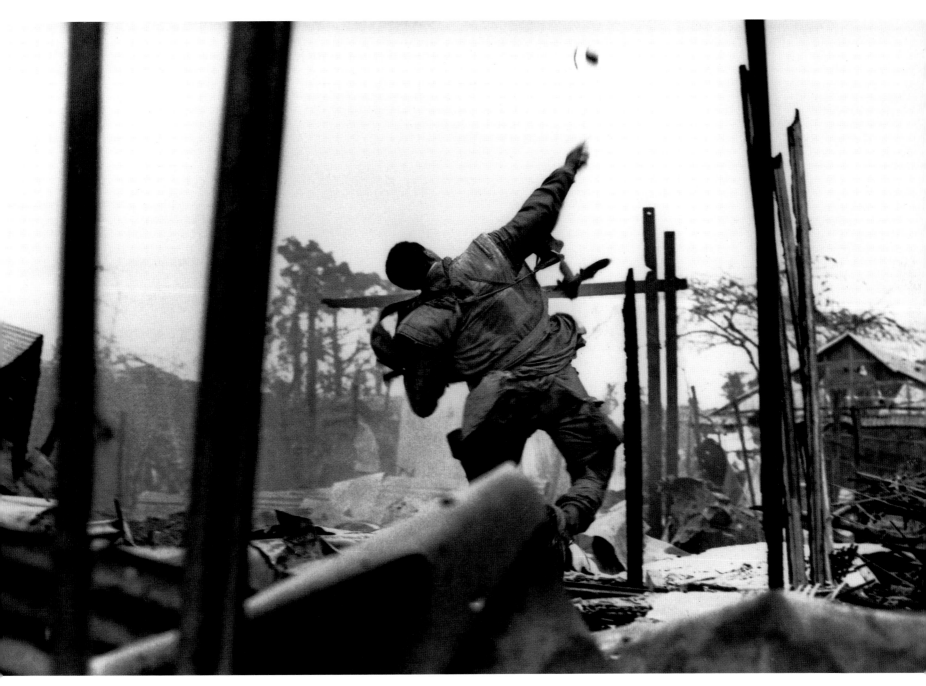

U.S. Marine, Hue, 1968

Do You Ever Help Anybody?

I've been asked every question in the world when I've given talks, but the number one question that comes up all the time is: Do you ever help anybody? My answer is that although I don't consider photographing helping, what else can I do? I'm not a qualified person; if I was, I wouldn't be there as a photographer, would I? I once carried a soldier on my back from the front. He had this horrible leg wound—a bullet went through both his legs. Another time I had crawled over to where a marine had fallen. All the muscle was hanging out off his bone. I put it back and bandaged it, and I helped to drag him away. Now that's not my job, but the trouble is that one becomes a humanitarian. All of a sudden you put your cameras down and you become a human being, and you say, "I can't photograph people dying without trying to do something." So I have carried a soldier on my back, and I have taken children to hospitals, but it often causes confusion. In Bangladesh I got an injured child on a rickshaw, but then he got separated from his mother. It caused so much bloody concern and pandemonium. Sometimes helping can cause bigger trouble. If you don't have the medical ability, what can you offer anybody?

Wounded U.S. Marine, Battle of Hue, 1968

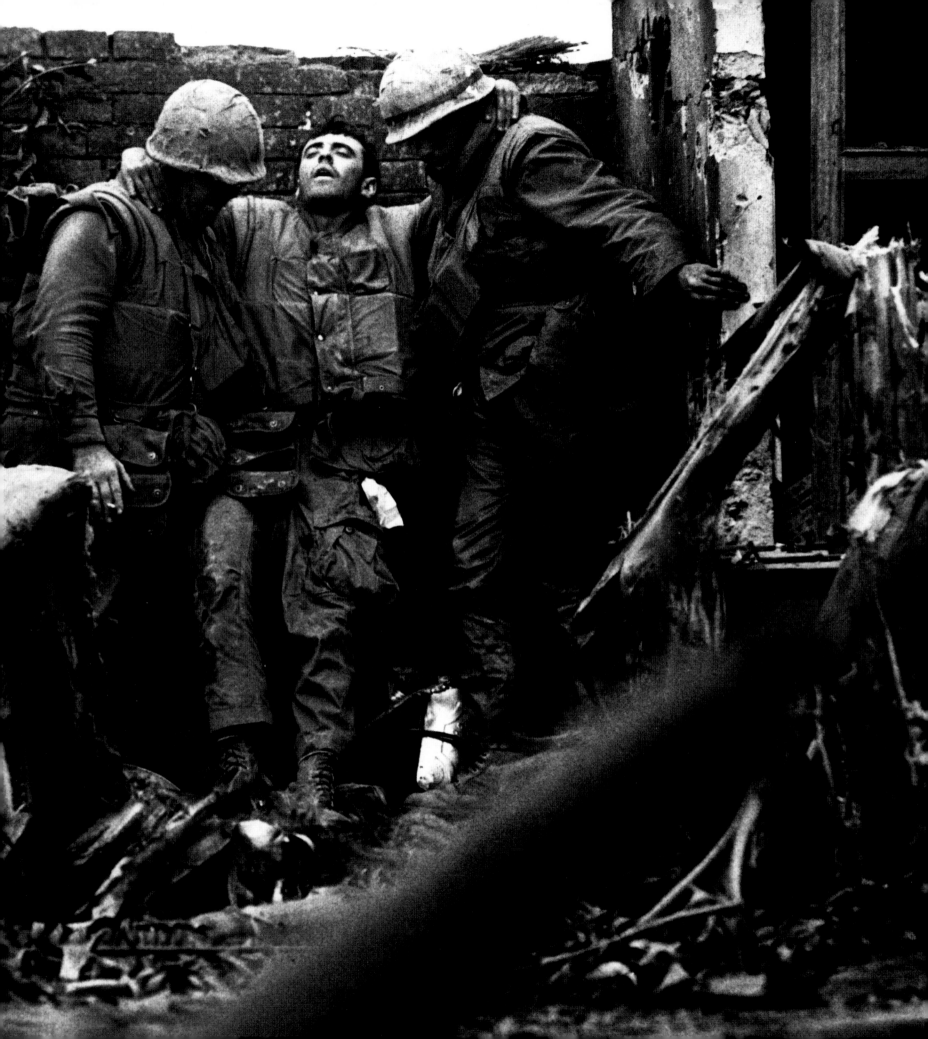

Dead Soldiers Can't Speak

I arranged the composition of this picture. I saw two soldiers plundering the body for souvenirs. They kept laughing at the photographs in his wallet and throwing them on the ground and calling him gook this and gook that and motherfucker, and then they wandered off. Normally they would have taken his belt, but in this case they didn't. I watched them leave, and I thought, This isn't right. Here was a young boy with a bullet through his mouth that had busted the whole of the back of his skull out, and he's lying in the rain. He had a picture of his mother and a young woman, a sister or daughter, and his little first-aid tin, which would hardly suffice for any bullet wound, let alone one in the head.

I've never denied the fact that I arranged the photo. I felt I was making a statement on behalf of this boy. Dead soldiers can't speak anymore, but I can speak for them. I didn't think that what I did was a crime or taking a big liberty. I wanted to show compassion for this man's sacrifice for his country. I wanted to get him and his possessions all in the same frame, so I had to compose it as an upright. In a way, though, I felt that just touching his personal effects was a violation.

Another time, just outside Da Nang, I was in a small firefight. The GIs I was with killed a man, then started pissing near him and throwing all his stuff away. They found his diary and were laughing over it, so I asked if I could have it. I brought it back to England, and we got a Vietnamese from Paris to translate it. It was published in *The Sunday Times* on the condition that it go back to the North Vietnamese legation in Paris, which would then forward it to the soldier's parents. I had nothing but the utmost respect for the North Vietnamese Army. Whereas the Americans were flying in with all this might, the North Vietnamese carried everything on their backs. When you saw how determined they were, you had to give them your respect.

These two little acts of mine were tricky, but they were done in the nicest way, with the nicest intentions. They still make me a bit queasy, but I hope they don't make me a violator. I have a conscience about photographing these people, intruding on their grief, walking away with images of their grief. Don't think it's been easy to live with that, because it hasn't. ■

During the Tet offensive, Hue, 1968

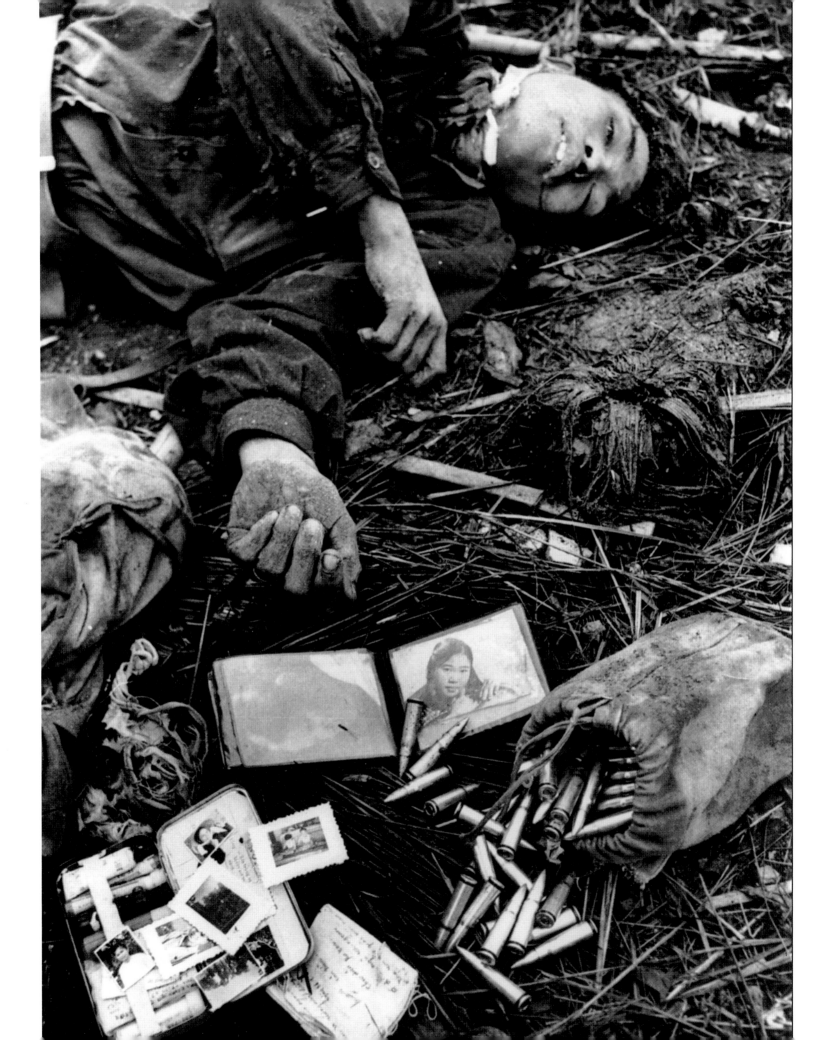

Taking Hollywood Out of War

I wasn't allowed to go to the Falklands. I'd built up such a reputation as a war photographer, or antiwar photographer maybe, that I was struck off the list of the British Ministry of Defence. What I've always tried to do is to de-Hollywoodize war. When I was a young kid after the Second World War, I grew up on a diet of Hollywood war films, like *Back to Bataan* and *Iwo Jima* and crap like that. Recently, I worked on the film *Black Hawk Down*, which I never thought would get released, because it's the story about the loss of Americans in Mogadishu. The film is about them going to the wrong house and the whole of Mogadishu turning on them and shooting down two $40 million helicopters. But they did release the movie, and people raved about it. That doesn't make me feel totally happy, because to me it's still about war, and it means we're elevating war into a glamorous kind of action.

War's not glamorous. It's total madness, it's evil, and it's a crime. If you're a sports photographer and you take great pictures of Muhammad Ali knocking someone out with his opponent's sweat flying through the air, it's glamorizing violence, isn't it? Isn't war photography also glamorizing violence, to some degree?

The only positive thing about photographing war is turning it into something negative. You show the negativity of dying children. What contribution can a dying child make to a political situation? War murders the innocent; they're the last people to be told when war's coming. Who are the refugees on the roads? It's always the peasants. We need to be informed about war. Don't you think it would have been convenient for Hitler to not have anyone find out about the Holocaust? But if people like George Rodger and Margaret Bourke White hadn't walked into Bergen-Belsen and photographed what happened there, we might have believed what this English professor David Irving said about it all being a big Zionist plot. Instead we know that he's talking out the back of his ass. ∎

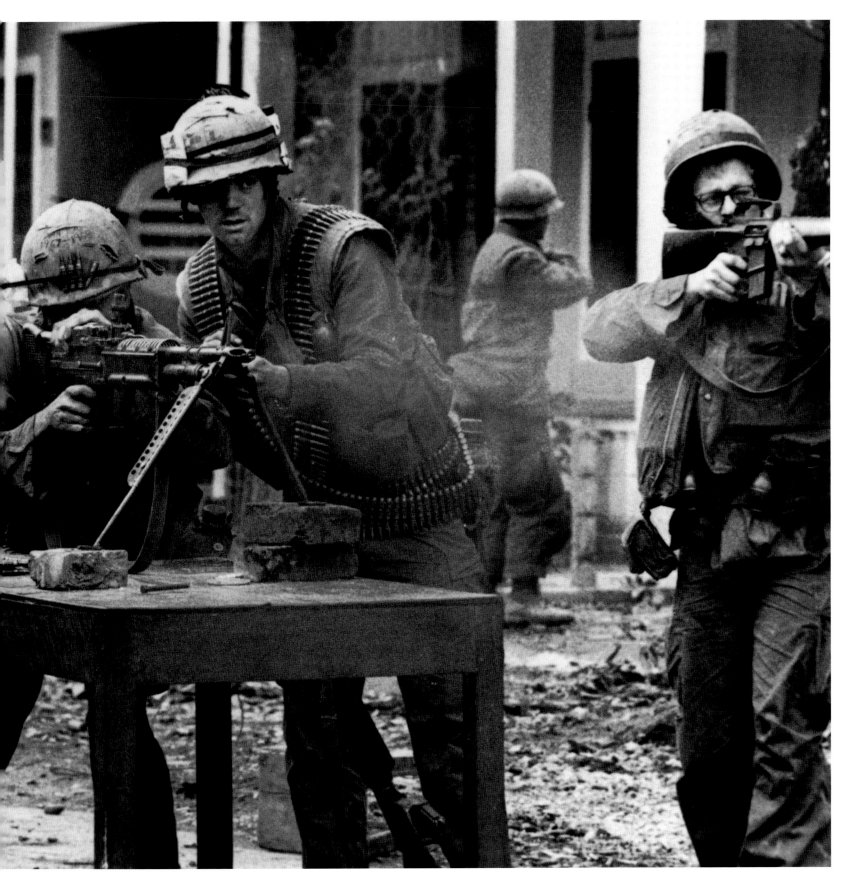

Battle of Hue, 1968

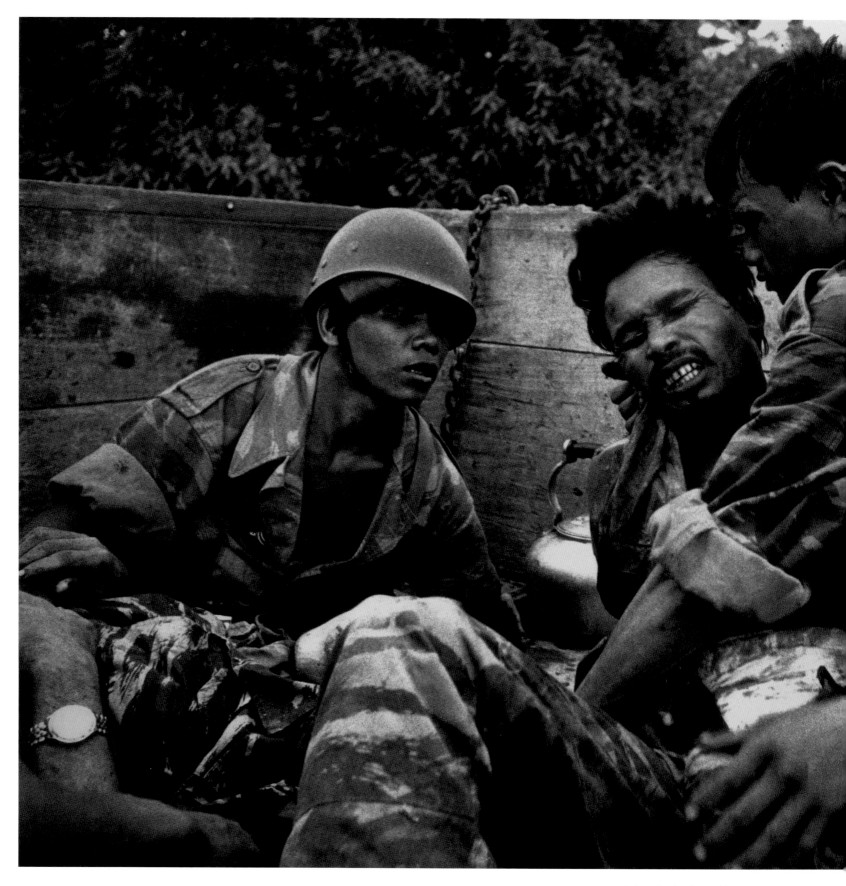

Dying Cambodian soldier, 1970

Keep Shooting

I was wounded on the outskirts of Phnom Penh. It wasn't the final battle for the city, but the Khmer Rouge were always very near, always probing for weak spots and making sure the government knew they were there. I was working with John Swain from *The Sunday Times*, and he had said, "Look, I'll take you to a place where they say there's a lot of tension, but I've got to go to a press conference. When it's over, I'll come back and get you." Well, he did come back to get me, but by then I had walked into a night ambush, and I was in the back of a truck with a whole load of wounded soldiers.

Until I got wounded, I thought I could do anything. To see my own blood coming out of my crotch and my legs, and to feel the pain of burning metal in my legs—and I was deaf as well because my eardrum was blown out—was good for me in a way. Lying in the truck, I knew for the first time what shock was like. But then I thought, Well, shit, I should be shooting pictures. So I got my cameras out and started photographing while the truck was filling up with more wounded. Then the truck itself started getting shelled, but I still kept taking pictures. Forget about yourself, I thought, you've only got leg injuries, that's nothing, keep shooting. I was lying on the floor next to this guy, and as he was dying, he kicked my legs, so I sat myself up to bring them out of the way. He had gotten hit by the same mortar bomb that hit me, but he was right in front of it while I was behind a jeep, which protected me. What hit me came under the vehicle, because I was kneeling down waiting to go forward with him. So it was him that died, not me. ∎

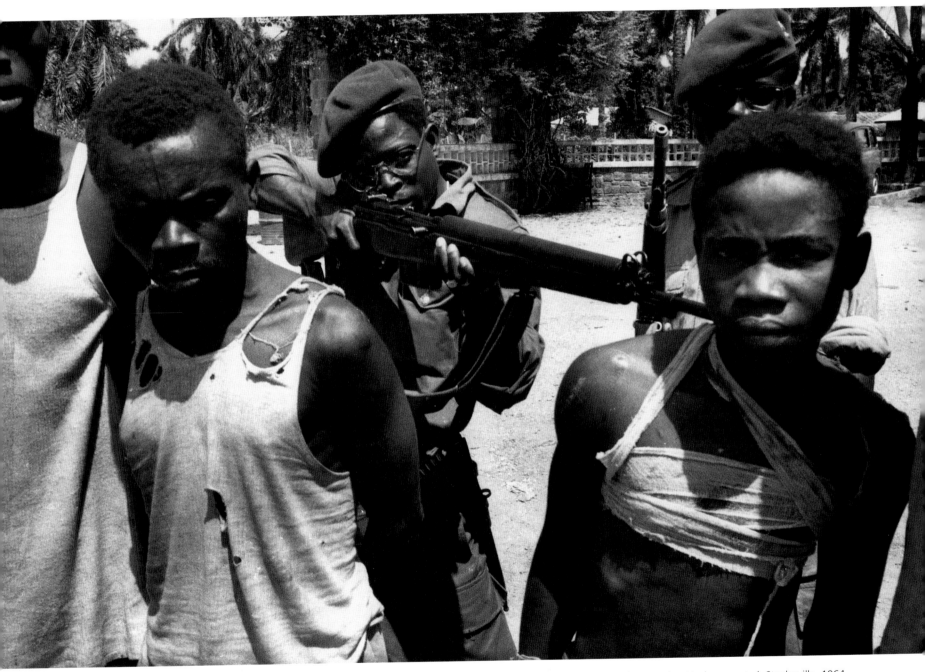

Congolese prisoners about to be executed, Stanleyville, 1964

Young Men Going to War

Within a year of my baptism of war, I was going here, there, and everywhere—the Belgian Congo, Vietnam—but I never ever took into account the morality of any of it. All I kept thinking about was me, about elevating my position in photography and looking for future opportunities. I think many young photographers these days are channeling themselves in that direction, thinking that photographing wars is the way to get recognition. Initially, war came to me at the age of about five and a half. The urban landscape I knew as a child was destroyed on a massive scale during London's bombing. My father used to go around digging people out. Then I went to war, and I photographed other people's wars, but when I came away from them I needed to rehabilitate myself. I don't believe you can go to war as a photographer without some compassion in you. And if you do, you're not going for the right reasons. When I was young, I was going for the wrong reasons. Well, I got over that. ∎

The Value of Being Alone

I used to try and get away from the mob, because if you're part of them, how are you going to take anything that's different? How are you going to attach any dignity to what you're trying to bring out of it? In the Six-Day War, I was on my own in the Battle of Jerusalem because everyone else went to the Sinai. The sweeping gains that the Israelis made there were pretty overwhelming. But the most important place to be was in the Battle of Jerusalem, the holiest of battles for them, and I was the only one there.

When you're on your own, you don't have to look over your shoulder at all these assholes, pushing and shoving and swearing and kicking each other, so I like to work totally alone. I think in a way being alone made it a lot easier for me. It's always beneficial to a man's work. Do you think a writer wants to sit in a room in a newspaper office trying to do a really great piece surrounded by a thousand other people? No, great writers get up at six-thirty in the morning and get a cup of tea and then work, and great photographers like Ansel Adams are alone. They may have an assistant, because as you get older it's nice to have someone carry your cameras, especially if you're in the Sierras with four hundred pounds of gear. But yes, I do prefer to be on my own. I like being alone in my darkroom while I play classical music. I have a mirror in there just in case I get lonely. ∎

To Biafra on the Ammunition Plane

Biafra was basically a connivance by the Igbo tribe to break away and become independent from Nigeria because they were sitting on all the oil. But the federal government wasn't going to allow that, and it had much greater military might in equipment and endless ammunition and so on, so it basically shrank Biafran territory down to an enclave where all that was left was a ragtag army of starving soldiers and several hundred thousand starving women and children. To get there, you flew in from Lisbon on planes loaded with ammunition. You flew out on the same planes loaded with raw rubber, gagging all the way home.

Death by starvation is possibly the most lingering of deaths, and to look into the eyes of eight- or nine-year-old children, sometimes even younger, dying of starvation, with their anuses collapsed out of their bodies and flies on this thing hanging out of them—when you walk away from that and you go back to your home life in England and your perfectly healthy children refusing their lunch, then you're in some kind of confusion and doubt about humanity, and about yourself.

The difficulty of photographing scenes like this is that it calls into question your commitment. What can I achieve by taking pictures of starving children? What kind of a risk am I taking here? What am I giving back here? I'm taking, but I'm not giving. If you photograph a person who's dying, you're not going to save that person's life, and you start having all these things go through your head that could wind up sending you mad. I took a photograph of an albino boy there. I photographed him and just walked away, but he followed me and held on to my hand. Every time I'm in the darkroom and that image comes up through the developer, it's a haunting experience. I rarely print that picture. That boy and many people in those images did not survive, and you say, How can I justify this? But how can I not do it? You're trapped in a no-win situation. You want to go out there and bring attention to what's happening so that others might be saved. But you're not going to save that boy, so whatever your achievements are, however small or large they may be, you still walk away with a slight crime on your hands. ∎

Biafra, 1968

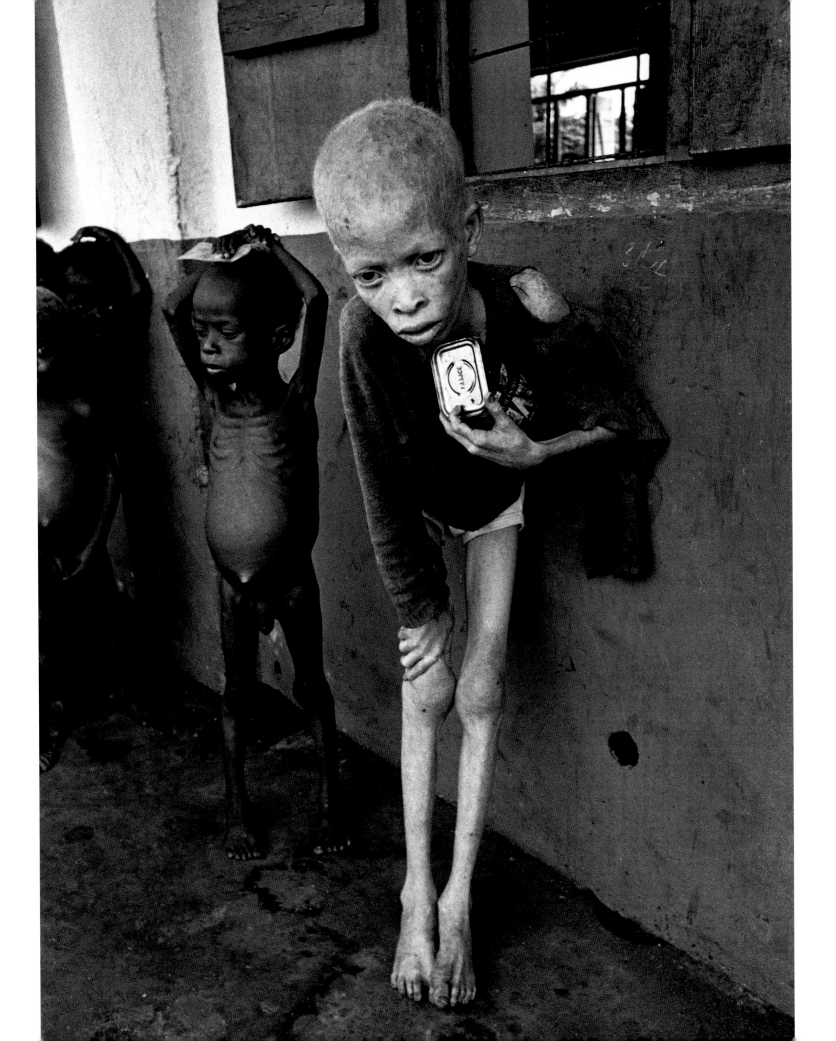

"DONALD, ARE THE TROOPS MOVING FORWARD?"

I think the name of the man in this picture was Captain Peter
Asadave. He was wearing Wellington boots while he was
lecturing a corpse and saying to me, "You see, Donald, this
man is a son of Biafra, and he's given his life. I'm talking to
this man because he has given his life." The man had a huge
bullet hole that ripped his throat out. I thought that Peter
was mad, but when I looked at him, I realized that he was
battle-fatigued. A few minutes after that picture was taken,
he took a bullet in his leg. He was dragged into a house
and given a shot of morphine. He was in a lot of pain, but he
said to me, "Donald, are the troops moving forward? Go
out and move the men forward. We must keep pushing
forward." Well, the troops were basically about two or three
hundred ragtag guys with no shoes or socks and with
their arses hanging out of their trousers. The dead man has
socks on, but there are huge holes in them, and I think
someone must have stolen his shoes. That would be natural,
because clothes were at as great a premium as food.

I stood outside the hut for a few minutes, and then
went back in. The captain asked me if the troops were
moving, and I said, "Yeah, they're moving forward, Peter.
Now just calm down and take it easy before they take you
away." I think almost anything goes in war, and during
these moments men are sometimes momentarily affected
by a total madness. (Biafra, 1968)

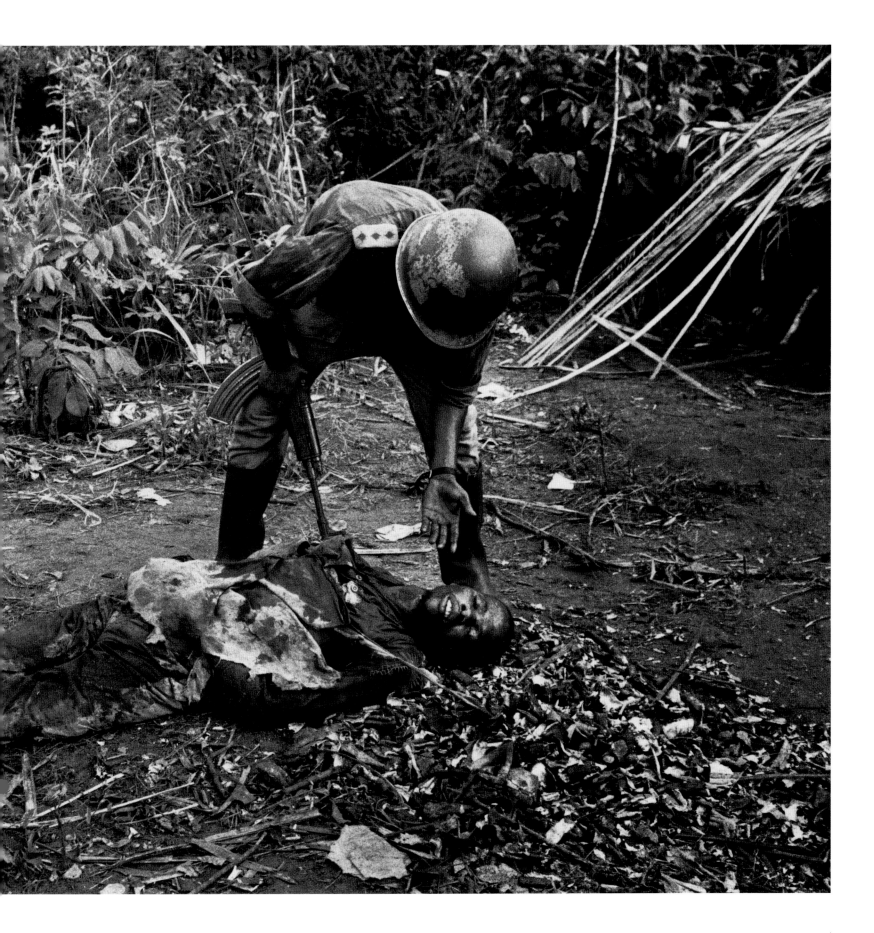

Who Are You?
Where Have You Been?

A woman viciously attacked me in Beirut. She came around a corner screaming because she'd seen an apartment building brought down with someone she knew in it, and I had taken her picture. She was so enraged that she had to beat me. Arabs often smack themselves because they want to beat something or somebody, and they have power when they're in that rage, so she laid into me. I went back to the hotel and I was in a pretty shaken state, having a cup of coffee, when somebody came in and said, "Hey, you know that woman? She's just been killed. Another car bomb just wiped her away."

How do you get through something like that? Who are you? I shall probably go to my maker saying to myself, Who are you? Where have you been? My wife died on my son's wedding day a few years ago. I found my own wife dead in bed, and if somebody had come in and started shooting pictures, I'd have kicked him down the stairs, wouldn't I? How did I get away with it? That's the question I ask myself. It takes great gasps of air from my lungs to talk like this and explain these things to you, because I am really a very emotional person. When I go out now and photograph an English landscape within a stone's throw of my house, I stand there and say, "Enjoy this, because there are no bills to pay anymore." When I do a landscape, there is no grief; there is no accusation; there is no crime that I'm perpetrating or being involved in. In fact it's the opposite. I'm redeeming myself in some way. At least I hope I am. ■

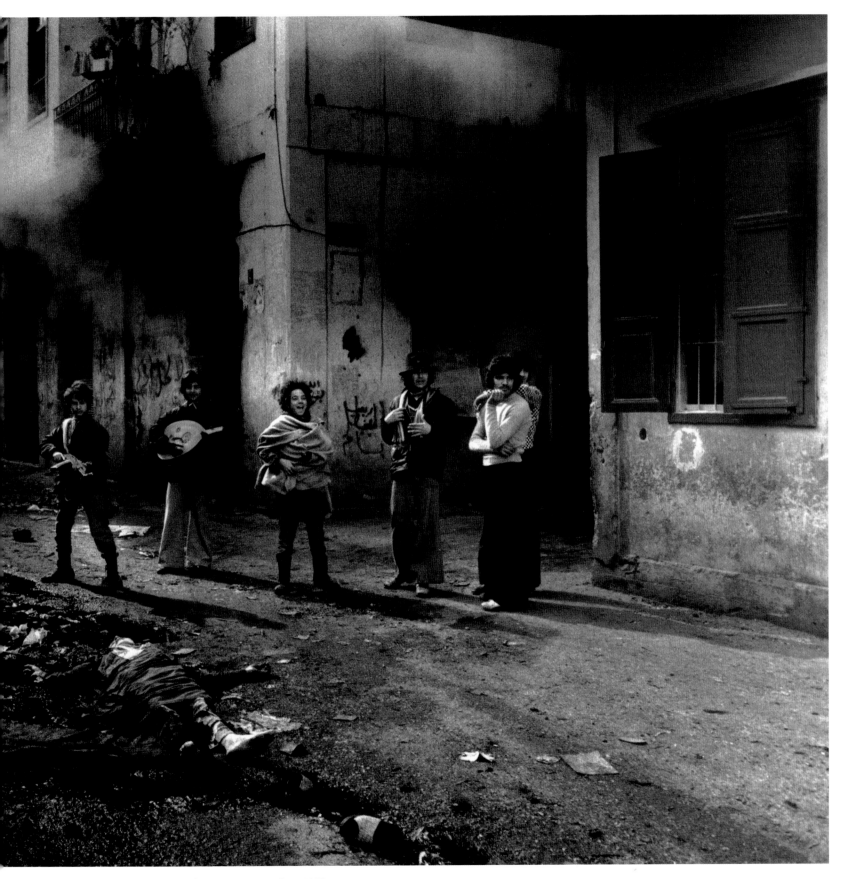

Phalangists serenading Palestinian corpse, Beirut, 1967

Susan Meiselas

Born in Baltimore in 1948, Susan Meiselas graduated from Harvard with an M.A. in visual education. She started several workshops and film and photography programs ranging from the South Bronx to the rural South. She joined the photography cooperative Magnum in 1976. Her coverage of the civil wars in Nicaragua and El Salvador was widely published in magazines such as *The New York Times Magazine*, *Life*, and *Paris Match*, and she was awarded the Robert Capa Gold Medal for her work in Central America. She was also honored with the Leica Medal of Excellence, a MacArthur Fellowship, and the Hasselblad Prize. She recently completed a six-year visual history of Kurdistan as well as a Website on this subject. She lives in New York City.

Get In, Get It, and Get Out

I became interested in Nicaragua because I had read about the assassination of Chamorro, the opposition newspaper editor, and the fact that the United States had had a role in supporting the Somoza regime. At the time it wasn't a war, just an evolving civil conflict. The bourgeoisie was quite involved, as were the kids of the upper class, and that was kind of intriguing to me. When I got there, it was a place where something seemed to be happening but you couldn't see it. Small incidents would occur, like a university protest that would suddenly be gassed. But things were building slowly, so I could find my own rhythm of working there. I like knowing where I am and kind of moving with the history of a place, versus landing in the midst of it. I had enough time to get a feeling for the different districts and different towns, and which neighborhoods were more rebellious. If you come into a society that's already in strife, you don't get an independent reading of what's going on.

I went back to *Time* magazine after I'd been there five or six weeks and showed them the photographs. I told them that it was just a matter of time before the place exploded. And

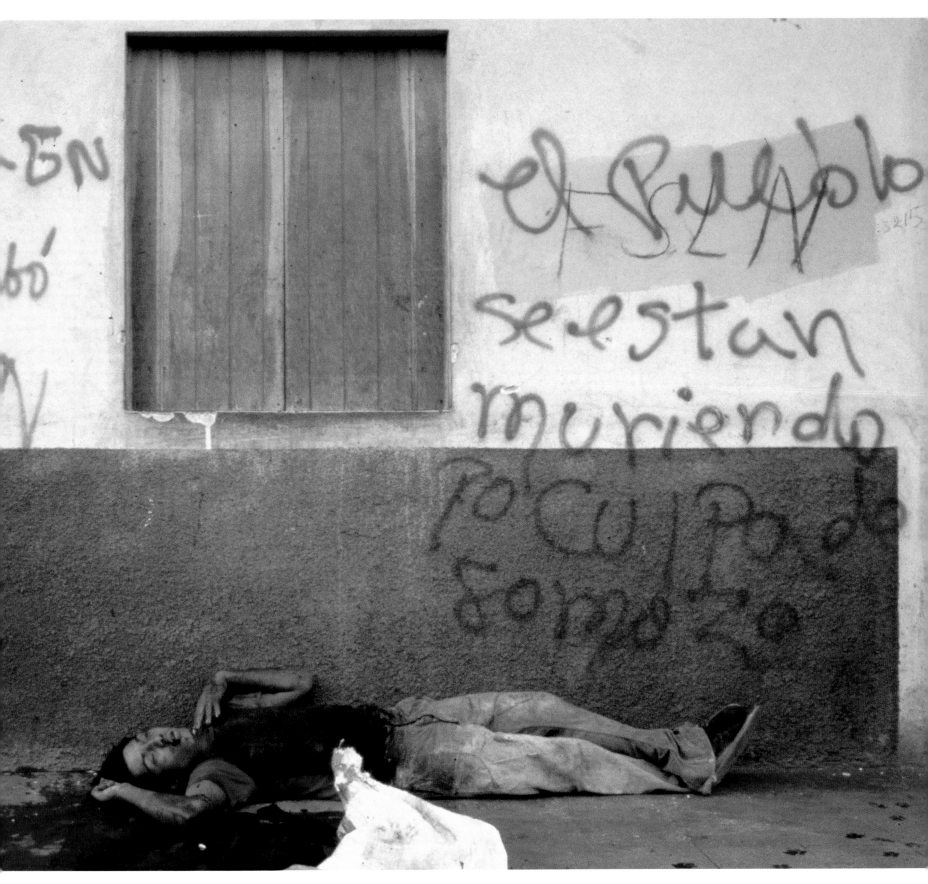

Young boy killed in fighting, Nicaragua, 1981

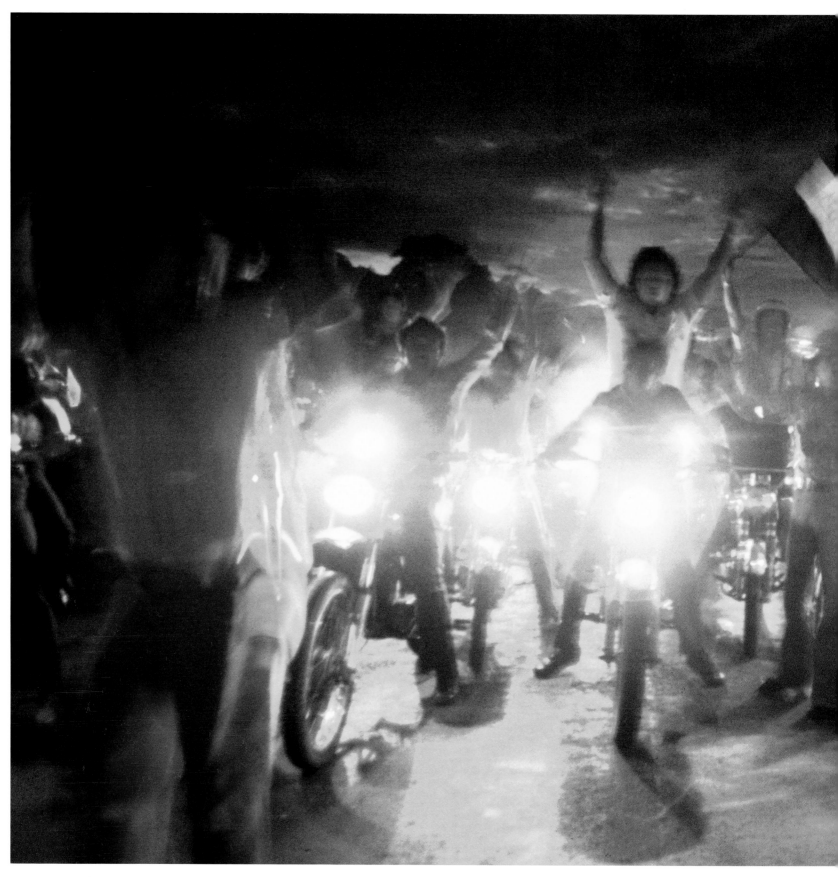

Motorcycle brigade, Monimbo, Nicaragua, 1978

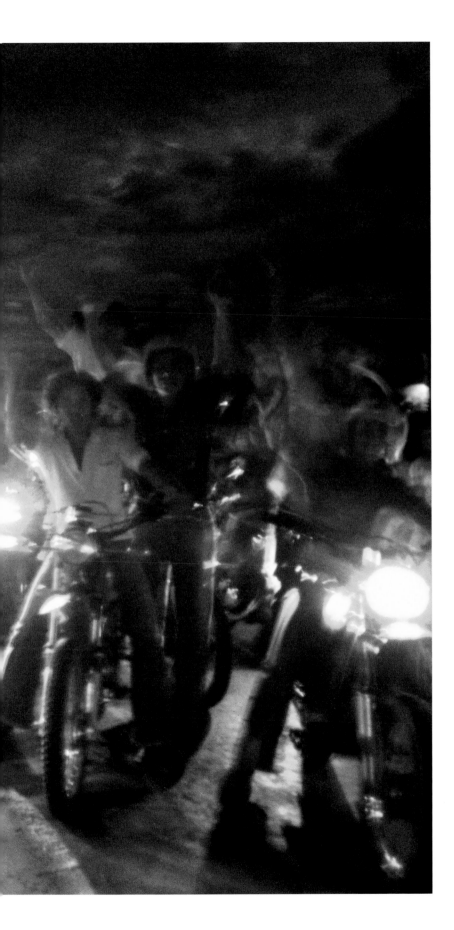

they said, "Well, that's interesting." All I was trying to do was to get them to give me film and send me back, because at that point I'd done all the work on my own, without any support. And then the Palacio Internationale was taken, and I returned to the middle of an insurrection.

Now everybody began to come in, TV in particular. Photographers had to hit the ground, figure out what was happening, get as much as they could in as short a time as possible, and get out. The big difference where I was concerned was that I was committed to staying as long as I could.

The hardest question for me after the first insurrection ended was, Now what? The news crews had gone home, so was it over? How long do you wait? These are critical judgments. Sometimes you can make them yourself, and sometimes someone else is making them from afar, saying, "No, that's enough, thanks, now let's just move you on." That's pretty much what Magnum said: "We've got what we need, we don't need more Nicaragua." That's symptomatic of the way we're supposed to work in an industry that's really interested only in the high dramatic moments and not the everyday life. The pressures on a photographer are to get in there and get the epitome of the event, not how it evolved.

I don't have any doubt that what propels you into these powerful situations is the feeling that whatever you're bringing home is evidence of something of tremendous significance. There are a lot of ways in which the pictures from Central America mattered. People found out about Nicaragua and El Salvador. People who went to Nicaragua, to participate and to contribute, have told me how seeing my work made them want to do something. To the Nicaraguans, it's a document of their history that they value. They now have an Instituto de Fotografía; young people studying there want to know how the pictures were made and what was happening. I'm one of the people who can tell them those stories. And yet ultimately, I think the harder thing to do is to make something that is less dramatic as important. That's a very great challenge. ■

THE BODY IN THE LANDSCAPE

My method of working at this time was very simple. I
used to get in the car as early in the morning as I could
and just drive, looking for things that seemed unusual.
One day I was driving up a hill on the outskirts of Managua
when I smelled something. It was a very steep hill, and
as I got closer to the top the odor overwhelmed me. I
looked out and saw a body, and stopped to photograph it.
To see somebody who has disappeared is different from
hearing about it. I don't know how long it had been there,
but long enough for the vultures to have eaten half of it,
and certainly long enough for a tremendous stench.
I shot two frames, I think, one in color and one in black
and white, then got out—to be caught hanging around
there would not be a good thing. I was terrified that
somebody would see me making the photograph and that
this could implicate me in some way.

 This is a difficult image for a reader sitting in North
America—what do they know about this kind of violence?
And yet it's so quiet. I think that if it's a powerful image,
it's partly because of the contrast with the beauty of
the landscape. You come into this fabulous countryside,
then suddenly you're faced with half a body, and you can't
quite believe that's what you're looking at. You don't
understand how it got to be that way, and hopefully that
provokes you to ask questions. For me it was the link
to understanding why the people of Nicaragua were so
enraged. (Cuesta del Plomo, Nicaragua, 1981)

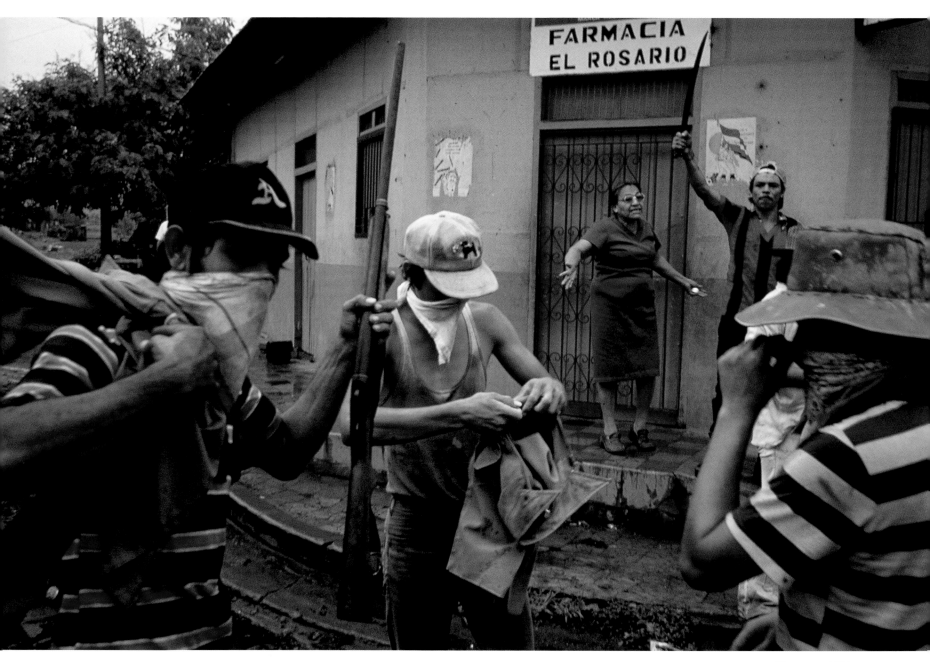

Nicaragua, 1981

The People Who Stayed

What do you do about the civilians—the refugees, the people who are watching, the people who are most impacted by the war that surrounds them, in which they're not necessarily participants? I was first drawn to the people who were active rather than the passive ones in the refugee camps—to the people who stayed versus the people who fled. So these little moments become tremendously important alongside the out-and-out fighting. I remember this image of a bourgeois family bringing food to the boys at the barricade because it really surprised me that they would want to be involved. But it reveals a lot about the social relationships at the time.

The opposite response is seen in the picture on the left. The muchachos had taken over a neighborhood in Managua and were in the process of putting on captured National Guard uniforms. The woman, afraid that the guerrillas would commandeer her pharmacy, was trying to protect her livelihood.

In the photo of the bus, the passengers are being searched and interrogated about any possible connection to the Sandinistas. The soldiers are looking for evidence—a sock mark that shows they were wearing boots, something in their pockets, messages being passed—of hidden war. It's not that different from what the FBI is faced with today: How do you figure out who the terrorists really are? How do you find the cell? There are the protagonists who reveal themselves and this undercurrent of those who remain out of sight. ■

Nicaragua, 1979 (photos above)

Anti-Somoza insurrection, Nicaragua, 1978

The Struggle for Independence

At the beginning of the uprising in Nicaragua, I didn't know the participants as Sandinistas; they were simply these muchachos, these teenagers, who put handkerchiefs over their faces and took over the streets. The first phase of the insurrection was everybody suddenly participating in this fight against Somoza. It wasn't about the National Guard, it was only about Somoza. El Salvador was more of a civil war, where you felt a division between the people who were in the army, representing the interests of those in power, and the people fighting them. In Nicaragua, it was the people who took over the streets who then became the Frente, the Sandinistas, and finally became the power that was in place for ten years. There was a lot of optimism about transforming the country, changing the history of fifty years under Somoza into a new society, and there was a lot of optimism that that would be possible.

I wasn't trusted as an American in either Nicaragua or El Salvador because America had basically helped to pay for and keep in power those regimes that were hated. You weren't seen as independent media, you were seen as representing those interests, and a lot of people didn't understand the difference. At the time, our biggest challenge was to be seen as independent from the government and government policy, which in El Salvador in particular was entrenched with the military. It was complicated by the fact that we covered both sides of the conflict. In Vietnam, you either worked with the Americans or the North Vietnamese. In Central America, we crossed these lines, and a lot of the time we were in territory that was a sort of no-man's-land. ∎

Wounded While Using Good Judgment

Suchitoto is a tiny little town on the other side of a lake, not that far from San Salvador. We heard that it had been taken, and a group of us decided to go. It was about five in the morning, and three of us—Ian Mates, a South African cameraman; photographer John Hoagland; and I—took off. We had figured out a way in that was behind and off the main highway, and we thought that we were being really clever. We were driving down this little dirt road slowly, cautiously, with our TV markers on the car, when suddenly a mine exploded. Ian was driving, I was in the passenger seat, and John was in the back.

The day was hot and humid, as it nearly always was, and it was hard to know how long it was between the explosion and our rescue. I remember everything in stages. The mine was on my side of the car, but the bulk of whatever was in it passed by me and lodged in Ian's spine and the back of his neck. The shrapnel made a deep cut above my eye and in my neck, and I went out cold. When I came to, which may have been only a couple of minutes later, Ian was trying to get the hood of the car up to figure out how to restart the motor; the mine had obviously wrecked the engine as well. He must have had some kind of delayed reaction, because within a few minutes he collapsed on the side of the road. He died within twenty-four hours.

The flying metal had only cut two of John's fingers. He was in the best condition, so he went off to get help, to call a local ambulance. It seemed like a long time, maybe two hours, before anyone arrived. I could feel the hole in my head and thought that my face had been blown off. It was quite surreal. When we finally got to the hospital in San Salvador,

the whole press corps was there, peering over the stretchers. It was strange to be on the other side of those lenses.

I remember very clearly thinking that we had been cautious and used good judgment and still this happened. A mine is very different from being in the middle of a battle, where you watch where the tanks are and see the bombers above you. Mines can be anywhere, and you can get very paranoid very quickly when you start to anticipate them around every corner.

John and I were evacuated out of El Salvador, which really enraged me. I was committed to documenting this region, to doing whatever I could do. When I recovered from my wounds and returned, it wasn't so much that I was scared but that I suffered from a great deal of anxiety following this incident. Soon after, a good friend, Olivier Rebbot, was killed, and John died in a crossfire a few months later. One event just seemed to spill into the next. At this point El Salvador became very real for me. Although the mine was the closest that I had experienced such danger, there were other incidents, such as when a grenade landed right in front of me and somehow didn't explode. I remember both how remarkable that was and also the terror connected with it.

I think the camera gives you an illusion of protection. It's sort of a false shield that makes you think that you can see the world but that the world can't see you. But all that changed after I was blown up by that mine. I couldn't work; it took me a couple of months to get back to feeling comfortable and connected again, to continue to do what I wanted to do. I also chose to be in a different kind of setting, and that's when I went to Argentina and did some work about the *desaparecidos*. ∎

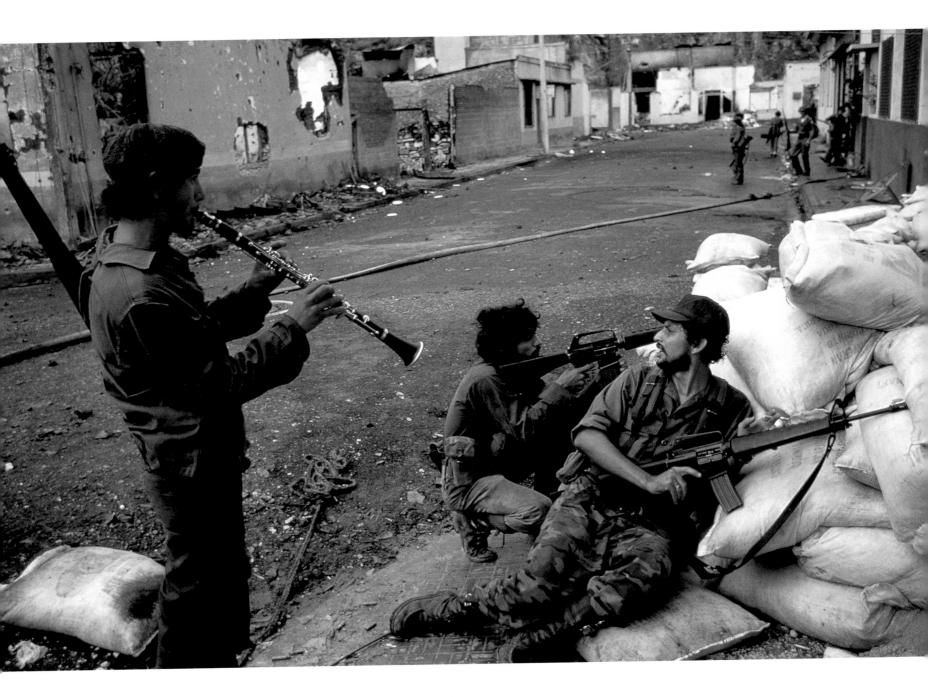

THE CLARINETIST BEHIND THE BARRICADE

This is in Matagalpa during the last offensive. What's deceptive about the photograph is that there's a wall just to the right of the sandbag barricade, so I'm actually protected by both the barricade and a part of the wall, as is the clarinetist. The National Guard is fighting back, which is why the other two men are calling out to each other and trying to figure out what to do. The army had retreated to the cathedral, which gave them a vantage point and a powerful position against the guerrillas. The guy with the clarinet found the army band's instruments at their abandoned headquarters. He decided that the war was almost all over, so he was sort of celebrating. He was right; it was the turning point. But one of the men behind the sandbags was Biardelarte, one of the nine *comandantes* of the Frente. He was still frantically worried about the guardsmen in the cathedral. I think this photo captured exactly the dilemma of a war winding down. Somoza had left the country, but there was still fighting. It was a question of how long this was going to dribble on. Eventually they surrendered. (Nicaragua, 1979)

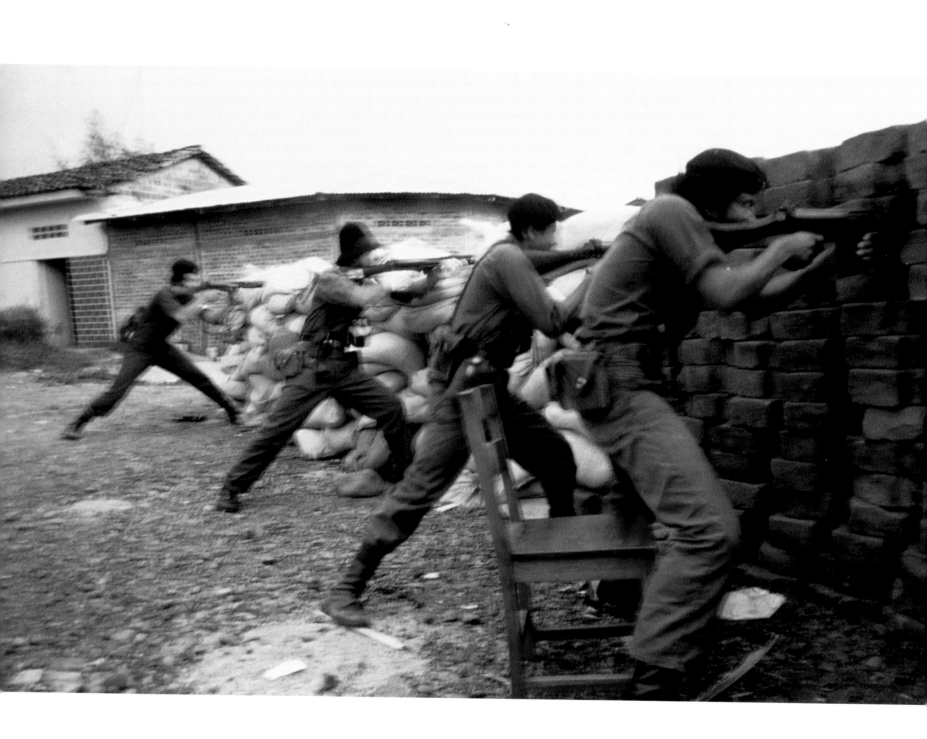

PASSION VERSUS PRAGMATISM

It's all about how close you can get in order to document what's happening. The guy in front of the chair had spent the whole night behind that barricade. They hadn't been shooting during the night because that would have been a waste of bullets, but early in the morning they had picked up the fighting again. I wanted to be as close as possible. I figured that if they were there, I could be there, although sometimes you're right in the center and there are no pictures to make. I remember a situation in El Salvador when I was about two feet away from the National Guard. They were under fire—I was, too, of course— and I couldn't do anything. There was one photograph, and that was it. I left that hill thinking, Was this one worth it? There was too much danger for too little return. So along with the passion, there's a pragmatism to this work. (Last day of fighting, Matagalpa, Nicaragua, 1979)

The Execution of the Maryknolls

In December 1980, John Hoagland and I were sitting in the AP office in San Salvador very early one morning when an anonymous phone call came in. All the caller said was, "I just wanted somebody to know that some white women have been found. Their bodies are reported to be in the Zacatecoluca district." John and I got in the car and drove all over the district the caller had mentioned. We went to a local judge, but he wouldn't admit to seeing or hearing anything. So we just kept on going down these little dirt roads until we came to a place where we saw some *campesinos*. I leaned out the window and shouted to them in Spanish: "Do you know anything about these women, white women, that something happened to out here?" And one of them said, "Oh, *sí, sí,* just down the road, around the turn, around a corner, in an open field." At that moment, of course, we didn't know if what he was saying was true. Then he showed us where the bodies of four women, who turned out to be American Maryknoll nuns, had been dumped. I remember feeling this phenomenal tension, because the guy was standing there with a machete, implying that the women were buried there and that we would be next—that kind of thing. We had been there a very short time when Robert White, the American ambassador, drove up with this big caravan of security people; the embassy had received a similar call with similar information. Soon other journalists began to arrive. Then people began digging and pulled out the four American nuns. It was really quite shocking to see the bodies of the women, who had been both raped and executed.

I'm really glad that I somehow had it in me to make the images of those murdered women. They are among the documents that today are part of the civil case that was filed in 1999 against Casanova and García, the director of the National Guard and the Minister of Defense at the time the nuns were massacred. That's being a part of history. As a photographer, I was just one stone in the path of the history of a people who today are still trying to contend with that period. It's like visiting a family that's being torn apart, the way that Salvadoran society was and Cuban society has been. We go away, we come home, and we pick up our lives where we left off, but these societies are scarred forever.

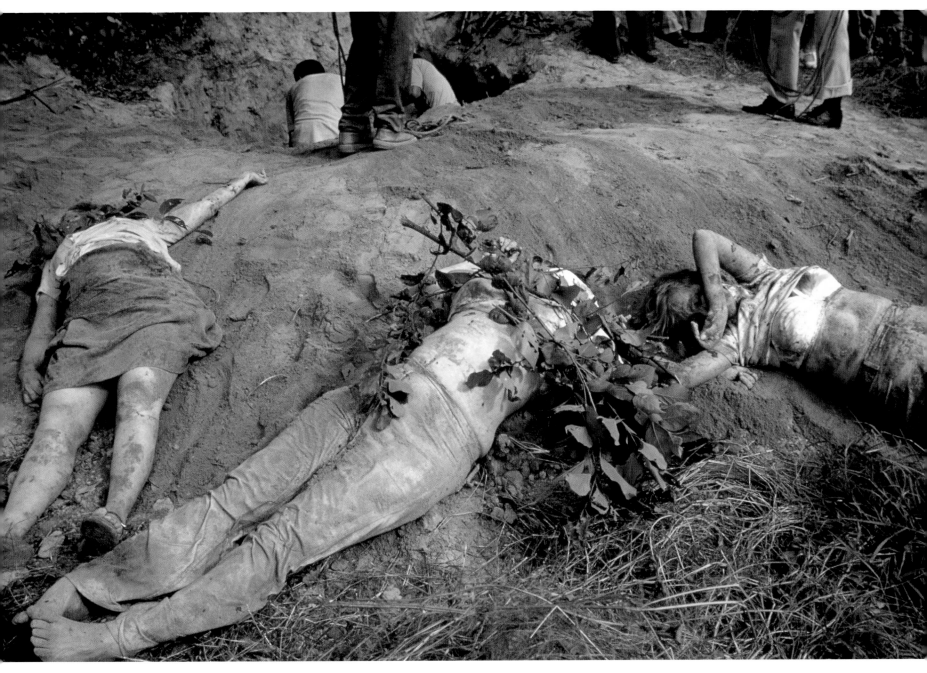

El Salvador, 1980

Christopher Morris

Christopher Morris was born in Tampa, Florida, in 1948. He received a B.S. in photography from the Art Institute of Ft. Lauderdale in 1980, won a scholarship from the International Center of Photography, and began to work at the Black Star agency, filing other people's photographs. Since 1984 he has covered conflicts in nearly twenty foreign countries, including Afghanistan, Yugoslavia, the Philippines, Chechnya, and the Persian Gulf. | Morris received the Robert Capa Gold Medal and the Olivier Rebbot award, both from the Overseas Press Club. He was named Photographer of the Year by the University of Missouri School of Journalism and won an Infinity Award from the International Center of Photography. He is currently a *Time* magazine contract photographer and a founding member of the photography agency VII. He lives in Florida.

The Art of Survival

The hardest part of combat photography is how you're going to survive—getting from point A to point B, where you're going to sleep, what you're going to eat and drink once you're there. Forget the war part of it—it's just the day-to-day living. This was especially true in Grozny. Everybody lived in their basements like little rats that would come out in the day to look for water and food and then go back underground. There was hardly any food. Sometimes you'd have to break into houses that had been abandoned by Russian families—not a great thing to admit to, but often they had left food behind.

There's a whole knack to survival. You're in a place where there's no infrastructure, no hotels, no taxis, no restaurants. When the war in Afghanistan began, I immediately was working out in my mind how I would do it. I could visualize how the photographers there were sleeping, what they were eating, where they were getting drinkable water or going to the bathroom, how they were keeping their laptops and sat phones charged. And *then* you start worrying about taking the pictures. ∎

Wounded civilian, Yugoslavia, 1991

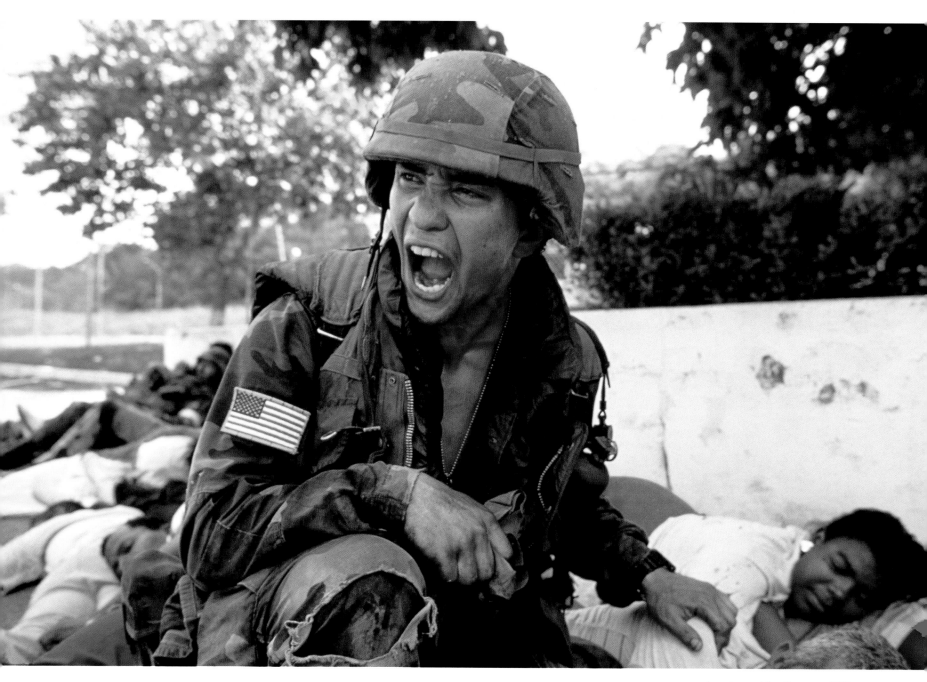

American soldier, Panama, 1989

Facing Fear

I went to Afghanistan in 1988 on my own with a small guarantee from *The New York Times Magazine*. It was the first time I was under shell fire, and the first time I understood what shell shock meant. To go through a night of shelling in a small village with nowhere to hide makes you really appreciate the term. I was pretty paralyzed all night, lying for hours on my stomach with my face in the dirt, just basically waiting to die. Under these circumstances, who cares about photography? You just want to see the sun rise in the morning and get the hell out of there. I was determined that fear wouldn't paralyze me again.

Panama was different because it was mostly small arms fire or small mortars. I got caught in a couple of firefights between the Panamanians and Americans, and during one of them I was actually pinned down for over an hour with a group of civilians. About eighteen of them were wounded, and several were killed. Strangely enough, that was when I fell in love with combat photography, because I realized that I had started to develop the skills you need—how you could hide, barriers you could get behind, how you could survive. At that point I knew this was definitely what I wanted to do.

You have to stay calm. The minute fear comes into your body, it rises up. Somebody's shooting at you, you're lying on the ground, and you can feel the fear rise. I had learned from my experience in Afghanistan that you have to take control of that immediately and use it, because if you let it consume you, you're not going to produce—you're not going to take pictures. I was determined that I was going to use the fear and channel it, and stay very calm. It's the same as somebody who's bungee jumping or parachuting. There's always that initial fear of jumping out of a plane, even for experienced jumpers. But if they don't learn to control the fear, they get petrified and they have to be pushed out of the plane. You don't want to be at the point where you're pushed out; you want to be able to function. ∎

Burnout

I had really burned out in Yugoslavia after the first year, but the war dragged on for another five. I couldn't sustain any level of enthusiasm. I stayed on but I couldn't work, and you can see it in my photography. I didn't like the Serbs, I didn't like the Bosnians, I didn't like anyone. I had become very emotionally attached to the story because there was a crime taking place, but I didn't know how to use my photography to affect it. It hadn't affected it from the beginning; it just kept going on and on.

There was one incident in 1993 or 1994 in Sarajevo that was particularly difficult. I must have been there for about forty-five days. The city was sealed; it was very grim. It was deep winter. There was no running water, no electricity, and no food. Twenty liters of petrol sold for $300, a cup of sugar was $50, and a Coke was $10. I heard Clinton give a speech on the BBC. Somebody had asked him what he was going to do about the humanitarian crisis in Sarajevo. He said there was no humanitarian crisis in Sarajevo; the people weren't starving.

Earlier that day I had experienced the point in the war that broke me, where I couldn't really cover it anymore. Six children were playing in the snow, and a shell dropped and killed them. Two colleagues and I rushed to the site, but all that was left was the blood in the snow and a sleigh. They had scooped up the bodies. The next day we went to the morgue and found these six children laid out; they still had their gloves on, their little snowsuits, like you see everywhere in Europe, little pink snowsuits. One of them was a girl, around ten years old. Her face had been removed by the shrapnel. When she was upside down in the snow, the contents of her head had completely fallen out, and now you could see the back of her skull inside. There was a boy next to her—I think it was her brother—and the same thing had happened to him. His face had been blown off, and they had put it back on in the morgue, only upside down. It was really tragic. And the hardest part was when two men, maybe the father and the grandfather of the children, came in to identify the bodies. I watched them weep over these children, and I remembered Clinton saying there was no humanitarian crisis. I couldn't understand it. The humanitarian crisis was daily. These people were being slaughtered. I called my editors at *Time* magazine that night, screaming at them to call the White House. I tried to go up the Time, Inc., command, but they told me it was time to get out. They realized that I had lost it, that I had basically had a breakdown. ∎

Children in morgue, Sarajevo, 1994

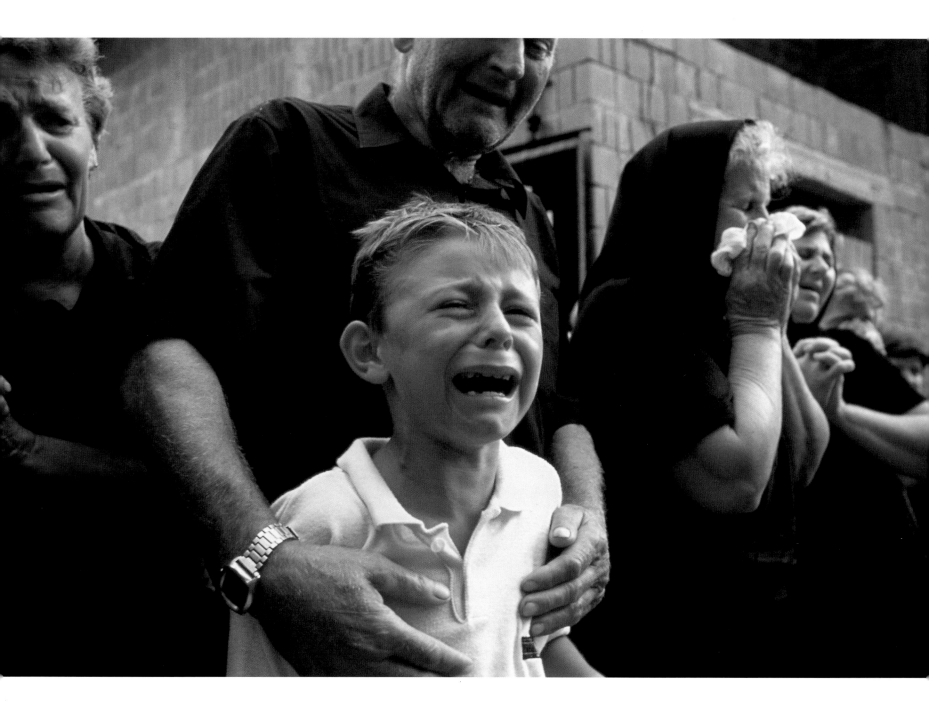

THE TEARS OF SARAJEVO

This picture was taken early on in Yugoslavia. The boy is crying over the death of his father. It was almost as if the country was crying. It expressed the anguish of the whole country. There was something about the boy that reminded me of myself as a child. We have very similar features. It was as if I became one with the boy in the photo, and it made me weep. I wept over all the death I had seen. I don't really cry much over the fighters who die, but I do for the civilian casualties and the horrendous wounds that weapons do to the human body. People don't realize how horrific war is. I used to really get into my pictures, but after that point in Sarajevo, I just stopped. I haven't gone through any returns since 1990. I don't even want to look at them. (Sarajevo, 1991)

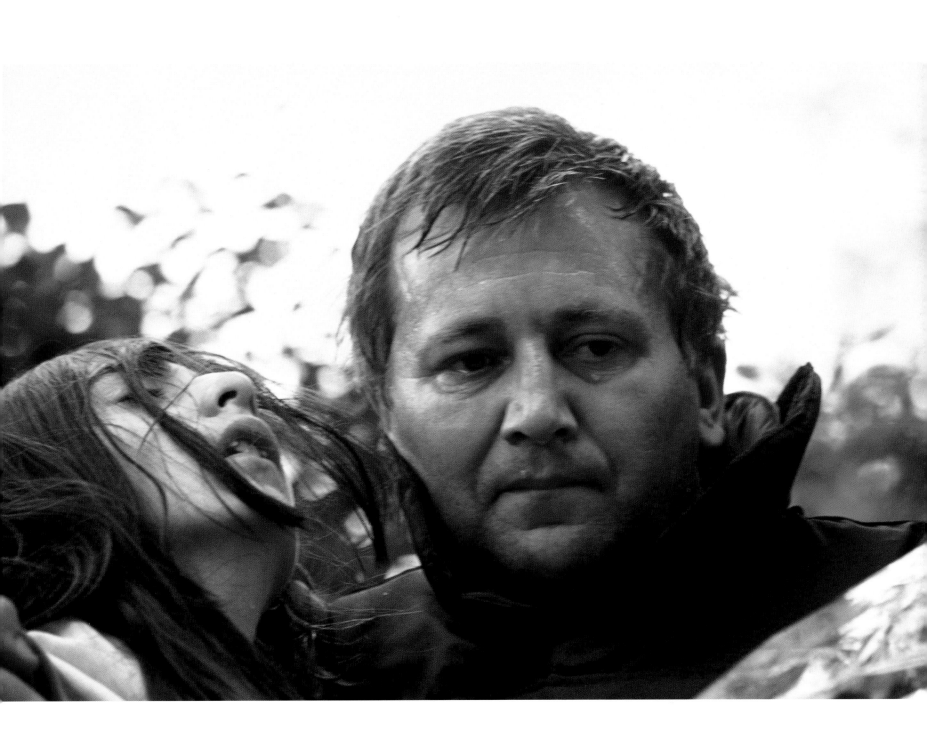

EMPATHY FOR THE PEOPLE

As a journalist, you could drive out of Sarajevo. You could fly out on a UN plane daily if you wanted to. You could come and go, but the citizens of Sarajevo couldn't. They were trapped, and you really felt it. The core photographers who worked in the city became very attached to the place. You were almost ashamed of the fact that you could leave, and it pushed you to stay longer. You would do forty-five days instead of just thirty. The majority of us had armored cars or would ride with somebody who did, but after a while you became embarrassed that you had that protection. You didn't want to sit in some café wearing a flak jacket and a helmet, so you just wore a T-shirt because of the attachment you had to these people who had no choice. (Sarajevo, 1991)

A Perfect Ten

For about ten years, my traveling companion through many war zones was the Italian photographer Enrico Dagnino. Between us, we developed a system of grading near-death experiences from one to ten. A ten was an incident in which you should have been killed, or at least badly maimed. A seven or eight was an occasion where, for instance, you were pulled out of a car at gunpoint. There were quite a few tens over the years.

Grozny was by far the worst over a sustained period. It was like a living ten. Anything could happen at any time. We'd start every morning by going out to find a group of Chechen fighters and follow them as they moved from building to building, often through underground tunnels or similar structures. On this particular day, I was working with Patrick Chauvel and Heidi Bradner. The Chechens we were following had moved into a square where there was an underpass. There we ran into two other photographers. As we entered the tunnel, I looked back. Patrick and Heidi had disappeared. I assumed that they'd gone off to take pictures of some people we had passed who were distributing food.

We waited in the underground passage, because shells were dropping now. After about ten minutes, I started to get worried. I finally said to the others, "I'm going to go out and look for them. Wait here." I walked up to the top of the stairs, and as I looked out onto the square, I saw two Chechen fighters running across it. For some reason, at that moment I didn't feel like joining them, so I turned around and walked about halfway down the stairs. I had these walnuts in my pocket—I'd picked them up from some trees that were still standing around the city. I distinctly remember looking back at the other photographers, and I said to them, "I'm going to eat a walnut, and then I'm going to go look for Patrick and Heidi."

At that moment, a volley of Grad rockets landed right in the square. The whole wall next to me turned orange, like a fireball, and debris rained down. I ran down the rest of the stairs. When the dust settled, I went back up; those two guys I saw running across the square were dead. So stopping to eat the walnut basically saved my life. To me that's like a ten, it's so close. Patrick and Heidi, by the way, were fine.

After an experience like that, it's almost as if you can walk on air, that's how exhilarated you feel. A couple of times I remember coming back from the front line and reaching my hotel. When your hand touches the doorknob of the hotel door, you really appreciate that you have a hand to open it with. I literally would weep sometimes when I got back, so grateful that I wasn't hurt, because you would see people maimed and wounded from shrapnel—faces ripped off, things like that. Just to feel the warmth of somebody's hand when you shook it was very moving. ■

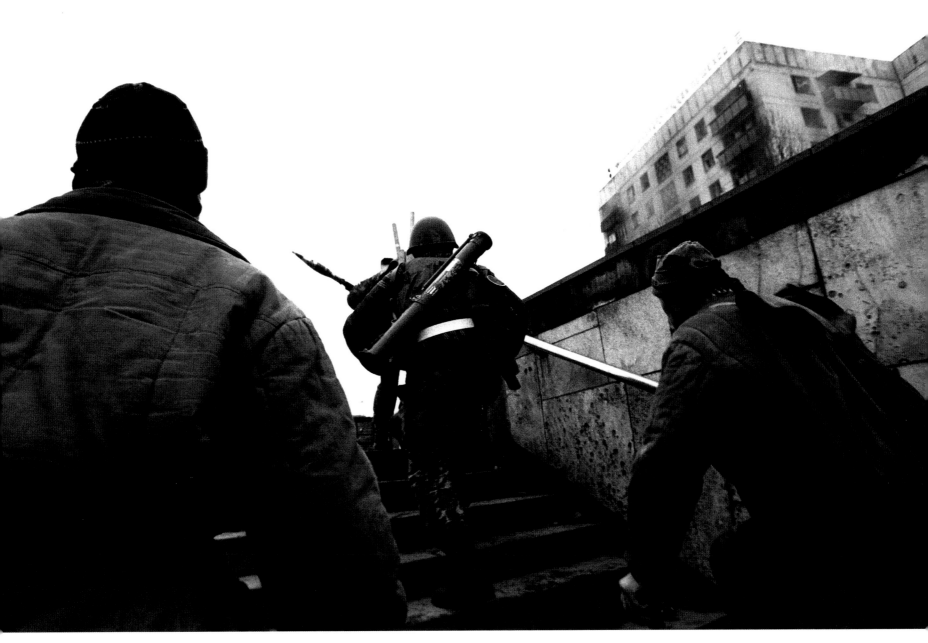

Chechen fighters, Grozny, 1995

Landscapes of the Apocalypse

I discovered several landscapes in my contact sheets that I don't even remember shooting. I'll have thirty-six frames of fighting, then tucked in among them there'll be one frame of a street scene. I didn't consciously shoot whole rolls or compose each frame. I was simply struck by the extent of the destruction, and I would just do a shot here or there. When you're there trying to do combat photography, you're so worked up—trying to find the guy with the gun fighting the other guy with the gun— that you miss so much. You're not slowing down to think where you are. I regret not doing more, because there's a lot to be said in photographing the aftermath. You can really see it in the World Trade Center pictures. If you look at Hue or the World Trade Center, Grozny, or Yugoslavia—cities when man destroys them—they all look the same. It's very apocalyptic. ■

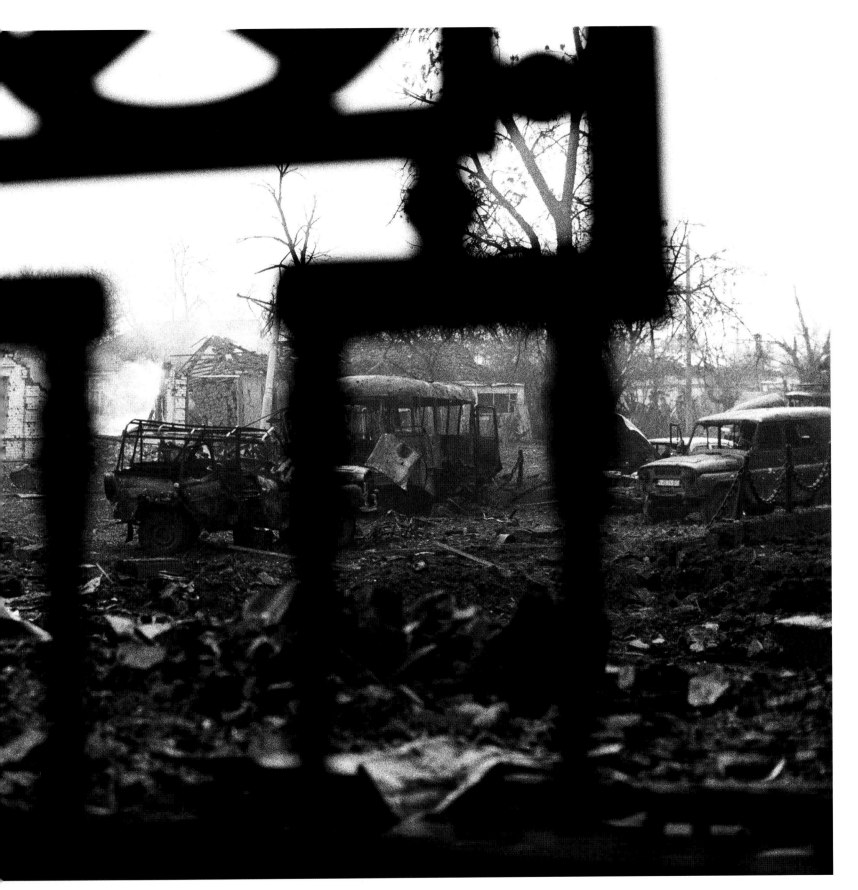

View from the presidential palace, Grozny, 1995

THE MOST DANGEROUS PLACE ON THE PLANET

I've made four or five trips to Chechnya. During
the first trip, I took this picture. I'm very fond of it,
but some photographers have criticized me for
intentionally doing this zooming effect. Anybody
who knows me well or has worked with me knows
that this has never been intentional. In all of my
photography, but especially with combat photog-
raphy, I try to put the viewers there, to make them
feel like they're in the picture. I want them to feel
the story. In these situations, you don't have time to
think, Oh, I'm going to blur. At least I don't.

Sometimes motion occurs if a shell lands nearby
and there's a lot of shake. What happened here is
that I'm running with the soldier. I'm actually with
him on a flight of stairs. I want to leave the building
myself, so I think I can go with him. He runs down
them and motions to one of his friends to cover
him. I follow, shooting pictures as we go. The motion
comes from the fact that I'm probably shooting
at a thirtieth of a second. I didn't go to a thirtieth of
a second because I wanted to cause some motion;
I went to a thirtieth of a second because there was
no light inside the building—it was the limitation
of the film I was using.

I like this image because it's how I felt at that
moment, and it's what I saw. I felt that rush of this
man running out the door. It's also the front door to
the presidential palace—to me, at that time, that
week, that day, it was by far the most dangerous
place on the planet. There was no square patch of
earth that was more dangerous than that spot, and
this guy's going out the front door. (Grozny, 1995)

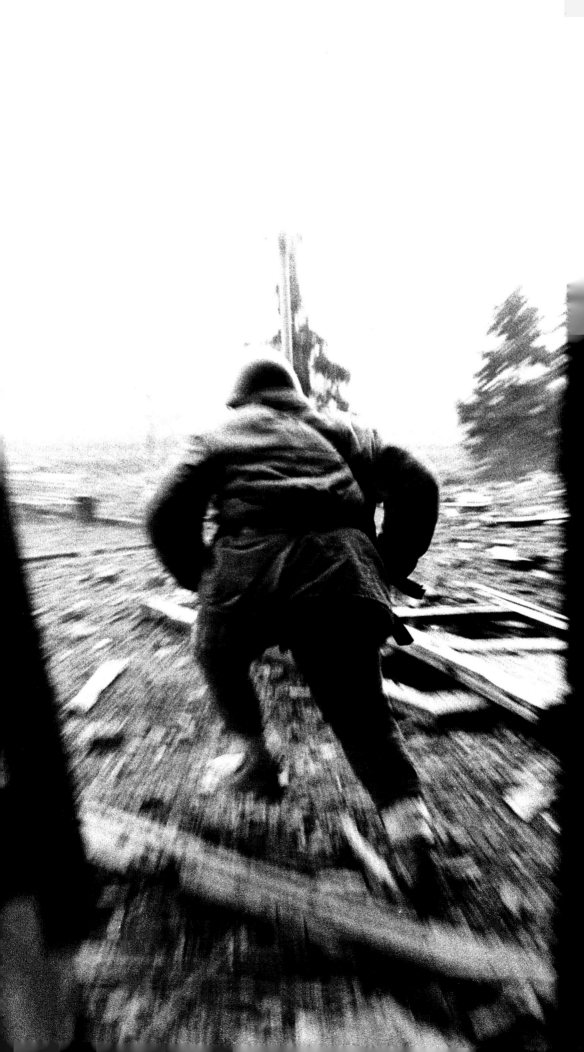

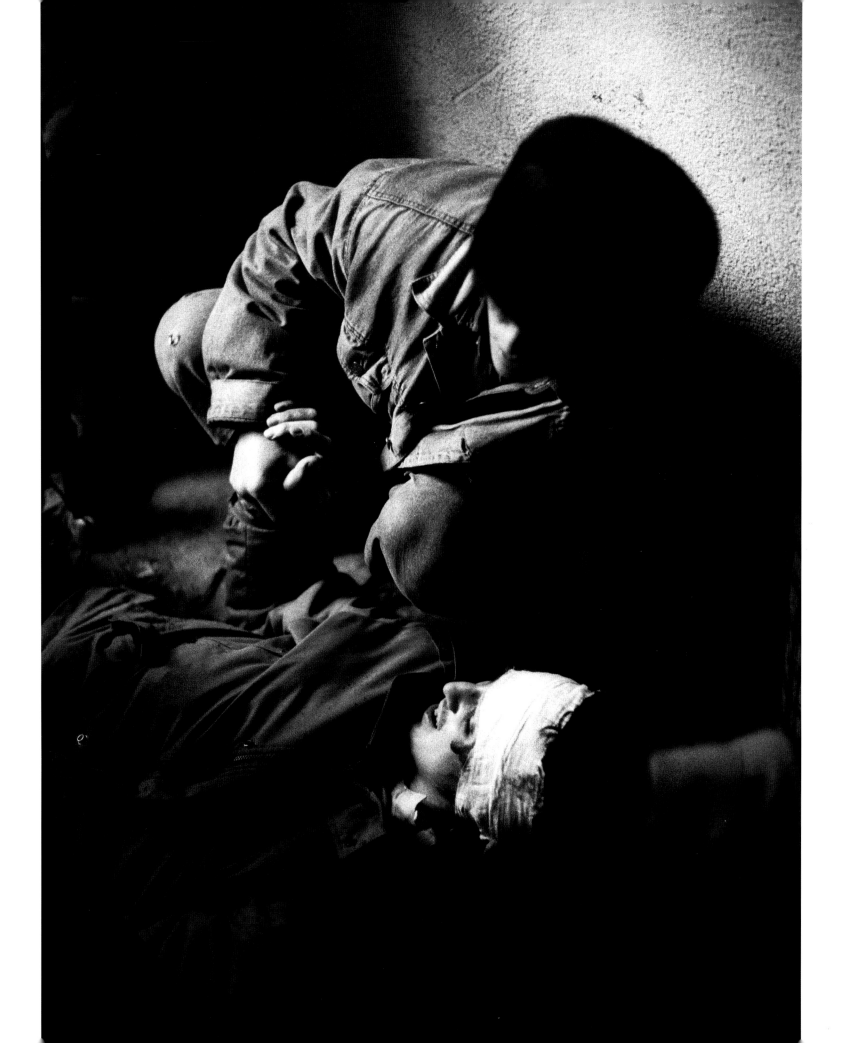

What's the Point of It?

I think you have to be very selfish to be a combat photographer—selfish with your parents, selfish with anybody in your life. And I think that for those of us who do it—and my friends will probably hate me for saying this—probably 70 percent of it is for ourselves. We can talk about being antiwar and all that, but it's more for us than for society.

I know photographers working today who continue simply because when they get back to their regular lives, they can't cope with the normality of existence. They're always looking for the next dangerous assignment because, honestly, it's an escape. You don't have to worry about taxes; you don't have to worry about mortgages and rents. The only things you have to worry about are your survival and taking pictures. You forget everything about the modern world. When you fly back into the real world, you feel separate from everything else. It's very hard to connect back into society because those people just don't understand what you've seen, what you've been through. During the whole Yugoslav conflict, I would do three or four weeks there, come home for a week, then leave again; do three or four weeks, come back for a week, then leave again. Every time I left Yugoslavia, I said I wasn't returning. But I would last five or six days at home and then be on a plane going back.

If there's a point to this work, apart from what we get out of it personally, it's the importance of producing a historic document. Future generations will value the work of the selfish photographer who went out, risked his life, and captured these historic moments. ■

A Change of Priorities

Another photographer at the White House asked me whether I regretted not being in Afghanistan. I'm here in D.C. with my wife and my three-year-old daughter, Savanna. I told him that I ask myself what I'm going to want to have a picture of when I'm seventy or eighty, my daughter or of some Taliban with a gun? And that's how I've balanced it out, how I've been able to back myself out of combat photography. There are different priorities in my life, and having a child has made all the difference in the world. It may change later on when she's older. Last year, when she was two, I made two trips to Chechnya, and it wasn't fair to anyone—not to the magazine, not to my family, and not to me, because I couldn't do the work that was required. I absolutely do miss it, especially a story as big as U.S. troops in Afghanistan. But it's an easy fight for me. It's just a balance—daughter, Taliban; daughter, Afghanistan. I get over it very quickly. ■

Dying Chechen, Grozny, 1995

James Nachtwey

James Nachtwey was born in 1948 in Syracuse, New York. After graduating from Dartmouth College, he worked on merchant marine ships, was a truck driver, and served as an apprentice film editor. He taught himself photography and began his career on a local newspaper in New Mexico in 1976. | In 1980 he came under the tutelage of Howard Chapnick of Black Star in New York. Since then he has covered conflict throughout the world. | Nachtwey has been a contract photographer for *Time* magazine since 1984. He received the Robert Capa Gold Medal five times, the World Press Photo Award twice, and the Alfred Eisenstadt Award. He is a Fellow of the Royal Photographic Society and a founding member of the photographic agency VII.

A Little Fresh Air

Northern Ireland was the first conflict I ever covered. I didn't have an assignment, but I'd been following the story, and I went there on my own. Howard Chapnick of Black Star gave me the encouragement and the backing to see what I could do. The Falls Road in West Belfast is a predominantly Catholic area, and the young lads who supported the IRA had been hijacking and burning vehicles to protest the treatment of prisoners in the notorious H-Block. One of the prisoners was a man named Bobby Sands, a member of the IRA who had actually been elected to the British Parliament. He was in the process of starving himself to death, and the reaction in the streets of Belfast was chaos and violence.

The man in the photograph was just an ordinary citizen. The protesters had been burning vehicles in front of his apartment block all day long, and he finally got tired of the smoke. He went out with a little basin of water and tried to put out the flames from a burning lorry. He wasn't against the demonstrators; he was just trying to get a little fresh air. ■

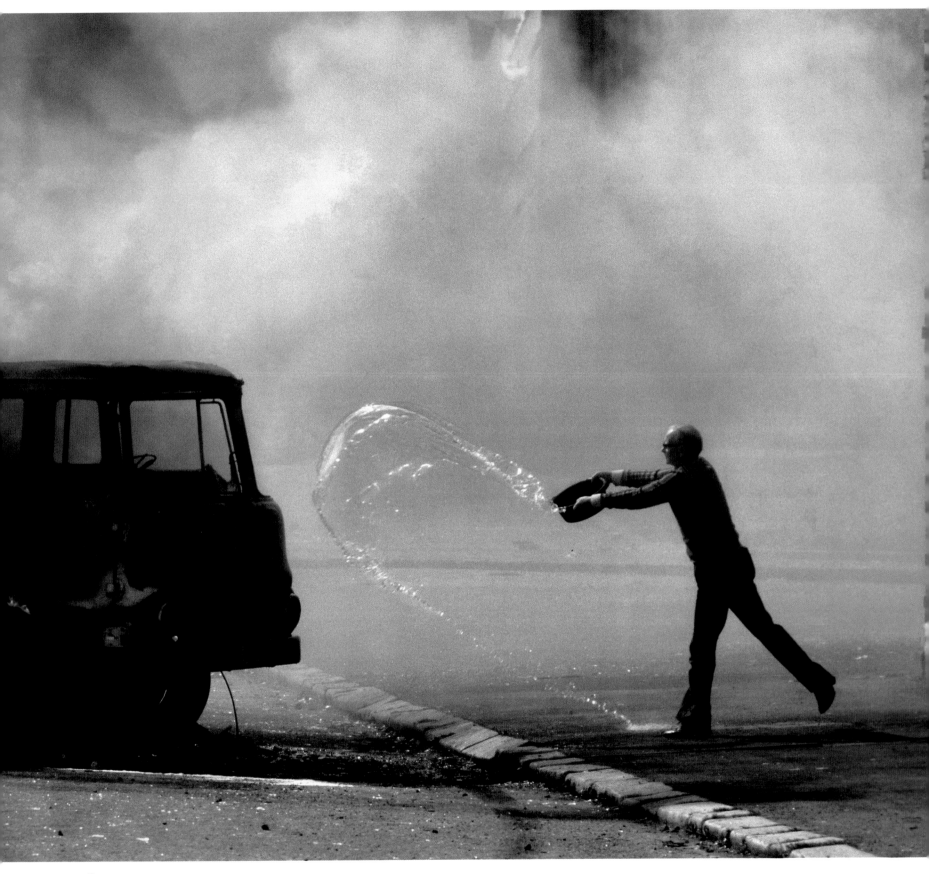

Belfast, 1981

Photography Chose Me

I became a photographer in order to be a war photographer, and everything I did as a photographer up until 1981, when I first went to Northern Ireland, was training. I was inspired by the images that were created during the Vietnam War and the American civil rights movement. They had such a profound effect on the consciousness of our nation. The pictures that came out of Vietnam were straight documentary images, but they became an indictment of the war. They became fuel for protest. They illustrated how insane the war was, how cruel it was, what a waste it was. When those images reached the eyes of the political leaders who were setting the agenda, they understood that millions of people were as upset as they were about what the pictures showed. Those photographs created pressure for change, and as a result, America got out of that war sooner than it would have otherwise. Those images not only documented history, they helped change the course of history.

I don't know how to explain it, but photography chose me. I was headed toward a career as a doctor, a lawyer, or a businessman, but when the war and the civil rights movement came along, they produced a sea change in my entire generation. Part of this change was produced by photography. Photography was creating consciousness, and it was moving the world. When I finally decided to become a photographer, this was the tradition I wanted to follow. ■

Refugee in Kijevo, Kosovo, 1999

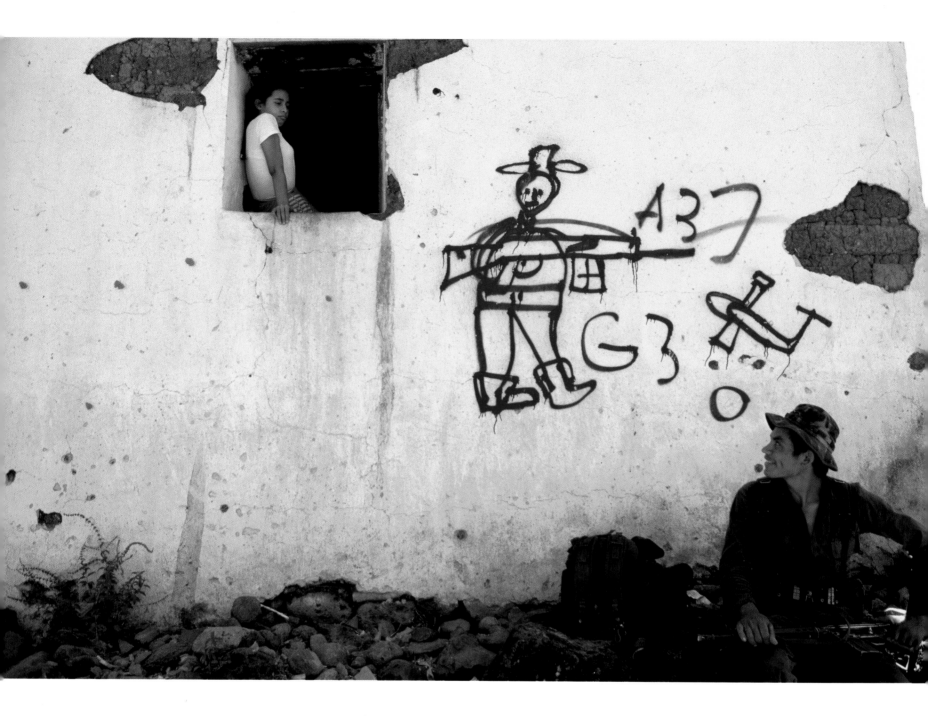

THE COLD SHOULDER

An army counterinsurgency unit searching for rebels in the mountains of El Salvador was in this village because it was known to be a rebel stronghold. A soldier was trying to flirt with one of the local girls. She was clearly unafraid and giving him the cold shoulder. He had the gun, but she was calling the shots. The graffiti on the wall depicts a soldier with a G3 rifle, which is the type of weapon they used, and an attack plane. It's an illustration of oppression that became a backdrop for a moment between a young man and a young woman. That moment is a product of war, but it also transcends war, which is something even more elemental. (El Salvador, 1984)

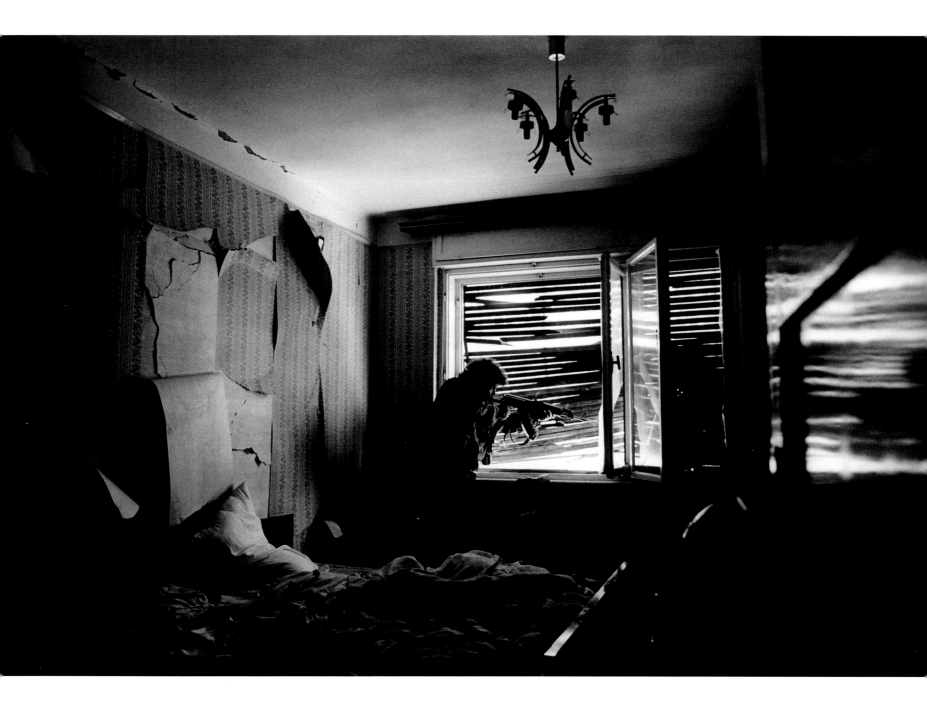

THE BEDROOM OF DEATH

This photograph is the reverse of the one of the soldier and the girl on the facing page. It was made in Bosnia in 1993, when the Croatian militia had begun to push the Muslim population out of Mostar in what became known as ethnic cleansing. A Croatian fighter was firing from the window of a bedroom that had been destroyed in the vicious house-to-house combat. The wallpaper was falling off the walls that had been damaged by shell fire. The bed was a total mess. The shutters in the windows were all broken. A bedroom is the most basic domestic setting. It's the place where people love each other, where they share their most intimate moments, where life itself is conceived. Now it had become a killing field. (Bosnia, 1993)

No Easy Witness

It's not easy to witness another human being's suffering. There's a deep sense of guilt—not that I caused the situation, but that I'm going to leave it. At some point, my work will be finished, and if I'm lucky, I'm going to get on an airplane and leave. They're not.

It's a hard thing to say, but there's something a bit shameful about photographing another person in those circumstances. None of this is easy to deal with, but overcoming emotional hurdles is just as much part of being a photojournalist as overcoming physical obstacles. If you give in, either physically or emotionally, you won't do anybody any good. You might as well stay home or do something else with your life.

People understand implicitly that when a journalist from the outside world shows up with a camera, it gives them a voice they wouldn't otherwise have. To permit someone to witness and record at close range their most profound tragedies and deepest personal moments is transcendent. They're making an appeal; they're crying out and saying, "Look what happened to us. This is unjust. Please do something about this. If you know the difference between right and wrong, you have to do something to help us." It's that simple, that elemental.

I try to connect with people in a very respectful manner, to let them know that I appreciate what they're going through. I'm not there to threaten them. I'm not there to exploit them. I'm there to give them that voice, and I want them to understand that I feel respect for them and for what they're experiencing.

But it takes a toll. You carry a weight, you carry a sadness, you carry anger and guilt. And it doesn't go away; if you have a conscience, you carry it with you, always. Sometimes I think it's ruined my life, and other times I think it's given my life meaning. ■

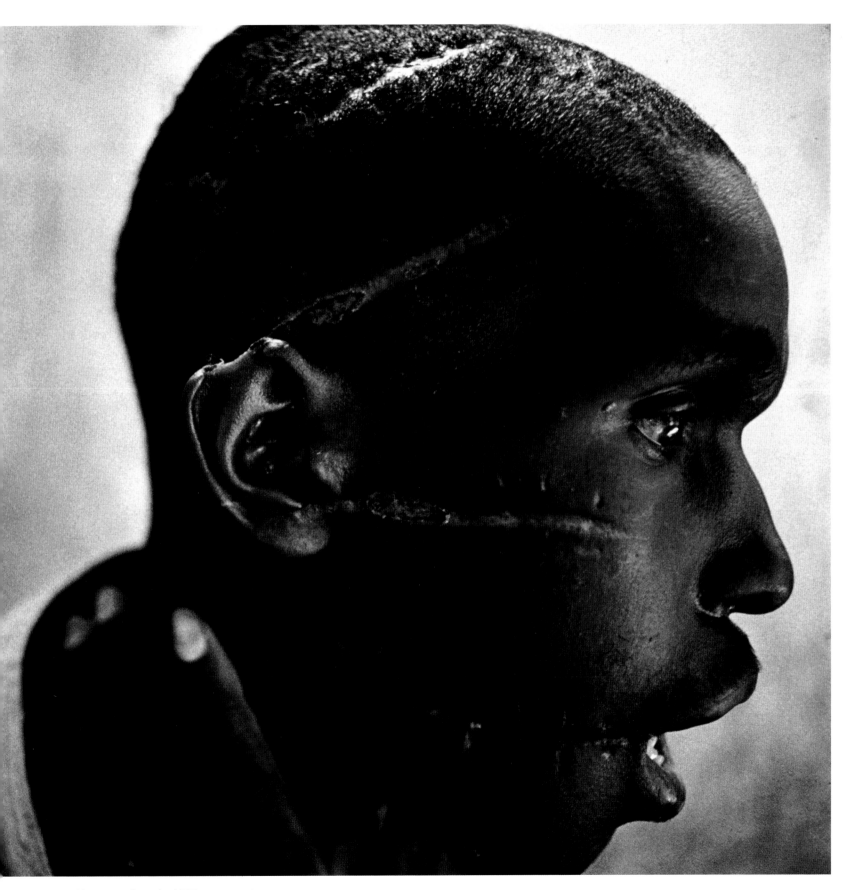

Hutu man, Rwanda, 1997

A Fugitive in Sri Lanka

In 1986 I traveled to the Jaffna Peninsula, the far northern part of Sri Lanka where several years earlier a civil war had broken out between the Tamils, who are Hindus, and the Sinhalese, who are Buddhists and the majority in the country.

I traveled alone, and in order to get there, I first went to Tamil Nadu, a state in southeastern India directly across from Sri Lanka. From there I crossed the Palk Strait in a smugglers' boat with a group of new recruits for TELO, the Tamil Elam Liberation Organization—so called because Tamil Elam is the name they've given to their country. It was an open fishing boat, no more than fifteen feet long. All these young guerrillas with their AK-47s were sitting on fifty-five-gallon drums of petrol and boxes of grenades. I noticed that each of them had what appeared to be an amulet around his neck. I asked what it was, and they told me it was a cyanide capsule. I realized then that I was with a very determined, very extreme group of people. They also told me that if we so much as saw a Sinhalese patrol boat on the horizon, we should immediately jump overboard and swim away as fast as we could. The patrol boats were capable of very high speeds and were armed with .50 caliber machine guns. If we were spotted, we would be blown out of

the water. Of course, diving into the Palk Strait was not an attractive idea, as it is infested with sharks.

We were lucky and made it across. I spent the next three weeks living in one of the TELO headquarters and making forays into the countryside. We were attacked a couple of times by the army, and the second time I had a very narrow escape. Everyone was running across a rice field as an armored car raked the area with machine gun fire. I managed to get away and hide. Helicopters were flying overhead, shooting down at us, when this old man with a long beard and wearing a sarong came along on a bicycle. He looked like he had just stepped out of a Joseph Conrad novel. We both hid under a tree, and when the helicopters moved away, he put me on his bike and off we went, fleeing an armored car and helicopters on a bicycle.

In the end, the people I was with were wiped out, not by the Sri Lankan army but by a rival guerrilla group, the Tamil Tigers. One day, I was in a car with several TELO guerrillas heading out of Jaffna Town, when I asked them to stop and take me back to headquarters. I thought there might be an attack on the army fort, and if there was, I didn't want to miss it. They turned around, dropped me off, and went on their way. A half

hour later, news came that the car had been ambushed and everyone killed. Several of the fighters piled into a van to investigate, and when I started to get into the vehicle, they refused to let me come along. I protested, but they would not give in and drove off without me. A short while later, we heard that the van had also been ambushed and everyone was dead.

The guerrillas prepared for an attack on our position, and as night fell, it came. The villa we were in was surrounded. Machine gun fire and grenades were coming from all sides. I realized we were going to be overtaken, and I knew my only chance of survival was to try to escape. I climbed over the headquarters wall in the darkness and made my way to a nearby house. The family inside was terrified by the fighting, but they understood I was in serious trouble, and they hid me. It was a gesture of pure compassion and generosity. From my refuge I could hear the terrible sounds of the headquarters being overrun. When the Tigers came to the house looking for TELO fighters, the only son of the family convinced them there was no one inside. I became a fugitive, hiding out for three weeks, not only from the army, but now from another guerrilla group. I moved from place to place. I took shelter for a while in a Catholic seminary, and one of the priests made contact with another guerrilla group that allowed me to stay with them. They were trying to get their leaders back to India, and they agreed to take me along. I honestly didn't know if I was going to make it home. It was like taking three weeks to drown; my life was passing in front of my eyes. Incidents from my past that I had totally forgotten would enter my consciousness and resonate with importance.

If the army had captured me, I suppose I might have been shot. The best I could have hoped for was a stretch in jail. In any case, I definitely would have lost my film, and the whole ordeal would have been for nothing. I did think about surrendering, because at that time all the Tamil boats attempting to cross the strait were blown up. Not one had made it. The patrol boats were out in force, and when we did eventually set out, we took a very circuitous route, north instead of east, then back around again. It was a very long trip. The seas were rough, the pilot was so afraid that he got drunk, and in the middle of the strait the engines failed. When I finally called Christiane Breustedt, my editor at *Geo,* I began to apologize for being late with the film, and she told me she was just about to call my parents to give them the bad news. ▪

The Oldest Weapon Known to Man

The famines I've covered are a product of war, not of nature. Famine is the oldest weapon of mass extermination known to man. It's very efficient and unspeakably cruel. You send in some fighters to terrorize farmers and disrupt their ability to produce food, burn their crops, and kill their animals. By the time another growing season comes around, hundreds of thousands of people have died a slow, painful death from starvation.

It's very hard to witness someone in that state, and even more difficult to concentrate on it in order to make a photograph. People are in dire agony, and their physical appearance is horrifying. All you want to do is make it stop; make it go away. Hopefully, that's what your pictures will eventually help to accomplish, but in that moment you have to overcome tremendous emotional obstacles to do your job.

Most pictures of famine victims are made in places where food is beginning to be distributed by humanitarian organizations. Word goes out that food is arriving in a certain location, and people begin to congregate. Relief centers become a point of access. We're not photographing people and then walking away and not helping them. The people we're photographing are already being helped by local and international nongovernmental organizations. It's very important to report a famine as early as possible because the sooner the pictures come out, the sooner the world knows about it and the faster relief becomes mobilized. Donors respond, and money and logistics are earmarked specifically for that emergency. The process gains momentum, and a lot of lives are saved. ∎

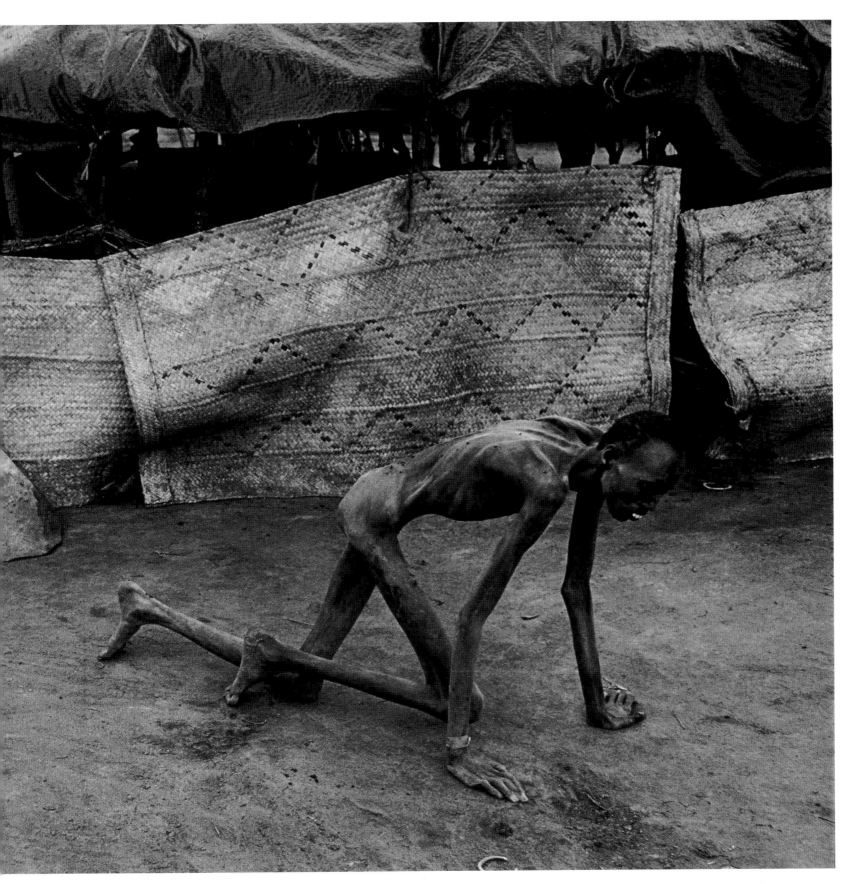

Feeding area, Sudan, 1993

YOU WANT TO GO TO THE FIGHTING?

This is a residential street in Mostar, in the
early days of the battle to push the Muslims
out of the city. The fighting was fierce; the
dark spots covering the pavement are spent
bullet casings. I managed to get access to a
group of frontline fighters by going to the
headquarters of the Croatian political party.
The spokesman was a Croatian-American
from Chicago who had gone to Croatia to
participate in the war. He said to me, "You
want to go to the fighting? I'll take you
there." It's probably because we were both
Americans, but he opened up access to a
band of militiamen, and I was able to photog-
raph the combat from close range. Once, we
got into a crossfire, and we were forced to
withdraw. From where I was photographing,
machine gun bullets were hitting the ground
so close to me that I was covered with dirt
sprayed up by the impact. (Bosnia, 1993)

185

It Does Make a Difference

Nothing can fix the world all at once. It's an endless process. Wars begin and end; we have to deal with them one at a time. We have to stay engaged—giving up doesn't accomplish anything. We have to have faith in each other and in our own best instincts. The alternative is simply not acceptable.

The results of our work in cases of humanitarian disasters are seen more clearly and more rapidly than in situations that are more political and protracted. Wars can't be stopped simply by the mobilization of goodwill and logistics. It takes more than that. The process is longer. I don't agree with people who say that information doesn't matter. Look at the facts. Look at history. Public opinion is a form of pressure; when pressure is brought to bear, things change, however slowly. And journalism is the most important element in the creation of public opinion.

The greatest statesmen, philosophers, humanitarians, and religious leaders who ever lived have not been able to put an end to war. Why place that demand on photography? Photographs and news reports are a kind of intervention. They prevent things from happening in the dark. They give people a voice. They create consciousness, and from consciousness, conscience grows. It's too easy to be cynical and say there's no point. You can turn your back, you can say nobody's responsible. That way everybody's off the hook. No one has to put anything on the line. I think we *do* have to put ourselves on the line and keep going out there, because it does make a difference. We have to help create an atmosphere in which change is not only possible but inevitable. When the next crisis comes along, we help change that one, and on and on. If I can't do it because I've run out of steam, or I'm too slow or too old or I'm not around anymore, then someone else will take my place. It says a lot that there are journalists willing to risk everything because they believe people's opinions matter. Each one of us is only a grain of sand on the beach, but all together we have an impact. There's no divine intervention. At the end of the day, all we have is each other. ■

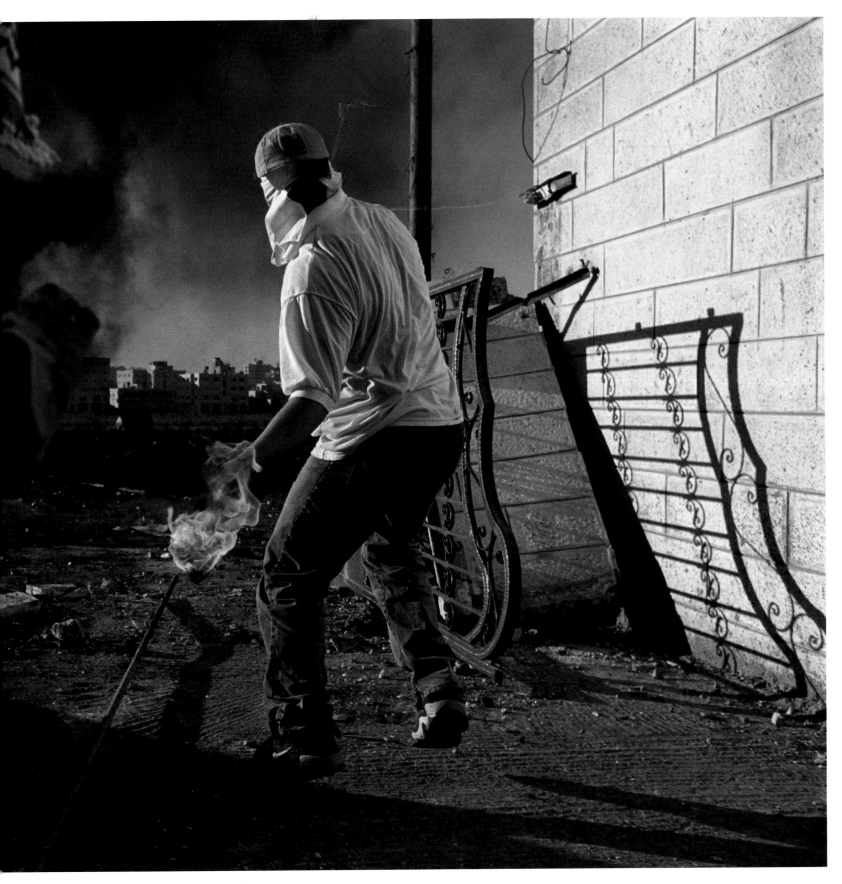

Palestinian combatant, Ramallah, 2001

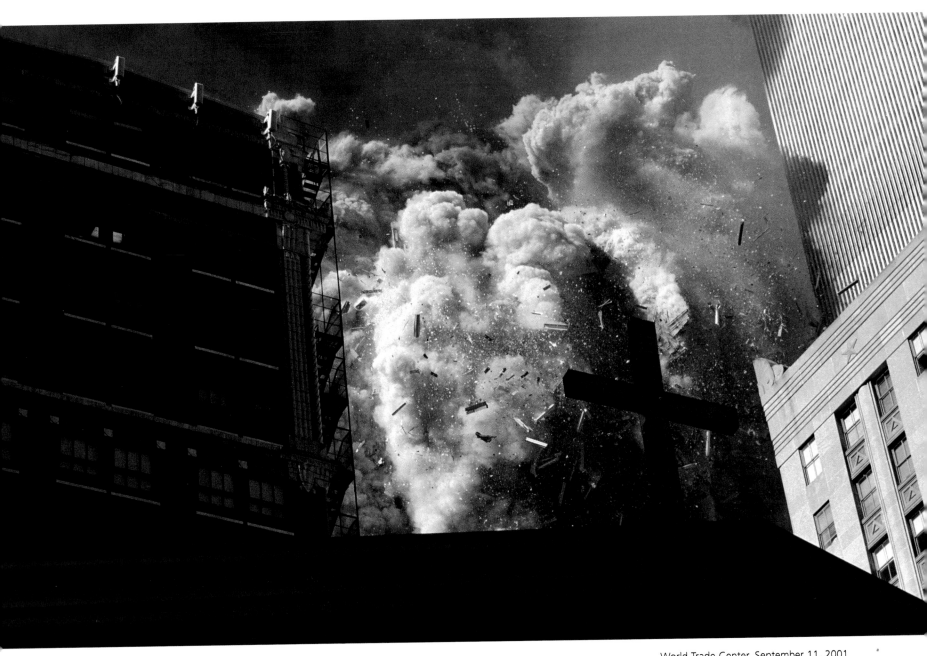

World Trade Center, September 11, 2001

Images from a Nightmare

By chance, I happened to be in New York on September 11, 2001. I had returned early from ten days in France, where I helped to launch the new photography agency VII. I arrived home about eleven P.M. the night before. There was a good view of the World Trade towers from the window of my loft, and I could hear the first explosion clearly. I went to my rooftop to make an initial image, then went back downstairs to organize my cameras and film. As I had so many times before, in so many other places in the world, I was heading into an area from which everyone else was fleeing.

I began by photographing the wounded as they emerged from the buildings and were being assisted by medics. I was two blocks from the first tower when it collapsed, and I photographed the cloud of debris as it boiled through the canyons of lower Manhattan. I made my way through the smoke to photograph the skyscraper where it lay in ruins on the street. The area was deserted. It looked like a set for a science fiction film about the Apocalypse. Then I heard what sounded like a huge waterfall in the sky. I looked up and saw the second tower falling straight down at me. It was an image from a nightmare. It was unreal. In a fraction of a second, I recognized what an incredible sight it was—that it actually looked very beautiful as well as terrifying, that it would make a brilliant photograph, and that if I took even a moment to raise my camera I would not survive. There was no place to hide as the avalanche of smoke

and glass and steel billowed down. I saw an open doorway in a hotel across the street and up the block, and the speed with which I made that distance defied the laws of physics.

I entered the lobby of the hotel and understood immediately that it was going to be obliterated. Like a trapped animal, I sought out the deepest recess I could find. I dashed into an elevator bank, then into an open elevator, the very moment the debris hit. Everything went black. The only reason I knew I was alive was because I was suffocating. I was convinced I was buried under the wreckage and had little chance of survival. A construction worker had rushed into the same elevator, and he called out to me. We were only a few inches away from each other, but neither of us could see a thing. It was like being blind. We held on to each other's hands and began to crawl through the pitch blackness. We called out to see if anyone else was still alive and in need of help. No one answered. We kept crawling blindly, and I saw small points of light blinking on and off in the distance. Eventually I realized they were car emergency flashers and that we were on the street. I knew where I was at that point and moved north until I could see daylight filtering through the smoke and ash. I made my way out of the cloud, evading the police who were beginning to arrive on the scene, and spent the rest of the day, until darkness fell, photographing the beginning of the rescue effort at Ground Zero. ∎

The Continuum of War

Virtually every war I've covered has been a guerrilla war, not a big conventional war the way Vietnam was, or the Gulf War. They've always been wars of liberation, ethnic conflicts, wars in developing countries—Central America, Sri Lanka, Bosnia, Chechnya, Rwanda, South Africa. When I was photographing the wars in Lebanon, the war in Afghanistan against the Russians, the Afghan civil war, and both Palestinian uprisings, I thought I was covering separate stories. But on September 11, 2001, I realized that I had actually been photographing one story, and this was its latest phase. That event crystallized the past twenty years of history, as I had experienced it.

The job of the press is to create awareness about the consequences of policy, about cause and effect, about the results of action or the failure to act. In a way, September 11 underlined the failure of journalism. I don't think individual journalists have failed to do their jobs well. On the contrary, journalists in the field have performed remarkably well, often at great risk, in harrowing conditions, and at great sacrifice. But there's more to it than that. The matrix of perception in which the work of journalists is understood is deeply influenced by government,

business, and culture. September 11 also underlined the failure of our political leadership, our foreign policy, and our society to comprehend what now seems obvious—that we are part of the world; that what we do and don't do, what we see and don't see, has serious repercussions. Only now are we trying to unravel it in our minds, when it's been happening for decades, just as journalists have been telling us.

All those conflicts form a continuum, the various parts of which have been reported on and photographed for a long time. Somehow the consequences were never quite understood. We can see from hindsight that things should have been done differently, that we should have paid attention to things that we ignored.

Although each conflict was part of a single, continuous process, each one has also been very different. There's no template for a war. If you go to a war and then a year later you return, it's going to be different the second time. You have to learn it all over again. You start from square one every time. You never know what's going to happen when you get up in the morning because it's totally unpredictable. It's not very comforting, but it makes for an interesting day. ■

Palestinian uprising, Ramallah, 2001

Maggie Steber

Maggie Steber has been a documentary photographer since 1978. She has worked in more than thirty-five countries; her photographs have appeared in *National Geographic, Life, Fortune, The New York Times* and *The New York Times Magazine, The New Yorker, Newsweek,* and *People.* | Steber's photographic honors include First Prize in Spot News from the World Press Photo Foundation in Amsterdam, Pictures of the Year First Prize in Magazine/Documentary from the University of Missouri, and the Leica Medal of Excellence. She was awarded the Alicia Patterson Foundation Grant and the Ernst Haas Grant for her work in Haiti, and her book *Dancing on Fire: Photographs from Haiti* was published in 1991.

Out of Africa, Into Haiti

Although I don't consider myself a combat photographer, I covered the last two years of the guerrilla war in Rhodesia, before it was renamed Zimbabwe. That was a war where you couldn't get to the front lines because it was simply too dangerous—if you were white and you ran into the guerrillas, you wouldn't live to tell about it. The front lines were really the farms. I was once on one that was attacked; it was terrifying. I couldn't photograph anything—it was very late at night and we had to stay hidden. But even though I couldn't photograph combat per se, the true battle lines were drawn within the structure of the society and how it was changing, and that was more interesting to me.

I lived in Zimbabwe for two years, and I loved it. After I left, I became very homesick for it. Someone said to me, "You should go to Haiti. It's much closer, and it's just like Africa." And in fact, when I first went in 1980, it really was. Haiti's a black country that was punished for its very successful slave revolt in 1791. At that time the world economy was based on slavery, so the world just turned its back on the country and it became very isolated, which I think is one of the problems with it today—and one of the things that saved its African nature. ■

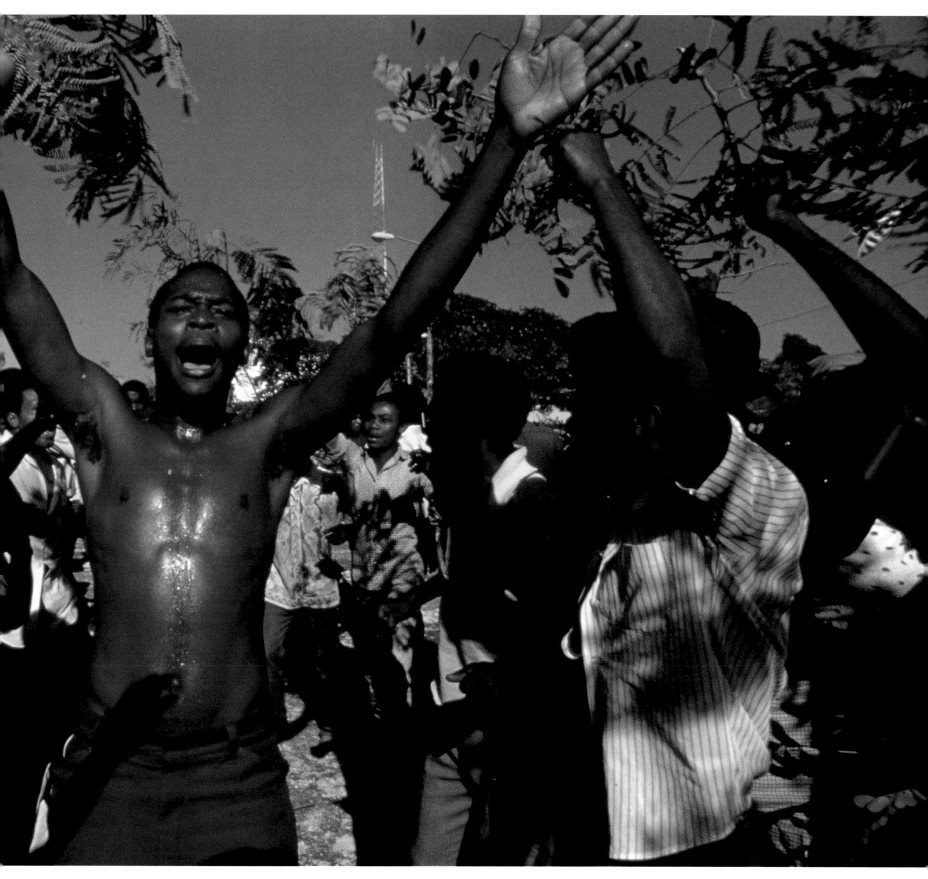

Haitians celebrating Duvalier's departure, 1986

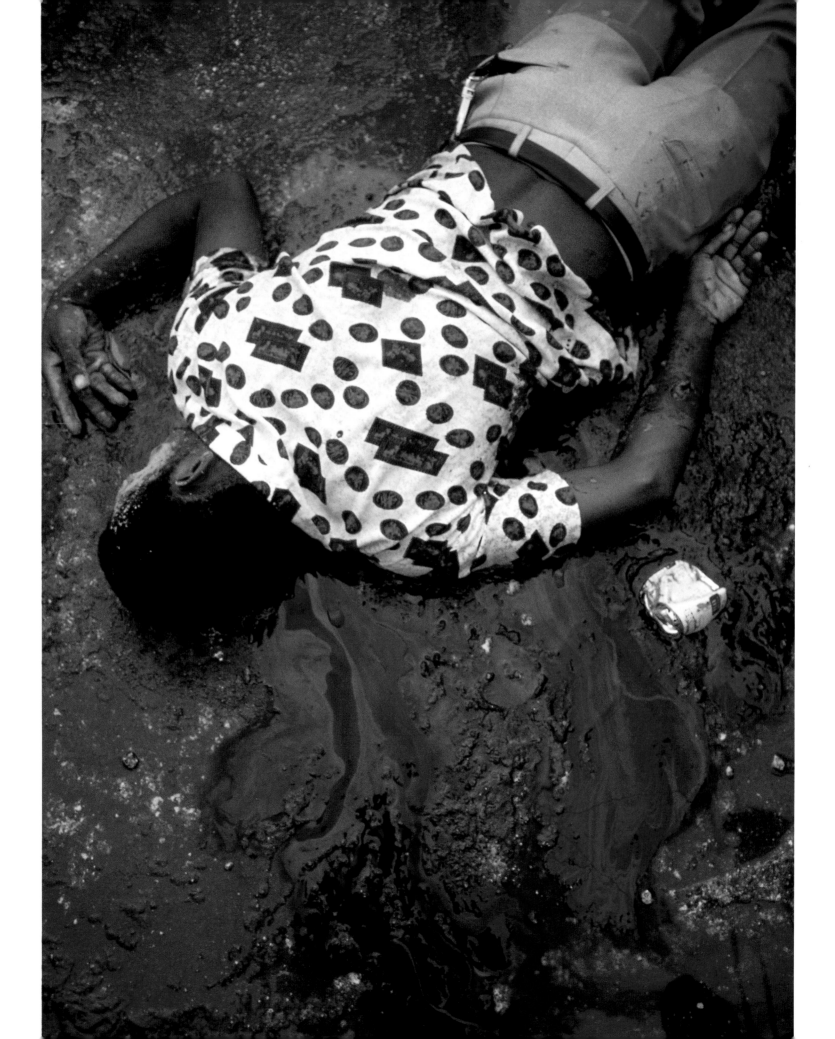

Every Body Has to Count for Something

For about two or three weeks before the 1987 elections, we heard shooting every single night, all night long. Each morning all the journalists would go out, and we would find the bodies of anywhere from twenty to forty people who had been shot. The Haitians would come up to you and drag you over to see this body and then that body. When something like this happens, I think you're really challenged as a photographer. You want to record what's going on, but just the act of photographing a dead body is hard. There you are standing over the remains that were once living and photographing them, trying to make them look artful or meaningful, and that's kind of weird. In those days, there were so many corpses that you got not jaded, exactly, but to the point that you couldn't photograph every body—and yet the Haitian people wanted you to do just that. I said to a Haitian friend, "You know, I just can't do it anymore. I can't photograph all these bodies. I feel like a vulture." She put her hands on her ample hips and said, "Maggie, you have to, because every single body that you photograph was a living person, and they all have to count for something. If for no other reason, it's a document of how many people were killed, and it's so important." Once she said that to me, it was liberating because she was a Haitian and she was giving me a kind of permission. She also gave me a different way to think about it, which was that it really was important that there should be something to mark your passing, even if it was the most violent death. It's so important to record that, even if nothing is done with it. The record continues to exist.

The blue background in the picture is the street. I was trying very hard to do a picture that talked about life ebbing away, and I wanted this body to represent Haiti. It's interesting because the Haitian flag is red and blue, and this man is wearing blue trousers, there's red in his shirt, and the blood is red and blue because it's mixing with the oil on the street. I wanted this picture to reach to a more symbolic level where it could really talk about the draining of life, because one of the real tragedies of Haiti has been a "brain drain" by assassination. Some of the best minds and people who could have been leaders have so often been assassinated. It's happened for decades, particularly so since 1986. So I was trying to photograph in a more metaphorical manner. ■

Port-au-Prince, 1987

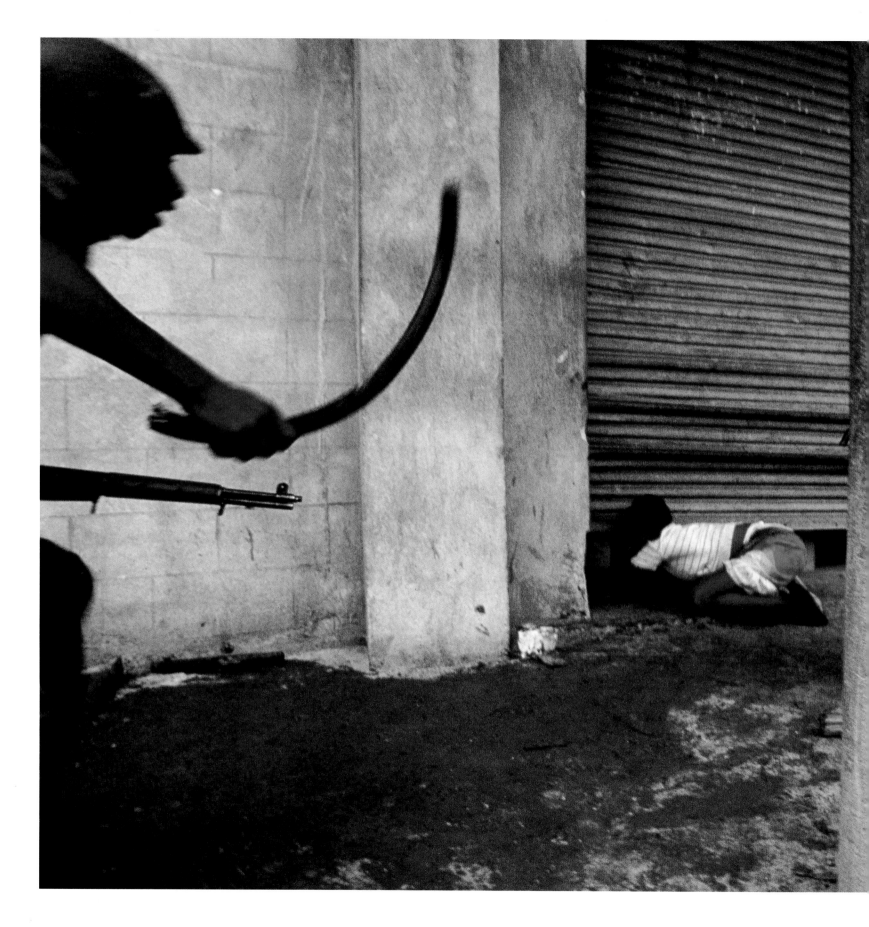

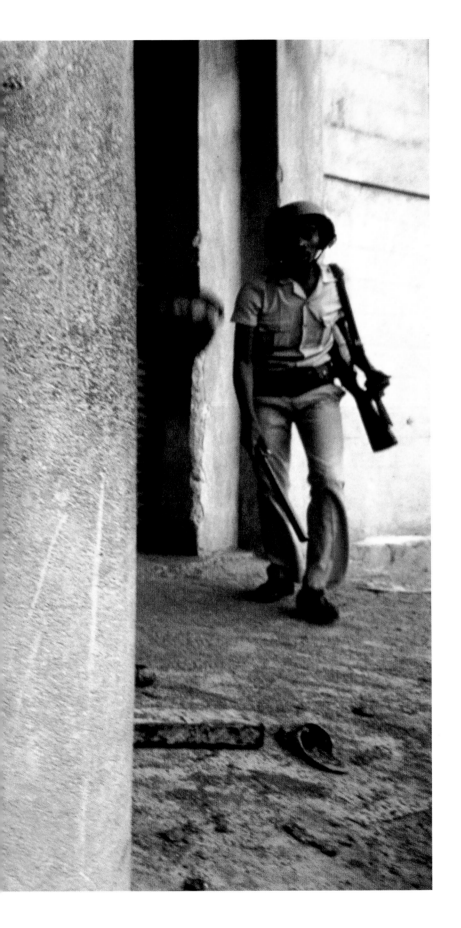

TAKING CARE

This picture was taken during the food riots in January 1986. A little boy or girl is trying to steal a box of food from beneath the shuttered doors of a food warehouse for CARE in Cap-Hatïan. People had been demonstrating and rioting all day, and I guess somebody finally said, "Let's go and invade the food warehouse." That's where everyone was supposed to be able to get food, but they never did because it's such a corrupt place. So they covered the warehouse like ants on a piece of candy. From one side a soldier is running in with a rifle and a baton. He's coming so fast to hit the child that the baton he's swinging through the air is curved.

It was really momentous. The army and the police arrived and started hitting people and trying to get them out of there, but it was impossible. They did hit this child, but I think he still got the box of food and ran away. Finally, the army gave up and pulled back because the people were so determined—they ended up taking everything. From the photograph, it looks like an isolated incident, but in fact there was violence happening all around.

It's an interesting picture because everything changed for me after I took it and after it won several awards. It's as if this soldier sliced through the air with his baton and I stepped from one side of my life into the next. In the middle of a Haitian voodoo temple is a pole called the Poteau Mitan; the Haitians say the spirits come into our world by slithering up the pole and coming out into whoever they're going to possess. There's something going on behind the pole in this picture that I think is probably the helmet of another soldier, but to me it's like a little spirit. So this picture has everything. It's all about Haiti and its violence, its poverty, its hunger, its voodoo. And it changed my life. (Cap-Hatïan, 1986)

Machine Guns in the Sacristy

The scariest moment in Haiti for me was in September 1988 when I was photographing at St. Jean Bosco, the church of the revolutionary priest Jean-Bertrand Aristide. On this particular day, a mass was to be celebrated at which the whole congregation would wear white, as a symbolic pro-democracy gesture. Everyone was screened as they entered the church, because it looked as if there would be trouble. Sure enough, ten minutes into the mass, forty or fifty men with machine guns, clubs, machetes, and spikes burst through the doors, even though they had been chained shut. They started hacking and shooting.

At first I took pictures, because so much was happening, but then I realized that I had to get out. The only way out was through the sacristy door leading into a courtyard, but this door got jammed really fast; I couldn't get within twenty feet of it. I panicked, and in a panic you forget anything that makes sense. I ran right down the middle aisle of the church, hoping to get out the front door, when a man with a machete caught me by the shoulder. He raised the machete over my head—he was going to chop my head off. I can still clearly see that moment. Everything was moving very quickly, but in my mind's eye everything played out in slow motion. It's so burned into my brain that I could paint it right now. I looked in that man's eyes and I saw nothing. That's what terrified me more than anything; it was like standing on the edge of a black hole and realizing that there was no bottom. This man had no soul at all in his eyes. I turned to run away. Fortunately, I had on an old dress that day, and it just gave way. It tore practically clean off me, but I got away. God bless those old dresses.

The man didn't chase me, because there was an unwritten rule in Haiti that you could kill as many Haitians as you wanted but you never touched a foreigner's head. I don't think he realized when he grabbed me that I was a foreigner, but he certainly knew it when he saw my white back. I ran toward the sacristy door and—you know those superhuman moments that you hear about? Well, I put my arms around everybody, and I just started pushing. Everybody pushed through the door and fell into the sacristy, and then we ran out into the walled courtyard.

They burned the church and sporadically shot at us from the wall. We had no weapons, so we gathered rocks and anything else we could use to defend ourselves. The thing I couldn't understand is why they didn't just come in and kill us, because they could have. I figure they wanted to torture and terrify us.

There was no exit from the courtyard, which was quite big because it was a church school complex, so some people started jumping over the courtyard wall, which was high. But if you jumped to the other side, all these men with machetes and guns were there, shooting, beating, and cutting people, so I stayed put. Finally, after about three hours, the men suddenly left. Even though there was an army post and a police post right across from the church, nobody came to our aid.

A group of us went inside the school and slipped out through a window. We saw all these bodies in the front yard of the church. My little car had been burned, my dress was flapping in the wind. I commandeered a taxi—it was full, but somebody actually got out so that I could get in. They took me back to the hotel, and the first thing I did was call the AP to give them an account. A friend of mine who worked for USAID came by and said, "I'm getting you out of here, because the people who hit the church have gone on the radio, and they're looking for you." I was in hiding for two or three days before I could get out of the country.

This whole incident stayed with me for quite a long time. After that, I had trouble driving on highways, flying on planes, and being in places where I couldn't be near an exit. But I got past it all. You know, photographers are such a funny bunch because you do feel as if the camera is like a bulletproof jacket, like it makes you invincible in some way. It's kind of crazy—you get so involved with taking pictures that it's only when you really start to look at what you're photographing that you realize what's going on. I hadn't panicked when they came in; I was more surprised. At first when I was photographing everyone running around, I guess I thought there would be a way out. When I realized there wasn't, that's when I panicked.

When you've lived through an incident like this, you sure make a lot of promises—you know, if I can just get out of here, I'll never do this and this and this again! I try never to make any promises that I can't keep, but I did break one, which was that if I ever got out of that situation, I would never go back to Haiti. It's a really strange place, though; you don't choose it, it chooses you. If it repels you, then you never go back; it doesn't want you. If it chooses you, you're there. But it decides. I know that's strange, but it's just like that—it's a land that's so haunted that it's really like a spirit. ■

Death in the Street of the Brave

I went to Haiti in January 1987, at the time Baby Doc Duvalier's government was collapsing. He fled the country the next month, and after an initial few days of revenge killings, the atmosphere was very hopeful and joyful. This tranquility lasted for a few months. It was a very exciting period—newspapers and radio stations flourished, and everybody was out in the street because for the first time in three decades of dictatorship, they were able to express themselves. But there were people who didn't really want things to change, because they had too much to lose.

Then in November 1987, the first attempt was made to hold democratic elections. The polls opened at seven A.M. and closed by nine A.M., and a lot of the polling stations were attacked. There was a particularly brutal attack in Port-au-Prince on a street called Rue Vaillant, the Street of the Brave. The polling station was in a school, and when we got there it was just bloody slaughter, with people's brains all over the floor. It was terrible, just terrible. And then twenty or thirty men, probably the same people who had committed this slaughter, came back and attacked the journalists. Several journalists were wounded and one was killed. I almost got killed three or four times that day myself, along with a couple of good friends. It was very bloody, and really violent. From that moment on, even if there have been times of tranquility, it's remained very violent. ∎

Port-au-Prince, 1987

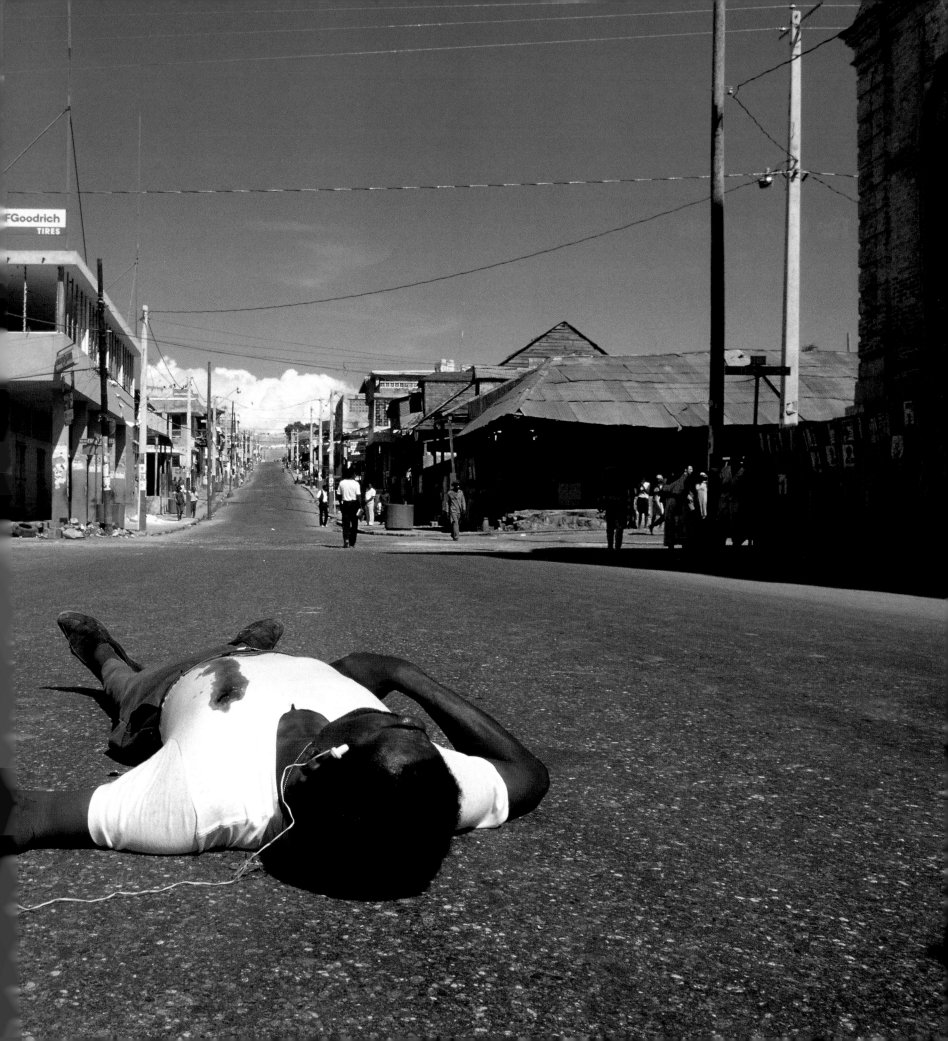

The Great Adviser

In this country, and in much of the Western world, we're divorced from death. People we know die, which may be devastating personally, but we treat their deaths in a very sanitary way. We have a funeral, and we put them into the ground or cremate them. But death is something we don't like to think about. What I found in Haiti, and in Africa as well, was that you were living, breathing, eating, and smelling death every day. In a way, it can become a great adviser: When you're so aware of it, when you're surrounded by it, it teaches you to live to the fullest—if it doesn't vanquish you first. It either gets you because it repels you, or it gives you a familiarity, which can be very comforting. You see it, you become used to it, and you realize that, yeah, it's inevitable. You even start to see some other things within it. It's like a wall you think is painted a solid color until you get right up to it. Then you start to see all of the little aspects of detail that suddenly give you a whole other vision of it. I think my experience with death in Haiti was very liberating, because it became familiar and less frightening. ∎

When a Woman Comes Back with the Goods

When you look at it, it's men who cause wars. There have been some women warriors, and some women leaders who were involved in warfare, but usually it's men against men. I suppose for the people who are waging the war and perpetrating the violence, it must be quite odd to see a woman photographing it, but truthfully I never much think about it. I'm aware that I'm a woman, and I adore being a woman, but when I'm covering a story I'm not even conscious of it. Maybe women photograph conflict a little bit differently, but that could just be something in my mind. I don't know that you could look at a picture a man took and a picture a woman took and really tell the difference, because when violence happens you just grab it. Sometimes it actually helps to be a woman photographer. It's a surprise for people even now, so they don't take you very seriously, and that can work to your advantage—they leave you alone, so you can get on with your work. You're less threatening in a sense, so you can go into situations a little more easily. People find it disarming that you can be a little gentler in your approach. Maybe even in this day and age and in our business, the same things aren't expected of a woman as they are of a man. That's when it's a wonderful surprise when you come back with something that the men consider to be "the goods." ∎

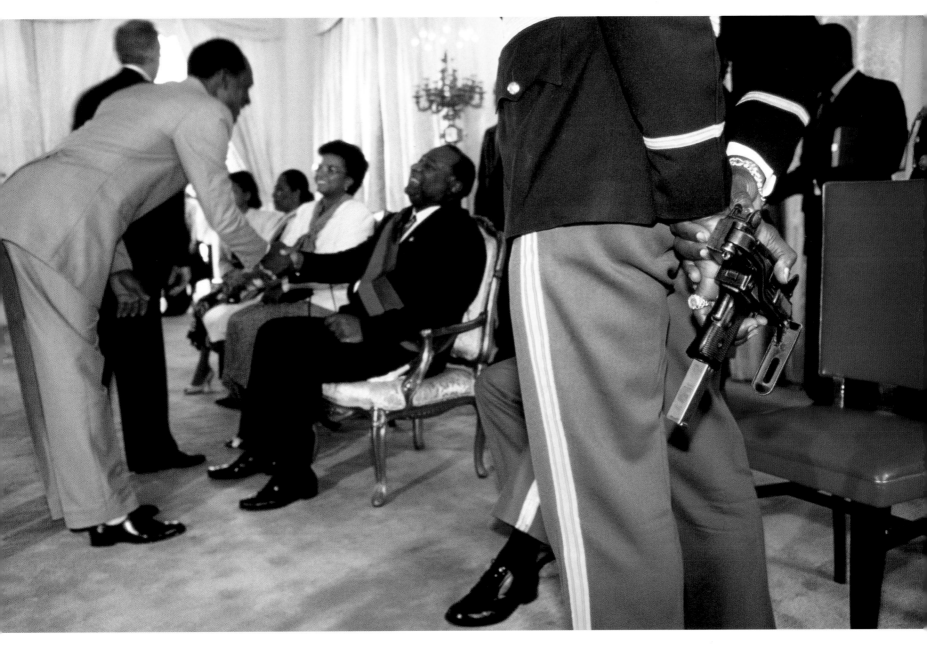

Presidential palace, Port-au-Prince, 1988

THE MAN IN THE ALCOVE

One day a group of us went out to an area in the slums
of Port-au-Prince on the daily body search. At one point,
some people pulled us over to show us a man who
apparently had been shot and seemed to have fallen into
some mud. His body had been taken from where he
was killed to this little alcove in a house situated along a
well-traveled path. It was put there to scare people and
to keep them from participating in the elections.

It's a very simple picture. I just photographed the
man; he's dead, but he looks as if he could be asleep.
He's covered in mud, and he's surrounded on three sides
by the walls of the alcove, which caused the color to
be deeply saturated. I think both of these elements add
to the mystery of the image. A friend was photographing
the same situation but in a very different way. He was
farther back; I really like to be up close. Because of
the distance, his picture also shows a pink cloth on a wall,
and a little girl peeking around the fence. He made it
macabre in a very Haitian way—there's the little innocent
girl, and even the pink cloth has a kind of innocence, or
at least normalcy, but in the background is this macabre
object. Maybe his photograph is a little bit more
intellectual, but mine is more like "Here it is. Like it or
not, here it is." (Port-au-Prince, 1987)

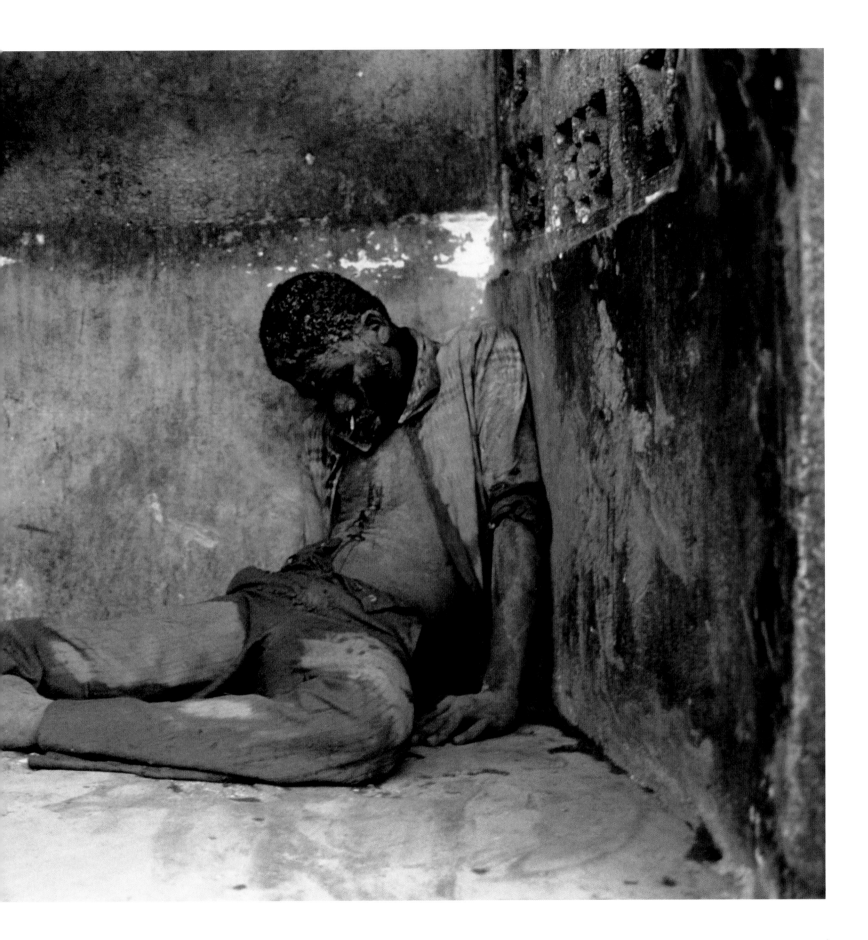

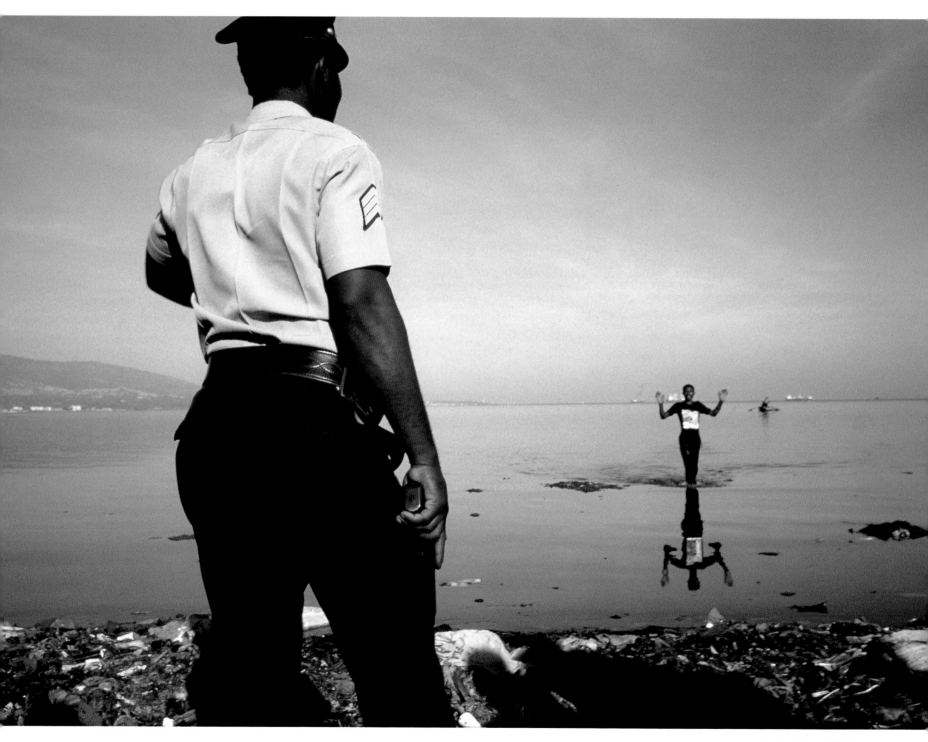

Port-au-Prince, 1990

Caught Off Guard

One day I was driving by the harbor in Port-au-Prince and I saw a group of people down at the water. I pulled my car over and went to see what was going on. The crowd consisted of just Haitians, because there were very few journalists in town at the time. Somebody pointed and said to me, "See those heads bobbing up and down in the water? Those are robbers who were caught stealing. The police chased them and they jumped into the harbor, but the police got a boat and rowed out, so the men realized that they had no recourse but to surrender. They couldn't swim very well anyway."

The man in this picture was the first of them to come in. He started walking toward the shore with his hands up. I was right in front of the crowd with my Leica, shooting away. Just as his foot touched the shoreline, out of the corner of my eye I saw a rifle come up. It shot his head right off, but I didn't take the picture. Partly I didn't take the picture out of surprise. It all happened so fast that I guess I was caught off guard. Then the next robber started wading to the shore, and of course you can imagine how terrified he must have been. I decided that if they shot him as well, I would photograph it, but when he reached the shoreline, the police threw him into the back of a truck and left. I don't know what happened to him. I went back to the hotel, very upset. It's always upsetting to see someone's head blown off in front of you, and I've seen it a lot in Haiti. On several occasions, I've had people die in my arms. I was very upset on two counts: one was having seen this really violent thing on an otherwise peaceful day, and the other was that I was quite angry at myself for not taking the picture. Then I had the internal argument I sometimes have where I think on one hand, Good, I'm glad I didn't take the picture—what if it had been an incredible picture and I had received a lot of attention when it was published, attention that I got on the back of somebody who died in such a violent way. I just don't know if I want that connection. On the other hand, I thought, You stupid woman, you're a journalist and you should have been steeled for it, and I thought of all of the guys who would have taken the picture. They wouldn't have turned away; they would have just done it.

To me, this picture typifies Haiti. It's like the crucifixion. The robber with his arms up looks like Christ on the cross, and in Haiti there is this continual crucifixion, this continual sacrifice of people for nothing—or for everything—and always at the hands of those in power. Because of this, it became a much more symbolic picture, which for me is much more interesting. And so I like it better than somebody with his brains being splattered in all directions into the air. ■

Laurent Van der Stockt

Laurent Van der Stockt was born in Belgium in 1964. In 1982, upon completion of his education, he became a full-time freelance photographer before joining the Belgian photo agency Isopress. In 1989 he paid his own way to Romania and, posing as a tourist, photographed life under the Ceauşescu regime. His work was distributed by the French photo agency Gamma Press, where he has been a staff member since 1990. He has covered conflicts in Afghanistan, the former Yugoslavia, Chechnya, Africa, the Gulf, Israel, and Yemen. | Van der Stockt's work has been published in *The New York Times*, *Stern*, *Geo*, *El País*, *The Independent*, *Paris Match*, *Newsweek*, and *L'Express*. He received the Columbia Journalism Award from the Columbia University School of Journalism for his coverage of the Gulf War; the first Prix Bayeux; and the Paris Match Prize. He has been wounded twice; he is presently recovering in Paris from injuries he sustained in Ramallah.

The First Time Is the Worst Time

At the beginning of 1990, I was watching the start of the Romanian revolution on TV. I was twenty-four. I had been there the previous year, when it was still under Ceauşescu rule, and I knew a bit about the country, so I made up my mind to go on the spur of the moment—in fact I left a dinner with friends in Brussels and started to drive to Hungary. I arrived at the Hungarian–Romanian border in the middle of the night and decided to sleep in my car and wait until morning before crossing into Romania.

I was awakened by three guys who identified themselves as journalists. They were all about forty years old, and they looked like the real thing to me. They had just arrived by taxi from Budapest. I told them I was a photographer and that I was waiting for sunrise, but they said, "No, no, we should go now," and they got in my car. I was impressed because they looked so professional, so I said okay. That was the first and the last time I took this kind of advice.

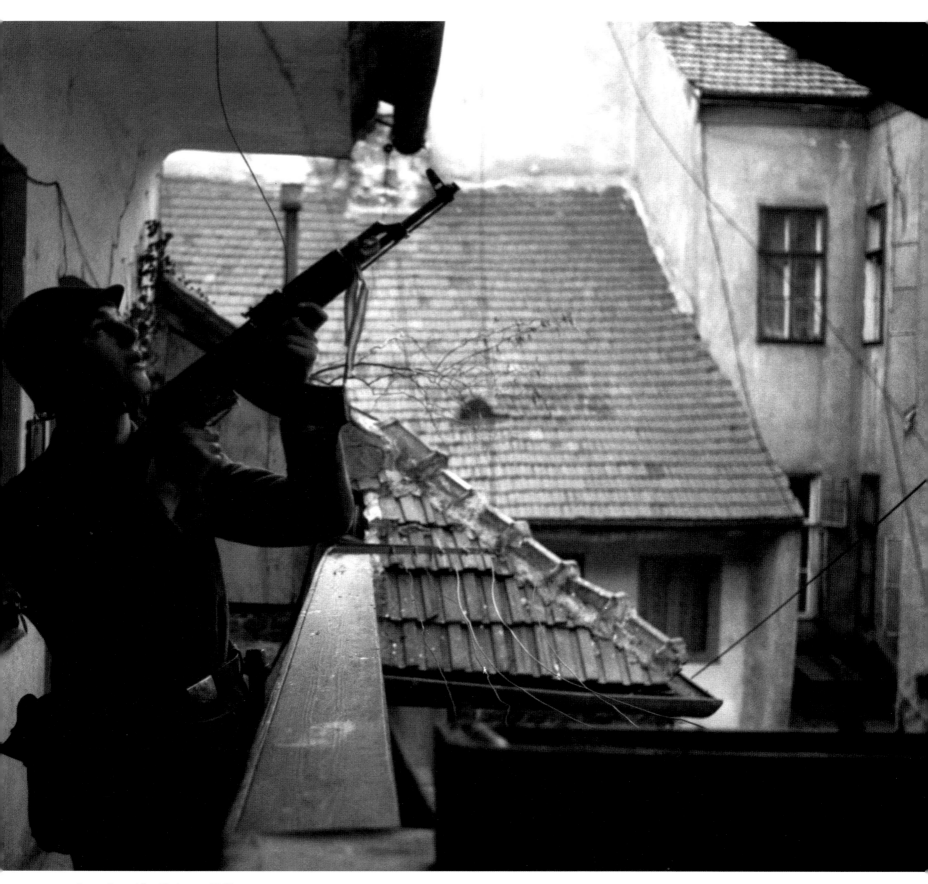

Romanian soldier, Timişoara, 1989

We crossed the border, and for a couple of hours we were all right. We drove to Timişoara because it was one of the cities where the trouble had started and it was very close to the border. At the first main crossroads on the outskirts of the city, we got caught in crossfire. I don't know who was shooting, but we were getting it from both sides. The car was hit about twenty times. This was my first day as a war photographer, and I was already in trouble after only two hours.

When the shooting let up a bit, I put the car into second gear and got out of the field of fire. The car was pretty much destroyed—the tires were flat, the windows all smashed—but miraculously only one person was hit. The guy on my side had a bullet through his hip. His name was John Tagliabue; I think he was working for *The Observer* at the time. As luck would have it, just down the street there was a hospital. Thank God he survived.

I remember thinking to myself, If the job's like this, I'm going to quit. If my life is like this every day, it's going to be a nightmare. I can't deal with this. But you learn to take care of yourself. Fear comes from not understanding. The more you deal with risk, the more you begin to understand that often what looks risky turns out not to be, and what looks safe is sometimes very dangerous. After experiencing the shooting, I was sure I was going to leave the next day, but by nightfall I had decided that it wasn't always going to be like this. I went to the main hotel of the city, met a few people, and got some information, and I was in the mood to work again.

When I got back to Belgium, everyone thought I was dead, because on the night of the shooting another Belgian journalist had been killed somewhere in Romania. A correspondent from Belgian radio had seen my wrecked car in the courtyard of the hotel and had reported that I was dead. ∎

National Army soldiers joining popular revolt, Timişoara,1989

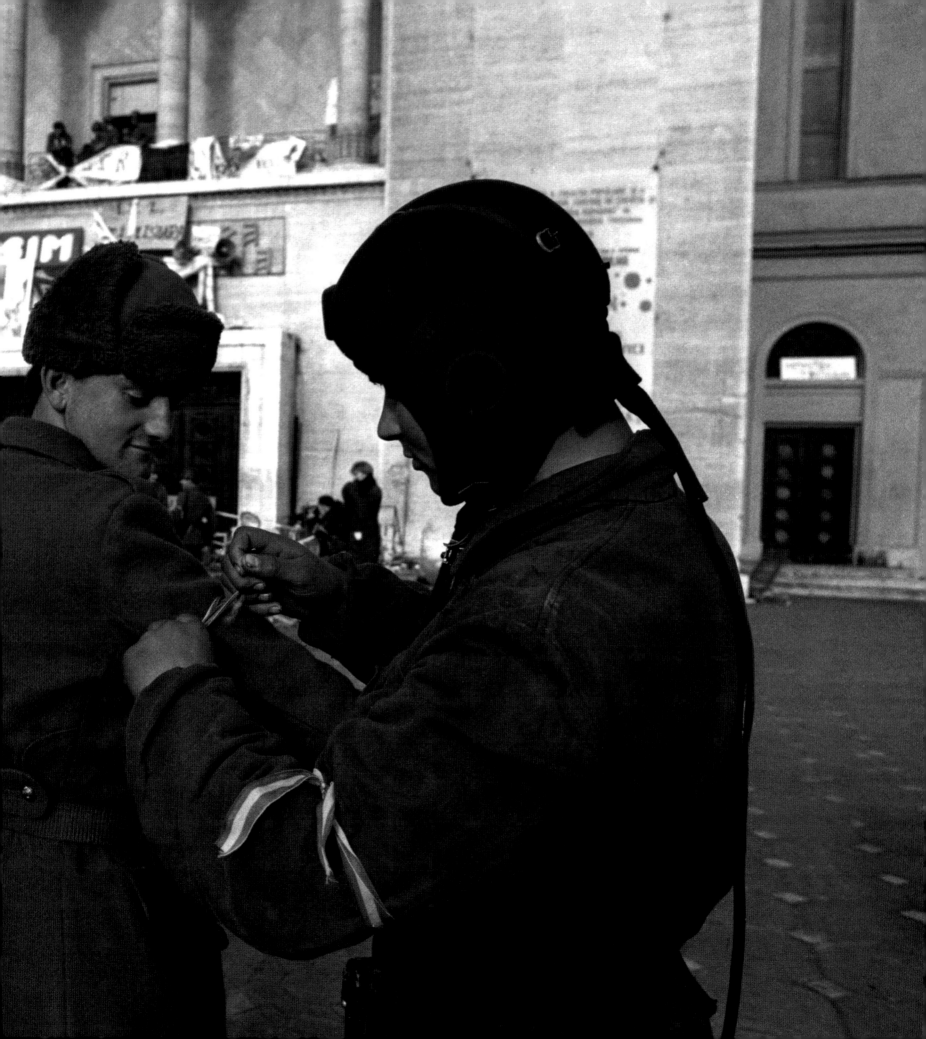

The Tragedy of Dying Unknown

I decided to do this job when I was very young. I was an idealist who felt ashamed of society and the world. How was it possible that we could go to the moon but not be able to feed people in Africa? Of course, I very quickly understood that it's not so simple as I thought. I came to the point where I asked myself, How can you continue taking pictures that serve no cause, that will not help anything and will not change anything, because man will always be like this?

In September 1993, I met a very old man who was living under circumstances that you couldn't ever imagine. All around, people were dying like animals, and this old man came up to me because he saw I had a camera. He said to me, "We can accept to die like animals. We can accept to be killed like a rabbit or to face somebody we don't understand and who doesn't care about our lives. But to die like this, unknown and without any proof of our existence—that's the worst thing possible." This old man was living in a situation where life has more clarity, where everything is reduced to the essentials. He was speaking about the future. He didn't want a witness for his own life and death. He was saying that if this is never known, it will be repeated in the future. And that means that it will never change; it will be like this forever.

At the time I was questioning myself: "What is this all about, what is this shit? You have a life, you have your kids. Why are you here?" But he made me understand then that even if at some point I lose faith in my job, and even if I don't know if it's useful or not, it doesn't matter. What matters is that this old man and the thousands like him don't die unknown. It was really moving for me. I was recovering from wounds, I was angry with what the press was publishing, and I was upset to see these people living their lives so close to a completely different way of life. Mostar was just a two-hour drive from the Croatian coast, where you could eat great fish and drink wonderful white wine. It was insane, and it was obscene. ∎

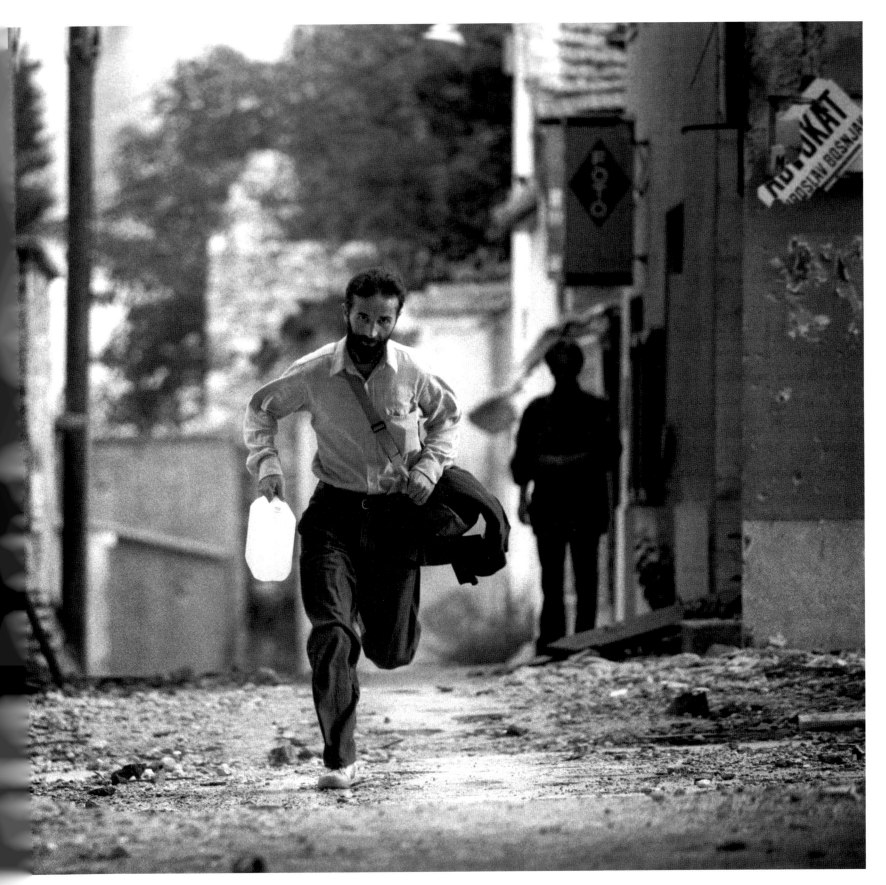

Dodging Croatian snipers, Mostar, 1993

Learning from the Chechens

Chechnya was the craziest place I've ever been. I was in Grozny in 1995, and the Russian army was using everything it had—planes, tanks, artillery, the lot. Strangely enough, though, I was in a good mood, and I had a good feeling about being there. At least you knew what was happening. You weren't in a situation where it's so quiet that something could happen without you knowing it. I think it's the most dangerous situation I ever experienced. The Russians destroyed the city in one month. I had never seen that before.

This picture was taken in August 1996. The Chechens are an amazing people. At the start of a war between civilians and an army, it's always very dangerous. Civilians, even if they're brave and strong, or even if they're crazy, usually don't know much initially about combat. I joined a group of Chechen fighters with fresh clothes and fresh guns going to the front line and I thought, Okay, I'll go with you, but I'm going to be very careful, because they were young and didn't know anything. But they went straight to the front line, as if it was in their blood. It's been like this for generations, for centuries. They're a strong community with a strong culture and a strong identity, and they know how to survive. I learned a lot from them. They're really beautiful. I'm not speaking about individuals, because there are beautiful individuals everywhere. I'm speaking about the group. The attitude of the Chechens is why I went there. I'm just in love with these people. ■

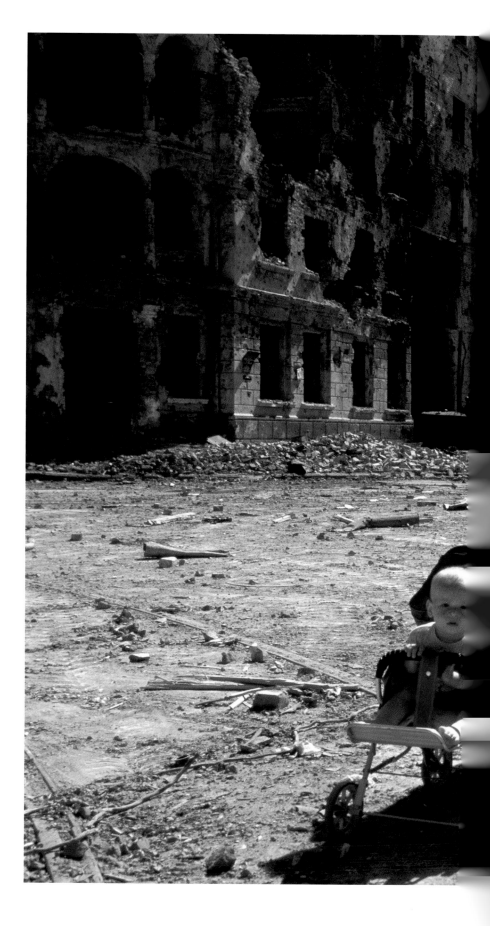

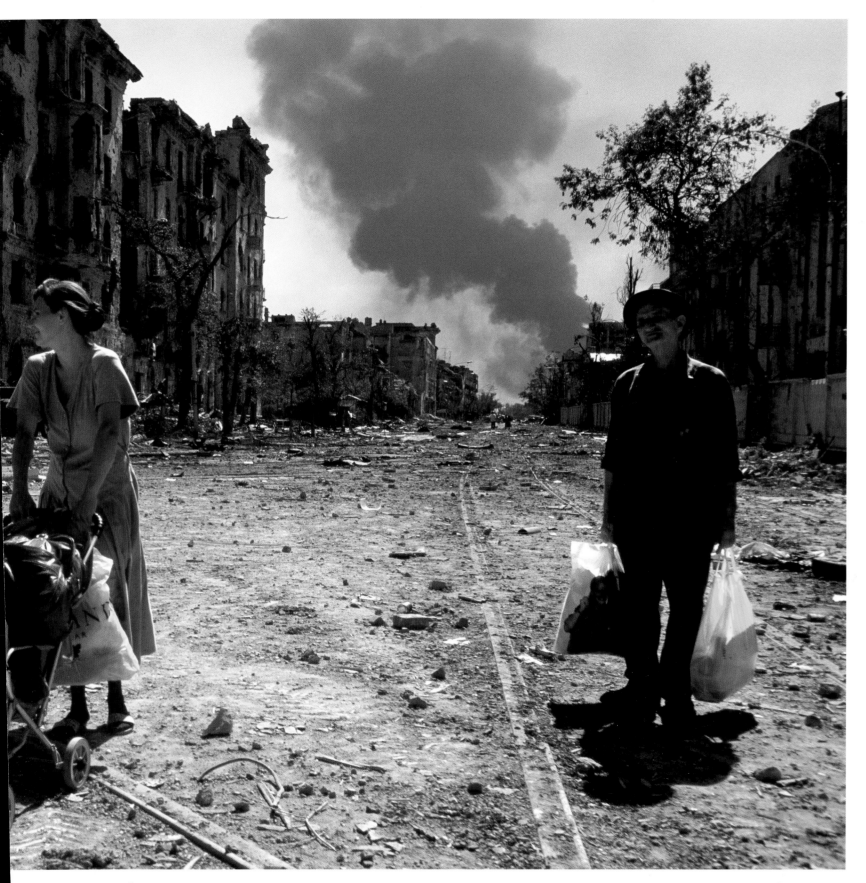

Ruins of Grozny, 1996

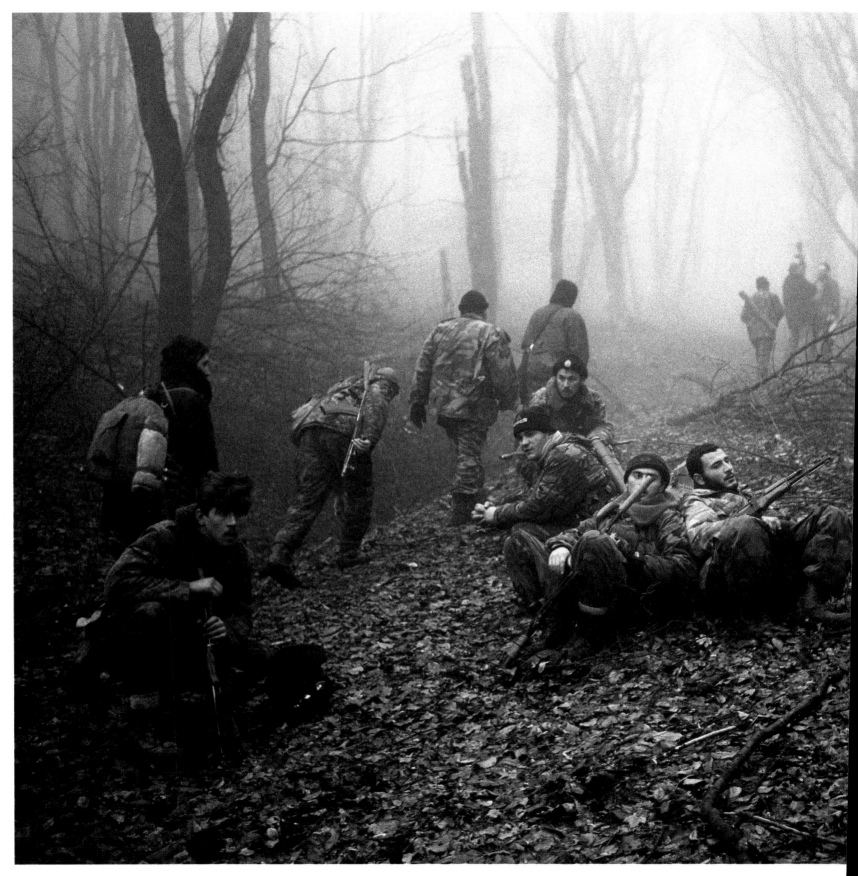

Chechen fighters, outskirts of Grozny, 1999

Just Getting There Is Tough

In December 1999, at the time when Putin was trying to get elected president of Russia, he was claiming that Grozny was under control. Grozny was not under control—nothing was. But the Russian army was well positioned, so he decided to take back the city. The Chechens were inside, but they were out-numbered and they needed reinforcements—the guys in this picture. They not only had to cross Russian lines—Russia was one of the most powerful armies in the world at the time—but also their own lines to get in.

For a photographer, getting into Grozny was a total of six months' work. First of all, you had to have been there before, because if they didn't know you, they would just take you hostage to get money to continue the struggle. The price for your release would be $1 million. In order for this not to happen, you had to know these people, and they had to respect you. You had to find somebody who could communicate with them and explain what you wanted to do. My way was to go via Ingushetia, a country to the west of Chechnya. I would have to stay there for up to a month just to organize everything. You had to cross the border, which meant crossing through more Russian lines. But you couldn't do that with a car; the only way was to walk through the mountains. And if you were bringing a lot of equipment with you, you would need horses. It was a huge logistical problem, and you never knew who you would run into. It's not only that you had to be safe with the people who were guiding you; they had to be powerful enough to con-vince anyone they met to not take you hostage.

I'm not going to go back there anymore, because now it's even more dangerous. The country's totally shattered, both physically and psychologically. Everything is destroyed. You can't even communicate it through pictures. ■

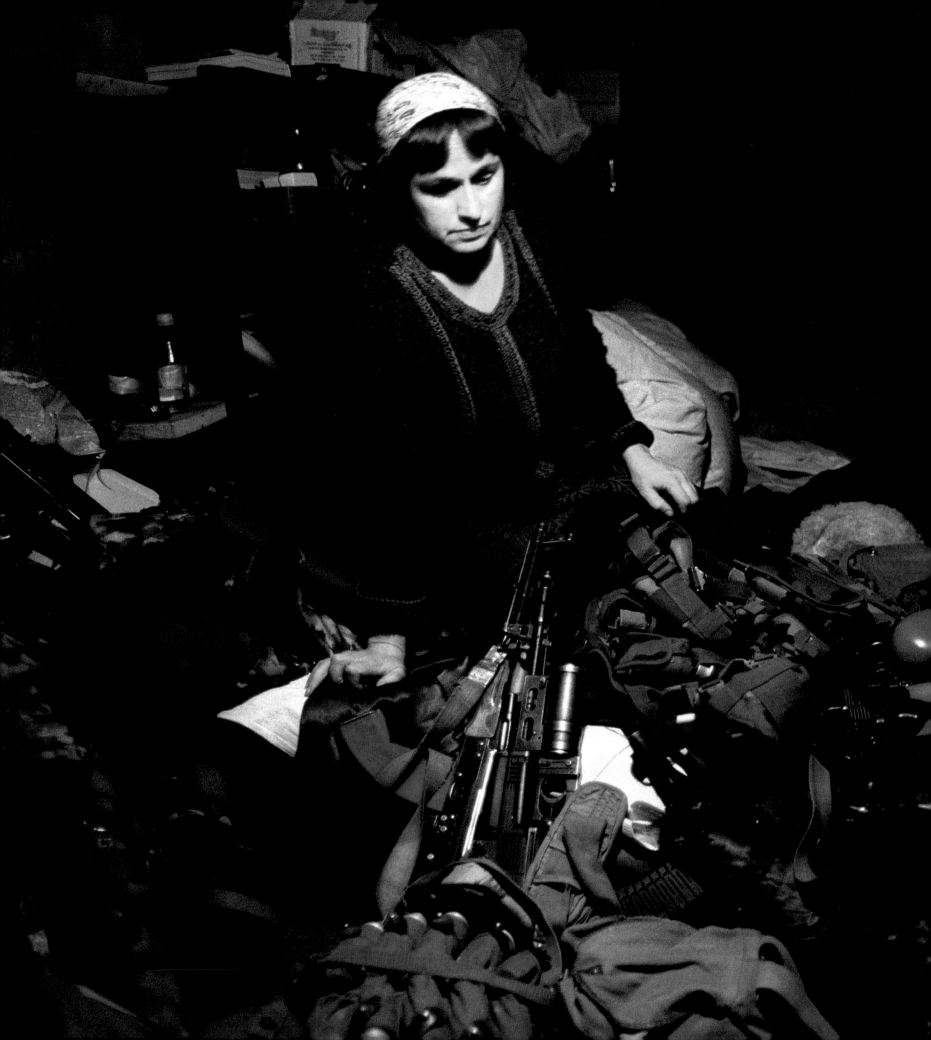

THE LIFE OF A FIGHTER'S WIFE

This is a couple who were a part of a huge
group that went into Grozny early on. The
wife has been by her husband's side since the
beginning of the war. She could have waited
for him in a safer place, but she decided to
share his life as a fighter. He won't stop
fighting because it's a question of honor, so
she stayed with him and went with us
through the Russian lines. It was a march of
seventy-two hours; I found myself falling asleep
walking in the mud, but she just wanted to
stay with her man. Their life will be like
this until the end. Here they are together in
the basement, preparing him for an operation
somewhere in the middle of the night.

Sometimes I get afraid when I'm leaving
for a place like Grozny, not knowing where
I'm going or if it's going to be a nightmare.
But if the people I photograph are still alive,
and if they're able to survive, then I will, too.
I'm healthier than they are. I come from a
country where we eat and sleep every day. I'm
going to leave when my work is finished.
I'm lucky compared to them, so if they're
alive, I'm going to be alive. (Grozny, 1999)

Deception in Dhahran

I was in Baghdad when the Americans started to bomb. I had been there about a month, just waiting for something to happen. A week after the bombing began, I was arrested because I was a westerner and kept in custody by the Iraqi military for twelve hours. They gave us a very bad time—they beat us, accused us of spying, and organized a kind of fake execution. Finally, some men wearing civilian clothing took us blindfolded back to the Al Rashid Hotel in the middle of the night and made me open the trunk of my car. When they saw all my cameras inside, they realized I was a journalist, but they threw me out of the country the next day. I returned to Paris and spent a few days there before rejoining the war, but on the other side.

The Gulf War taught me how to deal with the military system and avoid its limitations. All the photographers in my agency asked the New York office to buy us military uniforms that are available at any army surplus store. We knew that most of the allied officers didn't like driving Humvees, which they thought were too hot and dirty. So we rented a Toyota Land Cruiser, which they preferred, and decorated it with the appropriate symbols. With this and the uniforms, we were able to drive almost everywhere. If we had been caught, we would have been arrested and sent back to our respective countries.

You have to understand that at that time, we didn't have much to do. Most of our time was spent preparing for D day. We got to know the roads, and checked every day where the troops were and if they were moving. For this, the car and the uniforms were enough. When it was time to take pictures, however, the situation became more difficult. The day before

D day, I was in the same city as the French troops, west of Dhahran and about twenty miles from the Iraqi border. I found out that I needed to be at the Kuwaiti border, not the Iraqi, so a friend and I started driving. At one point, we saw something in the distance that looked like a column of trucks. We came to a sort of plateau that hid the ground just below us. As we descended, we suddenly found ourselves in front of a huge column of soldiers and tanks. Most of the troops were French, but there were some Americans.

The last thing we wanted was to be arrested on D day. I stopped the car, but we were too close to go back without them seeing us. A French officer brought the whole convoy to a halt and came over to us. He asked me in bad English where the border was, and I realized that he thought we were with the U.S. Special Forces, because we had come from the direction of Iraq. So I said to him in as good a Texan accent as I could, "You've got to go that way. We saw an Iraqi column over there, so be careful. We'll follow you." I pointed in the direction of the trucks we had seen earlier. I knew I was playing a dangerous game, but I didn't know what else to do. The officer thanked me and moved out, with us following them.

About two hours later, we made contact with the trucks, only to discover that they weren't trucks but a convoy of tanks. The French force engaged them, deploying everything they had, and the Iraqi convoy was totally surprised. It was D day, about five A.M., so it was probably the first engagement of the war. And there I was on the roof of my car taking pictures of an action between the French and Iraqis that I had provoked. ■

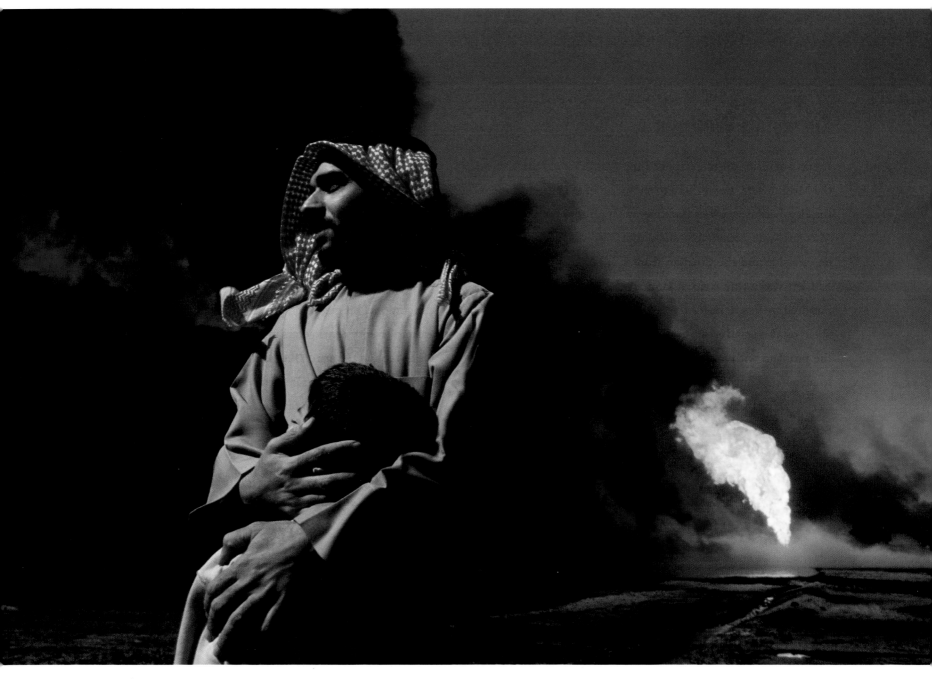

Burning oil fields, Kuwait, 1991

Surviving Wounds

It was awful in Mostar. I spent fifteen days inside the city on the Muslim side. I was there to show the life of the civilians in the city, because most of the time war is all about civilians. The Muslims were completely surrounded by the Serb front line on one side and the Croatian front line on the other. All they had left was a tiny strip of land about two kilometers by five hundred meters. I knew that photographs of the effect of the shells on this small area were an important part of the story, but the problem with taking that kind of picture is that you have to be outside during the shelling.

I had already been injured by shells in Vukovar in September 1991. I had been walking for just a few minutes when a shell fell about twenty meters away from me, injuring a civilian. I took some pictures, but the shells were still coming down, so I ran inside a house with some other people. Instinctively,

I had positioned myself against a wall between a door and a window when a shell landed directly in front of the house. It exploded, and the shrapnel from it came in the door and the window and killed five or six people; I don't remember exactly how many because I was in shock. Although I had been protected by this piece of wall, it was a small room, and some of the shrapnel hit me in the arm. As a result of that wound, I lost around twenty centimeters of bone, and it took two years of my life to rebuild the arm. Three different doctors—one in Vukovar, one in Hungary, one in France—wanted to amputate it because they thought it was too far gone. Finally, I met an amazing guy, a professor in Paris, who decided to take a chance, and through his efforts he managed to save it.

Then in February 2001, I was in Ramallah covering an ordinary demonstration. You could hear some shooting in the

distance. Suddenly, an Israeli soldier shot one live round. It hit me in the middle of the knee and went right between two bones. The bullet was from an M16. It's a very small but very high-velocity bullet that's designed to shatter bones, so I'm partially paralyzed because the main nerve was cut. Something will come back; I still don't know how much exactly, though not everything. I'll never run again, and I'll never be able to march with Chechen rebels through the mountains again.

I'm totally sure that I was targeted, that they decided to shoot the guy taking pictures. It's happening a lot nowadays. Reporters Sans Frontières published a study of forty-five journalists wounded in the occupied territories between September 2000 and August 2001. Sixty-two percent were photographers and 25 percent were television cameramen. Only five were television reporters and only one was a writer.

I don't know if they have actual orders to shoot journalists, but at the very least it must be accepted by the Israeli authorities.

Maybe one day I'll decide to stop this kind of work, but I'm not going to let somebody else decide that for me. It's a thought a combat photographer has many times in his life: "Should I stay or should I go?" But I'm not going to decide to leave because of something like this. I don't enjoy being in danger; it's not a reason to do this job. If I could do the same work with the same results without taking any risks, I would love it. But when you become more experienced and more skilled, you do get pleasure from being in danger and still being able to perform. If you're clever enough or lucky enough to survive or to not get wounded, it's like, "Fuck you. I wanted to do it, I had to do it, I did it, and it's great to succeed despite the danger." ■

Acknowledgments

Although one name appears on the jacket of this book, there should be about twenty. Prominence should justly be given to all of the photographers I interviewed who generously gave of their time and insights. Also deserving of display would be my friends at the International Center of Photography in New York, especially Phil Block and Deirdre Donohue. A special section would be reserved for the wonderful team at Artisan led by publisher Ann Bramson, and would include the relentless picture editor Leora Kahn; my gentle but persuasive editor Laurie Orseck; and the deeply talented designer Susi Oberhelman. They all made this project fun to get up to every morning. Ashley Woods of the agency VII, Robert Pledge of Contact, and MaryAnne Golon of *Time* magazine merit special mention as well. But if there is a name that deserves to be in bold type, it is that of my wife and life partner, Anthea Disney, who has supported me in everything that I have tried to do. Special thanks should also be given to my dog, Bobby Blue, who gives the best foot licks under the desk.

Photography Credits

pages 1, 8–9: Christopher Morris/VII

pages 2–3, 13: Laurent Van der Stockt/Gamma Press

pages 4-5: James Nachtwey/VII

pages 6–7: Susan Meiselas/Magnum Photos

page 11: Horst Faas/Associated Press

page 15: Yevgeni Khaldei/Corbis

page 16: Roger Fenton/Library of Congress

page 17: Mathew Brady/Library of Congress

page 19: photographer unknown/Hulton Getty

pages 20, 21: Robert Capa/Magnum Photos

page 23: W. Eugene Smith/Stockphoto.com

page 24: Joe Rosenthal/Associated Press

page 26: Eddie Adams/Associated Press

page 27: Nick Ut/Associated Press

pages 29, 30: Larry Burrows/Time-Life

page 33: photographer unknown/Associated Press

page 34: David Turnley/Corbis

page 35: Ken Jarecke/Contact Press Images

page 36: Bill Biggart, courtesy Wendy Biggart

THE PHOTOGRAPHERS

pages 38–51: Patrick Chauvel/Corbis/Sygma;
 pages 52–55: Patrick Chauvel

pages 56–77: Philip Jones Griffiths/Magnum Photos

pages 78–97: Ron Haviv/VII

pages 98–115: Catherine Leroy

pages 116-139: Don McCullin/Contact Press Images

pages 140–155: Susan Meiselas/Magnum Photos

pages 156–171: Christopher Morris/VII

pages 172–191: James Nachtwey/VII

pages 192–207: Maggie Steber

pages 208–223: Laurent Van der Stockt/Gamma Press